Paul Martin
Victorian Photographer

Paul Martin
Victorian Photographer

by Roy Flukinger, Larry Schaaf, and

Standish Meacham

University of Texas Press, Austin and London

Images in this book were taken from originals preserved in
the Gernsheim Collection and the Photography Collection of
the Humanities Research Center, The University of Texas at
Austin.

By permission, one image was taken from an original preserved
in the Collection of the Art Museum, University of New Mexico,
Albuquerque, and two images were taken from originals preserved
in the Collection of the Fine Arts Library, University of New
Mexico General Library, Albuquerque.

A LITTLE OF WHAT YOU FANCY DOES YOU GOOD
Words and Music by GEORGE ARTHURS and F. W. LEIGH
© Copyright 1915 by Francis Day & Hunter Ltd.
Sole Selling Agent MCA MUSIC, a division of MCA Inc., New York, N.Y.
USED BY PERMISSION ALL RIGHTS RESERVED

Library of Congress Cataloging in Publication Data

Flukinger, Roy, 1947–
Paul Martin: Victorian photographer.

Bibliography: p.
Includes index.
1. Martin, Paul, 1864–1944. 2. Photographers—
England—Biography. I. Schaaf, Larry, 1947– joint
author. II. Meacham, Standish, joint author.
TR140.M35F59 770'.92'4 [B] 77-4764
ISBN 0-292-76436-7

Copyright © 1977 by the University of Texas Press

All rights reserved

Printed in the United States of America

Contents

xi
Preface

xiii
Acknowledgments

3
Paul Martin: A Critical Biography
by Roy Flukinger & Larry Schaaf

79
Late Victorian London and Its People
by Standish Meacham

107
Notes

119
A Selected Bibliography

123
Photographs Taken by Paul Martin

219
Index

Figures

Paul Martin, 1895 4

"Don't tell me—let me guess" 5

Page from Martin's retrospective diary 7

Wood engraver and apprentices at work 9

Wood engraving from an illustrated paper 10

Snapshot and woodcut based on it 12–13

Earliest example of photography used to impress
image on wood block 14

Wet collodion process 16–17

Dry-plate process 18–19

Disguised cameras 20–23

Public relations problems 24–26

Page from Martin's early amateur album 29

Whitby, 1885 30–31

Martin in 1895, climbing Mount Pilatus 32

"The Onion Field," by George Davison 34

Interior of the Photographic Salon, 1897 36

The Facile camera 37–38

The new Kodak camera 39

Stop-action pictures, by Eadweard Muybridge 40

"Moment-Aufname," by Carl Hiller 41

"Loading Up at Billingsgate Market" 44

"Loading Up at Billingsgate Market: Cut-Out
Figures" 45

"The Balloon Seller: Cut-Out Figure" 46

"The Irish Street Seller," from a daguerreotype
by Richard Beard 47

"Halfpenny Ices," by John Thomson 48

"Children of the Poor in the Nineties" 49

"The Upward Path" 50

"Street Arabs" 51

Typical lantern slide 53

"Westminster by Night," by Walter Edmunds 55

"Big Ben (A Late Sitting) and Westminster
Bridge" 55

An early failure 57

Sketch with photograph inserted, by Henry
Peach Robinson 60

"A Composite Subject" 62–63

Dorrett & Martin 65–67

Photo-buttons 68–69

Martin in 1942 71

"View from Wengen" 72

Zeiss Palmos camera 73

"Water Rats," by F. M. Sutcliffe 76

"The Urdey Gurdy Organ" 77

Three street urchins: detail 81

Concert on Yarmouth Sands: detail 82

"A Street Cab Accident in High Holborn" 83

"Carrying Cases of Oranges from Ship to
Warehouse" 84

"A Policeman's Funeral in Lambeth": detail 87

"New Laid Eggs": detail 93

"The Swing in Our Alley": detail 95

"The New Purchase": detail 97

"Baby, Feed the Swan!": detail 100

"Waiting for the Signal to Bathe in the Lake" 101

"Bank Holiday on Hampstead Heath": detail 103

"Trippers Having a Paddle": detail 105

Plates

1. "A Scene in St. Paul's Churchyard"
2. Military volunteers skirmishing on Wimbledon Common
3. Unidentified group
4. Jack-in-the-Green
5. Children in pool on grounds of Lambeth Palace
6. Children following ice cart in the New Cut
7. Children in altercation at ice cream barrel in the New Cut
8. "Dancing to the Organ"
9. Street market in Farrington Road
10. "Covent Garden Market, 7 A.M."
11. "Loading Up the Railway Vans"
12. Market stalls in the New Cut
13. "The Midday Rest"
14. "The Cutler"
15. "The Tinker"
16. "A Drink in Cheapside"
17. "General Dealer"
18. "Butcher's Knives to Grind"
19. "The Cheapside Flower Seller"
20. Magazine seller at Ludgate Circus
21. "Unloading Straw"
22. Fish porter at Billingsgate Fish Market
23. Fish porters at Billingsgate Fish Market
24. Fish porters at Billingsgate: cut-out
25. Cheapside flower seller: cut-out
26. "Off to Bridewell"
27. "Rescuing the Lady"
28. "Waiting to See the Policeman's Funeral in Southwark"
29. "Chelsea Bridge Fair near Battersea Park"
30. Battersea Park Fair
31. "Children of the Poor of Battersea"
32. "Bank Holiday on Hampstead Heath"
33. "Entrance to Victoria Park"
34. "The Church Parade"
35. "Three Little Girls Resting"
36. "An Ice Covered Barge near Blackfriar's Bridge"
37. "Penn Ponds in Richmond Park"
38. "Snow Scene along the Embankment"
39. "Big Ben (A Late Sitting) and Westminster Bridge"
40. "Cleopatra's Needle"
41. "The Alhambra at Night"
42. "Eros in Piccadilly Circus"
43. "The Old Empire in 1896"
44. "Big Ben in Winter"
45. Pictorial effect
46. "A Game of Billiards"
47. Camp in Quarry Woods
48. Campers at Iffley
49. Early morning scene at Pangbourne
50. "An Old Surrey Tramp"
51. "Trippers Caught by the Sea"
52. "Returning from a Dip in the Briny"
53. "Bathers at Yarmouth"
54. Capstone Hill, Ilfracombe
55. Children playing on the sands
56. "A Loving Couple"
57. "Two Little Girls in Blue"
58. Another couple on the sands
59. Punch and Judy show at Ilfracombe
60. Fortune teller
61. Pears Soap advertisement board
62. University Boat Race
63. Seats on barges for viewing University Boat Race
64. Stormy seas at Hastings
65. Gales at Hastings
66. Deal boatmen
67. Fisherman dropping the anchor
68. "A Swing from Father's Boat"
69. Fisherman gives his boat a name
70. Gorey fishermen
71. "The Fisherman"

72. "Off to the Fishing Grounds"
73. Entertainment on the Margate Sands
74. Jersey? 1893?
75. Jersey, 1893
76. Bathing at St. Helier
77. Burning seaweed
78. Mussel gatherer
79. "The Critics"
80. Boulogne holiday
81. "Pioneers on the Quay"
82. Boulogne, 1897
83. Boulogne, 1897

84. "Hurry Up, Lazy Bones"
85. "How a Kodak Works"
86. At the railway station in Pilatus
87. "Decorating at Ludgate Circus"
88. Lord Kitchener talking to General Trotter
89. "Opening of Parliament by King Edward VII"
90. "Review of Indian and Colonial Troops"
91. "The King and Queen Alexandra Leaving the Horse Guards Parade"
92. "The Canadian Arch in Whitehall"
93. "Society at Tea during the Interval"

Preface

When the University of Texas acquired the vastly important photographic history collection of Helmut and Alison Gernsheim in 1964, it took on both individual examples of the progress of the art and many smaller "collections" within the collection. One of the most fascinating of these is a group of over one thousand photographs by Paul Martin.

Organized study of Martin's work began in the summer of 1972 when I was employed by the Photography Collection as a special assistant. Joe Coltharp, the curator, had always been intrigued by the candid snapshots taken by Martin. They had, in fact, proven to be some of the most popular images in the traveling exhibit *Victoria's World*. It was decided that my summer was to be spent organizing the Martin collection. What evolved was an index to the images, an incomplete realization of their importance, and the resolve to do some additional research.

The original glass plate negatives that Martin took in the 1890's are well represented in the Gernsheim Collection. In addition, there are a critical early album and many prints and glass lantern slides that Martin had mostly made in retirement to illustrate lectures. The prints were also employed by many periodicals and books and picture agencies as a nostalgic record of the late Victorian period and bear the routing and cropping marks of many handlers.

Martin's motivations had seemed very clear and simple when I first started working with the images. The pictures seemed very obviously to be a unique British parallel to the work of Jacob Riis and Lewis Hine, following in the tradition of British social workers such as John Thomson. This would later prove not to be the case, however. Three years were to pass before some persistent reminders by Roy Flukinger finally got us both involved in researching Martin's photography. The simple story rapidly evaporated as the facts became known.

While some aspects and individuals of late Victorian photography have been extensively covered, the story of the emergence of the amateur photographer in the dry-plate era was surprisingly hidden. Martin's role took on a whole new significance as it became apparent that he represented in his own life a miniature history of the rapid rise of amateur photography near the end of the century. His vocational evolution from a woodcut illustrator to a press photographer added yet another dimension. Standish Meacham, a specialist in the social history of the period, joined the group and made a much-needed contribution to the context of Martin's photographs.

Our story in the end is one of rising social and historical awareness, the replacement of a hand-crafted art by a semi-mechanical process, sweeping technological changes, and—most importantly—one man's struggle to define his role within this structure. All through this, Paul Martin recorded with charm and spontaneity the passing of the nineteenth century.

L.S.

Acknowledgments

In the early spring of 1976 Larry Schaaf and I dusted off our old notes and began research in earnest on the life and career of Paul Martin and the photohistorical periods in which he lived. The investigation continued throughout the summer, and the writing and final revisions of our text brought us into the autumn of that year.

During this time our chief source for both the imagery of and the information about Paul Martin had been the Gernsheim Collection, located at the University of Texas at Austin in the Humanities Research Center. This collection, together with the holdings of the General Libraries of the University of Texas, formed the basis for our study of Martin, his photographs and his time.

Nonetheless, we did not restrict our investigations solely to the holdings of this university. Other institutions and individuals were consulted and questioned throughout this period, providing us with even more information about Martin and insight into his work and his place in the history of photography.

We would like to thank especially the following persons and organizations for their contributions to the research or production of this book:

Joe Coltharp, Curator, May Ellen MacNamara, Secretary, and Terry Faucheux, Page, Photography Collection, Humanities Research Center, University of Texas at Austin;

F. Warren Roberts, Director, and William R. Holman, Librarian, Humanities Research Center, University of Texas at Austin;

Elizabeth Airth and Kathleen Blow, Reference Department, and Jo Anne Hawkins and Marcia Parsons, Interlibrary Services, Library, University of Texas at Austin;

J. B. Colson and C. Richard King, Department of Journalism, and Martha A. Preston, University of Texas at Austin;

Bob Smith of Accurate Image, Austin;

Van Deren Coke, Director, and Charles Harrison, Museum Aide, Art Museum, University of New Mexico, Albuquerque;

Colin Ford, Keeper of Film and Photography, National Portrait Gallery, London;

Kenneth H. Warr, Secretary, Royal Photographic Society, London;

Joyce I. Whalley, Assistant Keeper, and D. G. Wright, Victoria and Albert Museum, London;

Brian W. Coe, Curator, Kodak Museum, Harrow;

Nancy Hall-Duncan, Curatorial Assistant, Gretchen Van Ness, Research Assistant, and Marianne Margolis, Research Assistant, International Museum of Photography at George Eastman House, Rochester, New York;

Center for Research Libraries, John Crerar Library, and Newberry Library, Chicago; and the libraries of the University of Wisconsin and Dartmouth College.

R.L.F.

Paul Martin
Victorian Photographer

Primary source materials by and
about Paul Martin from the Gernsheim
Collection were used in compiling information
on the following photographs. Martin's exact words
are included in quotation marks. In most cases these
quotations and other information were derived from
original manuscript captions accompanying the
original photographic images in the Photography
Collection, Humanities Research Center,
The University of Texas.

Paul Martin
A Critical Biography

by Roy Flukinger & Larry Schaaf

Introduction

Paul Martin was one of the true pioneers of modern photography. His snapshots of the common working people of late Victorian England hold immense appeal and tend to fit easily into modern photographic aesthetics, as evidenced by the almost universally favorable comments about his work in photo-historical writings. His images, reminiscent in style and content of some of the work of Eugene Atget, Alfred Stieglitz, Jacob Riis, and many of the classic photojournalists, are important both in helping to define photography as a distinct art and in recording for posterity aspects of the times in which he lived. Much of his photography can be characterized today as "candid photography," or "snapshots," or perhaps even, for those jaded by images, "just plain photography."

The snapshot itself was unusual in Martin's early days. The term is a hunting term, meaning, according to the 1919 *Oxford English Dictionary*, "a quick or hurried shot taken without deliberate aim, esp. one at a rising bird or quickly moving animal." Its application to photography was first suggested by the great scientist and photographic pioneer Sir John Herschel in 1860: "What I have to propose may appear a dream; but it has at least the merit of being a . . . realisable one . . . It is the . . . representation of scenes in action—the vivid and lifelike reproduction and handing down to the latest posterity of any transaction in real life . . . I take for granted nothing more than . . . what photography has already realised, or . . . will realise within some very limited lapse of time . . . the possibility of taking a photograph, as it were, by a snap-shot—of securing a picture in a tenth of a second of time."[1] Technology was to lag many years behind Herschel's fertile imagination, but, when it did catch up to and even sur-

pass his prediction, Paul Martin was one of the leaders in vindicating his foresight.

Martin began his career as a wood engraver in the mid-1880's, illustrating newspaper and magazine articles by a hand-crafted process. He was fascinated, and eventually put out of work, by the rapidly expanding role of photography in communications. As we began to unravel his story, his involvement in photography became symbolic to us of the great upheavals in the young art's structure near the turn of the century. It was a time when the whole economic, social, technical, and aesthetic basis of photography was being radically altered. Martin's work and his experiences reflect these changes, sometimes mirroring the photographic world around him, sometimes pushing him to the vanguard of change.

If Martin had worked in another period, the type of research that we have done would probably have been impossible. But, because of the photographic societies and the photographic press of that time, his situation was quite similar to that of a person living in a very small town, where everyone knows what everyone else is doing all the time. Every "serious" photographer of the day belonged to at least one photographic society. Meetings were frequent, as were judged photographic competitions. The photographic press was very different in nature from what we know now. Sparsely illustrated, issued annually, monthly, or even weekly, the journals of the period were full of seemingly endless pages of fine type. The meetings of the societies were reported in detail, including the names of officers, speakers, and questioners from the audience. The almost continual exhibitions were regularly critiqued, often with reference to the participants by name. Correspondence was printed in bulk. It would have been al-

Paul Martin, photographer, 1895. Detail of a photograph, taken perhaps on an outing with the West Surrey Photographic Society. The group's members entertained and educated one another with displays of their photographs and took outings together.

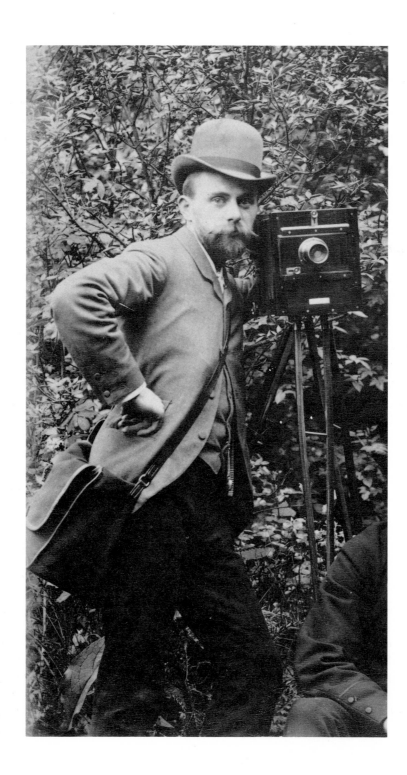

*A trick photograph by Paul Martin of himself,
captioned "Don't tell me—let me guess." It was made by
combination printing, a common pastime for amateur
photographers of the time.*

most impossible to participate in photography in
any significant way and not be referred to in print.
Given sufficient patience and complete runs of the
journals, one can usually count on being able to
discover and document a subject in minute detail.
Since Martin lived in London, the center of pub-
lishing, belonged to a society that had many
influential members, and managed to gain some
recognition and stature in his own day, we have
been able to piece together a good part of his
photographic life.

The story behind this simple, working-class
man turns out to be not so simple. We have pre-

sented his life in considerable detail because it is
a paradigm of this period of photography. Alfred
Stieglitz later formalized the types of changes that
Paul Martin went through into a new photograph-
ic aesthetic, but Martin himself was actually in-
volved in and propelled by the forces in photog-
raphy in this period. In our minds, there is no
other figure whose work so completely summarizes
the death-throes of nineteenth-century pictorial-
ism while materially helping to usher in twentieth-
century realism. Martin stands out as a unique
and fascinating experimenter in photographic
areas that were later to prove of significance.

Early Biography

Paul Augustus Martin was born on April 16, 1864, in Herbeuville, France, a quiet village situated at the foot of a range of vineyard-covered hills. Although he later made his home and livelihood in England, he remained a French citizen throughout his eighty-year life.

Most of our information about Martin's childhood is quoted from his retrospective diary, written in 1935.[2] In it he chronicled a rather rough and frightening childhood, including a near drowning when a boyfriend pushed him into the mill pond and a nasty head wound received when he fell out of a window. In 1869 his parents gave up their mill and vineyards and moved the family to Paris. His father joined Paul's uncle in the manufacture of stay-horn, used in corsets. Paul attended school and occasionally went out with his father to hunt the now-extinct wild boars of the region.

But the Martin family had picked the wrong time to come to Paris. Their successful livelihood and even their lives were threatened in the 1870 Franco-Prussian War, during which the armies of Prussia and its allies encircled the French capital in a four-month siege. Young Paul had what he termed "indelible recollections of the war." His little sister died as a result of the Siege of Paris. The family took to living in the basement to avoid the bullets shattering the windows of their home. Food was extremely scarce; the little bread available turned black, and the animals in the city zoo had to be eaten. Paul narrowly escaped death one day when a shell screamed over his head and killed a next-door neighbor.

The French defeat was soon followed by a Republican revolt against the monarchist government. A revolutionary municipal council known as the Paris Commune held the capital for more than two months in 1871 against a new siege from the troops of the Versailles government. Under the Commune, summary executions were commonplace. The Communards at one point threatened to blow up the town hall near the Martin home, and Paul's father was barely saved from execution by the intervention of a friend.

Escaping the problems of France, Paul's family emigrated to London in the middle of 1872. His father superintended the opening of a new factory to manufacture stay-horn, and, except for a very rough voyage to England, the family apparently made the transition to a new country quite easily. Paul's diary entries become more optimistic from this point. He was enrolled in a private school, where, "although I could not speak the language when I first went there, there is nothing in my memory that would indicate that I was thereby handicapped. Children evidently have a language of their own." The Falcon Road area where he first lived in London was rather rural in those days. The boy watched the blacksmith shoe horses, and he visited the Market Gardens that "stretched as far as Price's Candle Factory." Martin grew up in an area of commerce, used to a variety of agricultural pursuits and industrial trades. It was common to take a shortcut across a cabbage field. After that came a brickyard, where Paul and his friends delighted in watching the workmen make bricks. This familiarity with the working class and interest in the trades undoubtedly influenced his later photographic work.

Paul was fascinated with sports and lamented the lack of football facilities. His energy found many outlets, including boyhood mischief. "On the other side of the railway was a low neighbour-

A typical page from Paul Martin's retrospective diary.
The year 1888 was a busy one for him, as these entries show:
the roll-film Kodak camera was introduced, he took one of
his larger stand cameras on a camping trip, received a medal
for a photograph, and started the camera club—the West
Surrey Amateur Photographic Society—that was to have such
an influence on him. From the Collection of the Fine Arts
Library, University of New Mexico General Library,
Albuquerque.

hood. They nearly all kept jugs, and we used to fight their boys with stones flung from slings from the railway track." His schoolwork progressed well, however, and by 1876 he was "top boy" in his class in physiology, physical geography, and drawing. At the Christmas exam he took second prize for model drawing.

In 1878 Paul's mother took him to Paris to study in the Ecole Gosserez Preparatory School. On the way, they visited the Paris International Exhibition, the first of many trade and scientific shows that Martin was to attend. By 1880 he was top boy in the class again, this time in mathematics, drawing, and metal working. Two of his drawings were retained by the school museum.

After passing his exams in July 1880, Paul Martin was ready to look for an occupation and fortunately was drawn into the then-booming field of woodcut illustration. A "friend of the family [Mr. Paul Douet], on meeting me, congratulated me on the little drawings I used to make on the backs of envelopes when I wrote home from school. He said I was 'artistic,' whatever that meant. He invited me to his house to see some of his work, which was wood-engraving. I went, and had the pleasure of seeing him at work, and the work quite took my fancy. He saw my people, and he eventually agreed to teach me wood-engraving. A premium was to be paid, and my remuneration was to be nothing for the first year, 5s. a week for the second year, 7s. 6d. a week for the first six months of the third year, and 10s. a week for the last six months, the usual time of apprenticeship being five years; he undertook to see me through in three years."[3] Martin's apprenticeship to Douet started on August 27, 1880.

Martin's First Occupation

Paul Martin's newly chosen career of wood engraving was a promising field, as woodcuts dominated the market for illustrations in mass-communication publications in this period. Although the half-tone process for reproducing photographs and text simultaneously in print was demonstrated in 1880, it was not enthusiastically received and really was not at all important until closer to the turn of the century. The wood engravers (called "woodpeckers" because their tools made sharp tapping sounds on the blocks) would transform an artist's drawing or photograph into a line drawing, using distinctive shading to gain the appearance of tones. It was exacting, time-consuming, methodical work that was scarcely rewarded in the end. The individual woodcutter's name virtually never appeared on the block.[4]

Martin excelled at the task, progressing at a much faster pace than was to be expected even from his abbreviated apprenticeship. His boss—only nine years his senior—saw in Martin a woodcutter of unusual talent and was soon entrusting his personal jobs to the young apprentice. There was plenty of work to be done, often on a rush basis, since the Douet firm was partly concerned with the Fleet Street news business. Artists would send in sketches from the various wars and other newsworthy events of the time, to be converted to woodcuts for publication in the illus-

*London, 1884 or 1885. A master wood
engraver and his apprentices at work, probably
at Paul Douet's firm, where Martin was employed at the time.
A photograph of Martin rests on the small easel on the
table. This is one of Paul Martin's earliest amateur
photographs, probably taken with his quarter-
plate Lancaster camera.*

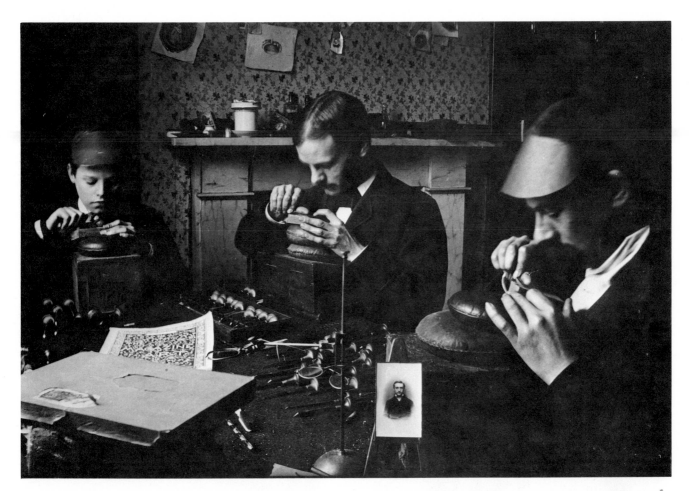

trated papers. Particularly large illustrations that had to be produced in a hurry were split into smaller blocks to allow several men at a time to work on sections. In the end, these were bolted together to form the completed picture. Paid by the hour, the woodpeckers often toiled for days at a stretch without rest to turn out the public's visual record of the news.

Martin stayed with the Douet firm for another three years after his three-year apprenticeship ended. In 1886 Douet moved too far away for him to get to work, so Martin signed on with another

woodcutting firm, Mssrs. R. & E. Taylor. His initial contract there was also for three years.

During this period, Paul lived at home with his parents and contributed to the household expenses. He records in the diary going to several exhibitions and scientific demonstrations, and we know that he enjoyed going camping and taking holidays, sometimes with his woodpecker friends and sometimes with his family. His major source of entertainment, however, was to become amateur photography.

Although few people at the time saw it that way,

A wood engraving, depicting the publishing office of The Illustrated London News. *From* The Illustrated London News, *May 24, 1851.*

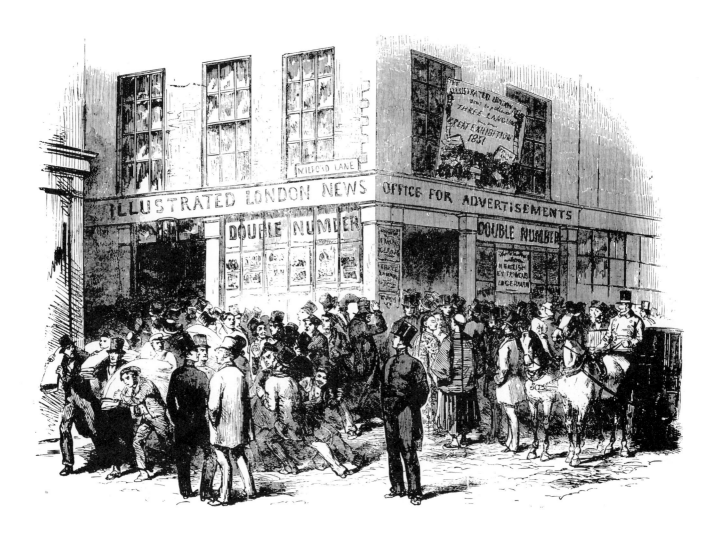

Paul's hobby was already endangering his chosen profession. Photography, which had coexisted with and even aided wood engravers for some time, was soon to threaten the woodpecker's very livelihood. The final two decades of the nineteenth century, besides being a time of rapid technological change and aesthetic reappraisal in the field of photography, also marked a revolution in the graphic arts and mass communication. By 1900 the lives of nearly all those involved in illustration would be affected; one of these was Paul Martin.

By the time photography had completed its first decade before the public in 1850, mid-century Europe and America were already experiencing an increasing awareness of the power of graphic arts in mass communication. The daily newspapers and the weekly or monthly periodicals on both sides of the Atlantic employed the services of more and more wood engravers to add a visual dimension to their reporting, and especially to inflate their sales. In 1842 *The Illustrated London News*, "the pioneer of all illustrated newspapers," sold 26,000 copies in its first week. By 1863 its weekly run was in excess of 310,000 copies.[5]

The photographer and the wood engraver got along peacefully for a number of years. There was no direct way to print photographs and type simultaneously, so the two professions were not in competition. In fact, photography at this time proved to be a distinct boon to wood engravers. Publishers easily recognized that photographs were better models for woodcuts than the vague sketches of their staff artists. From the first year that photography was known to the public, 1839, a method of sensitizing the surface of the wood block was employed so that the photographic image could be produced directly on the wood surface.[6] This eliminated the need for an artist to sketch an approximation, in reverse, of the photographic image on the block for the engraver to follow. In fact, one reason that photography was first invented was that Joseph Nicéphore Niépce, an inventor interested in lithography, could not draw well enough to copy the images that he wanted onto the lithographic stones and sought a method, using light-sensitive varnishes, to get the sun to do this exacting work for him automatically.[7]

A variety of photoreproduction processes surfaced in the decades after 1850—photoengraving methods such as photoglyphy and photogravure; the photograph-like Woodburytype; and surface-printing methods such as photolithography and collotypy.[8] However, none of these could be used to print photographs on an ordinary press, on the same page with type. Photographs produced by these processes could be bound or pasted into books, but such methods were not practical for the mass-communications media, which continued to rely on the wood engravers.

The year 1880 marked the beginning of the decline of the woodpecker's profession. In March of that year, New York's *Daily Graphic* published the first half-tone reproduction of a photograph in a mass-circulation publication. The crude image was one example of many new experimental processes for graphic reproduction that were demonstrated in a two-page display. The process, experimental as it was then, was based on the same principle as those to follow. The various shades of gray in the photograph were represented by different-sized areas raised to a uniform surface above the plate. In the case of the *Daily Graphic* demonstration, tones were reproduced by varying the width of closely-spaced lines that made up the image. Later, improved techniques would vary the size of dots, using the screen so familiar to readers of newspapers today.

Refined through the following years, the proc-

A Paul Martin snapshot, taken with his Facile camera, 1892.

ess was very slow to catch on, being employed in the periodicals mostly as a novelty at first. Editors and the public were trained and inclined to expect the flexibility and false perfection of the woodcut illustration. Magazines employed the half-tone process more and more in the 1890's, but many newspapers held out well into the twentieth century. The rapid erosion of the wood-

engraving market began to be felt severely by the turn of the century.

Some bitterness marked the passing of illustration from the highly trained artist/craftsman to a mechanical process, but the importance of the fledgling half-tone process was not to be denied. The number of illustrated journals in London jumped from five in 1890 to thirteen by 1899.

A woodcut by Martin's firm, clearly based on the photograph on page 12. The half-tone reproduction of photographs was not in common use until close to 1900. Editors preferred the flexibility of being able to do things such as leaving out the half-hidden heads and changing the boys' activity from fishing to playing with toy sailboats. In fact, Stephen H. Horgan, the photographer for The Daily Graphic *who published the first halftone from a photograph, said in 1880 that the plate was produced "in such a manner that an artist could add figures or other changes as he wished, the photographic effect being retained in horizontal lines through the picture" (*The Photographic Times and American Photographer, *October 1880, p. 232). Woodcut from the Collection of the Fine Arts Library, University of New Mexico General Library, Albuquerque.*

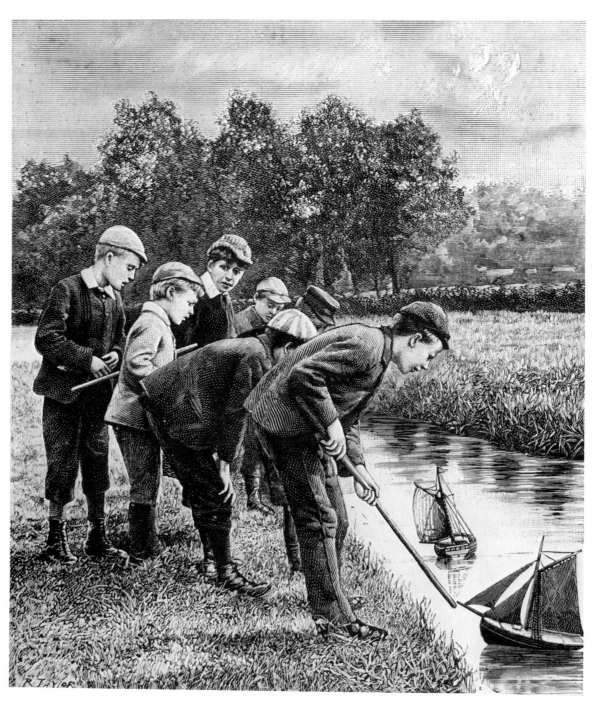

The earliest known published example in which photography was used to directly impress an image upon the wood block for the wood engraver to follow. The common procedure was to have an artist draw a rendition of a photograph on the block first. It was many years before photographic wood blocks became common and practical, but by the time of Martin's wood-engraving career they were a standard tool. From The Magazine of Science, And School of Arts, *April 27, 1839, pp. 25, 28.*

THE

MAGAZINE OF SCIENCE,

And School of Arts.

No. IV.] SATURDAY, APRIL 27, 1839. [PRICE 1½d.

FAC-SIMILES OF PHOTOGENIC DRAWINGS.

IMPORTANT APPLICATION OF PHOTOGENIC DRAWING.

SIR.—I send you three drawings of this new art, *which were impressed at once on box-wood*, and therefore are fit for the graver without any other preparation. I flatter myself that this process may be useful to carvers and wood engravers, not only to those who cut the fine objects of artistical design, but still more to those who cut patterns and blocks for lace, muslin, calico-printing, paper-hangings, &c. as by this simple means the errors, expense, and time of the draughtsman may be wholly saved, and in a minute or two the most elaborate picture or design, or the most complicated machinery be delineated with the utmost truth and clearness.

The preparation of the wood is simply as follows :—place it face, or smooth-side, downwards, in a plate containing twenty grains of salt, dissolved in an ounce of water, here let it remain five minutes, take it out and dry it ; then put it, also face downwards, in another plate containing sixty grains of nitrate of silver to an ounce of water, here let it rest one minute, when taken out and dried it will be fit for use, and will become on exposure to light of a fine brown color. Should it be required more sensitive, it must be immersed in each a second time, for a few seconds only. It will now be very soon affected even by a very diffused light.

Two other wood blocks of a different nature I will send you shortly.

55, *Great Prescot Street.* G. FRANCIS.
April 8th, 1839.

[The above communication is indeed important, and we heartily thank our kind correspondent ; the three wood-cuts mentioned illustrate the present number. The lace our engraver has done justice to ; in the flowers he has failed to express the delicacy and beauty of the drawings. The flower on the right hand is the *Æthusa Cynapium*, or Fool's Parsley, a too common weed in gardens and waste-ground. The other is the *Parnassia palustris*, or Grass of Parnassus, a beautiful snow-white plant, not unfrequent in swampy alpine pastures in the North of England. The other beautiful wood blocks we have received. They are now in the hands of our engraver, and intended for the embellishment of our next number.—ED.]

The floodgates opened in the twentieth century. In 1899 an "analysis made of the illustrations of nine of the leading journals, English, American, Italian, German, and French, of March last" revealed that 213 out of 328 illustrations were half-tone reproductions of photographs.[9] These half-tones directly replaced wood engravings. The *London Directory* shows that while wood-engraving firms dropped in number from 162 in 1884 to 80 by 1899, process-engraving firms grew from 6 to 56 in the same period. Photography benefitted from this shift so much that by 1900 a journal could claim that "the most profitable new field lying open to photographers is in the supply of matter for reproduction in the illustrated press . . ."[10]

Paul Martin was a rare convert who was able to bridge the professions of both woodcutting and photography in their heyday. Looking back in 1939, he would recall that "Few wood-engravers realised what photography was going to bring in its train. I knew that monster when he was only a sprat, for I took up photography as an amateur in 1884. . . . When the monster made a lunge at me I dodged him and clung to his tail and am still hanging on."[11]

A Brief Photographic History

Paul Martin would probably have felt thoroughly comfortable if he had been able to enter photography at the time of its first public announcement in 1839.[12] He was, above all, an experimenter, and in the first few years it was this type of person that helped to shape a largely accidentally discovered novelty into a workable and useful tool. As it was, he entered the field at perhaps the last period in its history when there were simultaneous and sweeping changes in both its technology and its aesthetics. Photography was reborn on new terms at about the time Martin caught the "Bacillus Photographicus," and for a decade they were to have an exciting time together.[13]

The evolution of photography as a science and an art is well covered in the standard histories.[14] Some background is necessary, however, to appreciate the aesthetic and technical circumstances under which Martin worked.

The first practical photographic processes were announced to the public in 1839. Because of long exposure times, expensive materials, and restrictive patents, photography was at first a difficult and costly undertaking, requiring more time and money than the average person could afford. Amateur photographers were, for the most part, fairly well to do, since the lower classes did not have the time for such a hobby. Frederick Scott Archer's wet collodion process, freely published in 1851, was a major technical advance, producing, with a relatively short exposure (from a few seconds to a few minutes), a fine-grained negative that could be used to make inexpensive paper prints. It soon was in almost universal use and remained the dominant process well into the 1880's. But the necessity of preparing and processing the plates within a few minutes of exposure made it difficult to use in the field. The means for producing a successful dry plate, based

*Before the advent of the dry photographic
plate that could be purchased factory-made, the
photographer had to cope with making the sensitive
plates in the field, using the wet collodion process. Each
plate had to be coated immediately before use, exposed while
still wet, and processed on the spot before it dried. These
restrictions limited the number of amateurs and certainly
precluded "candid" photography. From Gaston Tissandier,*
A History and Handbook of Photography
(London, 1876), facing p. 298.

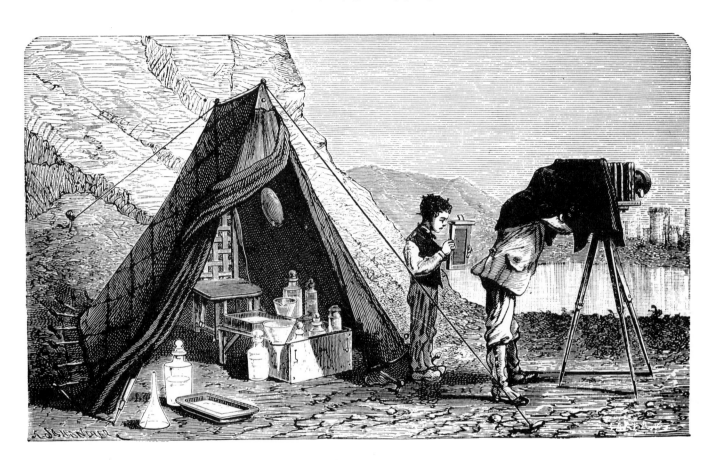

Upper, *a portable photographic dark tent.*
From Edward L. Wilson, Wilson's Cyclopaedic
Photography *(New York, 1884), p. 115.* Lower, *portable
photographic apparatus. From Tissandier*, A History
and Handbook of Photography, *p. 136.*

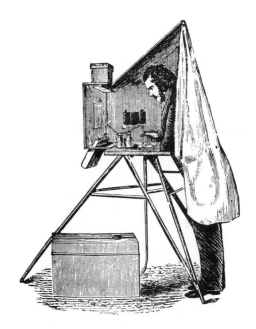

on employing a gelatin emulsion, was first indi-
cated by Dr. Richard Maddox in 1871. His health
had been threatened by the fumes of the then-
common collodion, and his search for a substitute
base had led to gelatin. While his own plates were
obviously experimental, he published his results
and enabled John Burgess to market a practical
version of the gelatin emulsion by 1873.[15] The dry
gelatin plate, available ready-made in a form that
could be used by even a person of very limited
technical knowledge, was also enormously more
sensitive to light than wet collodion. This char-
acteristic finally made possible shorter exposures
capable of capturing action and created a need
for a photographic shutter, a rarity before that
time. By 1880 dry gelatin plates had emerged
strongly in the photographic market, and in 1897
Photography magazine estimated that "not more
than one or two per cent of our readers have actu-
ally worked wet plates in the field."[16]

The advent of a sensitive, factory-manufac-
tured plate with reasonable storage life also led to
a re-evaluation of the design of cameras. Most
cameras before this period consisted of a simple
wooden box or a box with bellows, very large and
firmly married to a cumbersome tripod stand.
Dry plates led to what we recognize today as the
hand camera. In Martin's period these were un-
fortunately dubbed "detective cameras," initially
evolving from the stereoscopic cameras then
commonly in use. (Large cameras had been most
common because the only really practical printing
method was contact printing, requiring a negative
as large as the final print. Stereo pictures were
used in a stereo viewer which magnified the
image—thus the cameras could take smaller
negatives and still find an outlet with the public.)

The idea of a hidden camera, observing without
being observed, appealed to a sense of curiosity

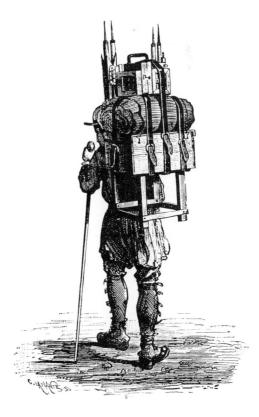

Dry plates—sensitized photographic plates on glass, usually made in a factory—freed the photographer from much of the burden, both physical and mental. Amateur photography flourished as a result, even though this setup seems hopelessly bulky by today's standards. At least a porter and an intimate knowledge of chemistry were no longer required to take photographs in the field. Upper, *from Walter D. Welford, comp.,* The Photographer's Indispensable Handbook: A Complete Cyclopaedia upon the Subject of Photographic Apparatus, Material, and Processes, *ed. Henry Sturmey (London, 1887), advertisement section.* Lower, *from* The British Journal Photographic Almanac, *1884, adv. p. cxxv.*

and fit in well with the rise in detective and mystery fiction in the popular literature of the day. Cameras were disguised as books, watches, or field glasses. There were cameras hidden in hats, in ties, in walking sticks, and in purses. One stuck its tiny lens out through a buttonhole; another was even disguised as a revolver, certain to at least momentarily distract the subject's attention from thoughts of photography!

Many of these were no more than novelties. Cheaply built with simple lenses, they often took pictures on plates far too small to be enlarged by the technology of the time. For all their absurdity of design, however, the hand and detective cameras immediately made photography available and attractive to a far wider range of amateurs. The tremendous amateur interest in photography, stimulated by the Great Exhibition in 1851, had finally found an outlet. A middle class had been steadily growing in Britain, capable of affording a small outlay of time and money for a hobby. There were only 14 camera clubs in England in 1880. By 1885 the number had grown to 40, by 1890 to 131, and by the peak of the amateur period in 1895 to over 250.[17]

Eventually the most popular, but certainly not the first or only, hand camera for the amateur was George Eastman's Kodak. Originally introduced in 1888 by the Eastman Dry Plate & Film Company, it was the first camera to be backed up by factory processing of negatives.[18] The customer bought a camera loaded with sufficient film for one hundred pictures, took the pictures, and then mailed the entire camera in to the Eastman Company. The film was developed, prints were made and mounted, and the camera was reloaded and returned to the customer. Its extremely simple action coupled with the factory processing freed photographers from having to know anything about

Dry plates and amateur photography
caught on much sooner in Martin's England
than they did in America. Upper, *from* The British Journal
of Photography, *July 18, 1873, adv. p. ii.* Lower, *from Welford,*
comp., The Photographer's Indispensable
Handbook, p. 188.

ii THE BRITISH JOURNAL OF PHOTOGRAPHY. [July 18 1873

MR. J. BURGESS

Begs to announce that, as the result of innumerable experiments, he has made an

IMPORTANT PHOTOGRAPHIC DISCOVERY,

which enables him to Prepare Dry Plates equal in Sensitiveness, and superior in many respects, to the best Wet Plates, and that simply by pouring an Emulsion (prepared by an entirely new and original method) on the glass and allowing it to dry without any washing or the application of any preservative, thus saving an immense amount of trouble and expense, and what is more important, still securing films of absolute uniformity, of good keeping qualities, and up to the highest standard of excellence.

In order that anyone may test the truth of the above statement a Four-ounce Bottle of the Emulsion, sufficient to coat Four or Five Dozens Quarter-Plates, will be sent, post free, for 3s.; and, when the new method has been thoroughly tested, if 500 Subscribers are willing to pay One Guinea each, a pamphlet will be printed giving an account of the experiments which have been tried, and the formula by which the results above described have been realised.——Address, Mr. J. BURGESS, Artist, 207, Queen's Road, Peckham, S.E.

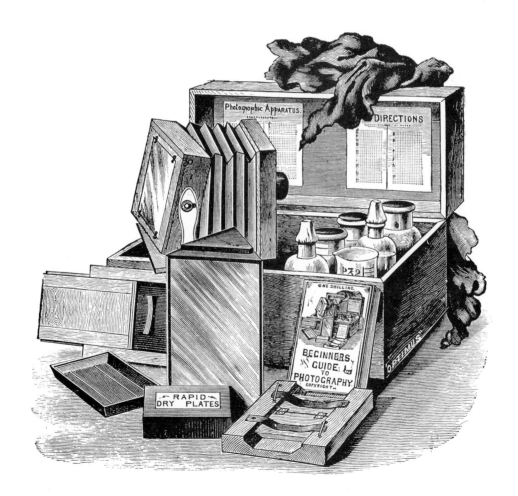

The dry plate—and perhaps the rising popularity of detective fiction—led to a plethora of disguised cameras. Martin's Facile was made to look like a package from a store. Upper, from The Amateur Photographer, *May 25, 1888, p. 340. Lower, from an unidentified clipping in the Gernsheim Collection.*

THE SECRET CAMERA.

IMPROVED 1888.
Patented in all Countries.

SIX PICTURES
Without Changing Plates.
No Focussing Necessary.

The Amateur Photographer,
March 23rd, 1888, says:
' The only really 'detective' camera that we have seen is Robinson's Secret Camera."

PRICES.
No. 1.—Complete with Plates for 36 pictures, 32/-
No. 2.—The New Large Size, for lantern size pictures, complete with Plates for 24 pictures, 45/-
The No. 2 takes Four Pictures Without Changing Plates.

J. ROBINSON & SONS LONDON

THE PHOTOGRAPHIC CRAVAT.

photography except what they wanted to photograph. The slogan, "You push the button and we do the rest," certainly applied. George Eastman wrote in the instruction book of that year:

To day *photography has been reduced to a cycle of three operations:*

1—Pull the string. 2—Turn the Key. 3—Press the Button.

This is the essence of photography and greatest improvement of all; for where the practice of art was formerly confined to those who could give it study and time and room, it is now feasible for every body. THE KODAK CAMERA RENDERS POSSIBLE THE KODAK SYSTEM, *whereby the mere mechanical act of taking the picture, which anybody can perform, is* divorced *from all the chemical manipulations of preparing and finishing pictures which only experts can perform.*

Hence, it is now easy for any person of ordinary intelligence to learn to take good photographs in ten minutes.[19]

Implicit in Eastman's advertising was a tremendous threat to the established amateur photographers. They had become complacent in the years when they were a small and rather elite group— now their position was threatened by the public, who thought more than ever before that good photography could be as easy as the push of a button. The influx of amateurs forced the old photographic power figures to try to find higher art forms of photography. Some turned to imitation of painting, in forms such as the gum-bichromate print, but others began to exploit the potential of the new technology. Dry plates and hand cameras became increasingly popular.

One of the most popular hand cameras, and the one Paul Martin later preferred, was Jonathan

More disguised cameras. Upper left, *from*
The British Journal Photographic Almanac, *1889,*
p. 277. Lower left, *from* The A B C of Modern (Dry-Plate)
Photography, *22d ed. (London, 1886?), advertisement section.*
Right, *from an unidentified clipping in*
the Gernsheim Collection.

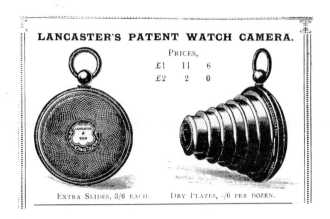

LANCASTER'S PATENT WATCH CAMERA.

PRICES,

£1 11 6

£2 2 0

EXTRA SLIDES, 3/6 EACH. DRY PLATES, -/6 PER DOZEN.

The London Stereoscopic and Photographic Company's
NEW DETECTIVE BOOK CAMERA

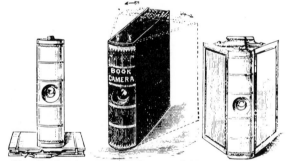

For Instantaneous Pictures of Moving Objects.

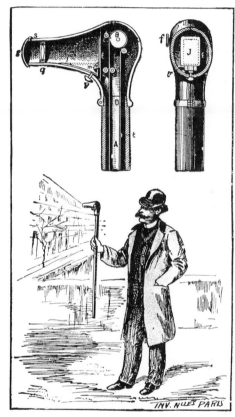

A WALKING-STICK CAMERA.

This ingenious invention consists of a hollow
walking-stick, having a band of sensitized celluloid
passing round a pulley (B), which is turned by a
button (f). In order to take a picture the cap (r)
is opened in front of the lens (q), and by pressing
the knob (p) an aperture in the screen (E) is opened
and the exposure made. The cap is then replaced,
the button (f) turned, and another portion of the
band is brought into position for the next operation.

Revolver photographique de M. Enjalbert.
From Josef Maria Eder, La Photographie instantanée:
Son application aux arts et aux sciences, 2d
ed. *(Paris, 1888), p. 31.*

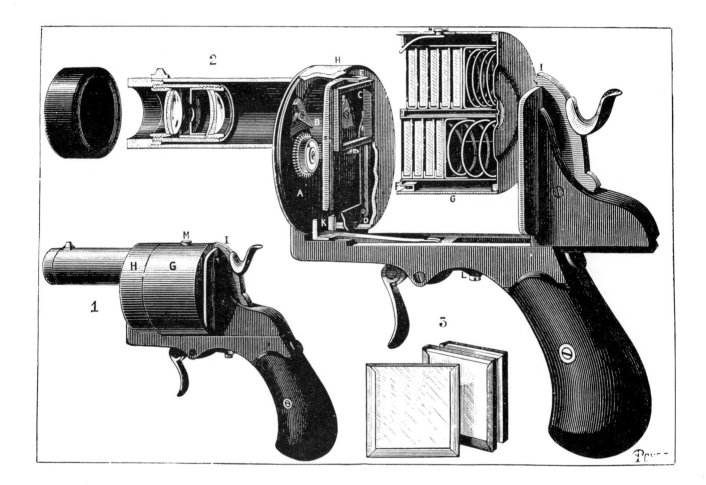

Left, *photo-chapeau de M. J. de Neck.*
From Eder, La Photographie instantanée, *p. 39.*
Right, *parcel detective. From Welford, comp.,* The
Photographer's Indispensable Handbook, *p. 63.*

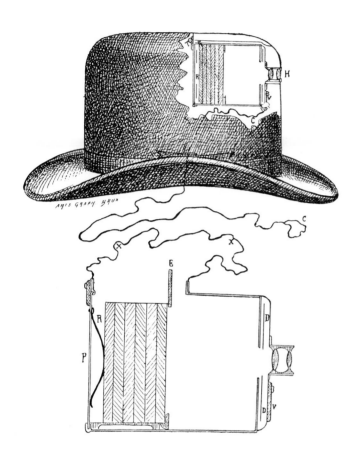

*Photography has always had its public-
relations problems. In the early days the general
populace did not always understand the strange machinations
of the person slaving over the wooden box and hidden
under the piece of black cloth. From Cuthbert Bede
[pseud. for Edward Bradley], Photographic
Pleasures: Popularly Portrayed with Pen
and Pencil (London, 1855), p. 54.*

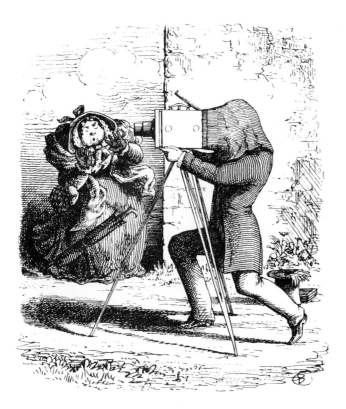

A PHOTOGRAPHIC· PICTURE.

ELDERLY FEMALE [*WHO IS NOT USED TO THESE NEW-FANGLED NOTIONS.*] "O SIR!
" PLEASE SIR! DON'T, FOR GOODINESS SAKE, *FIRE*, SIR! " ——

Fallowfield's Facile Hand Camera. The original
disguise of the Facile was a wrapping of brown
paper. Very little stuck out, and presumably the
cool operator would appear to be innocently hold-
ing a "neat brown parcel in handstraps such as
one or two books of the same size neatly wrapped
by the shopkeeper would present."[20]

In spite of (or perhaps partly because of) the
disguises, the hand and detective cameras were
not particularly well received by the public or the
law. The 1890's saw swarms of new photogra-
phers out "Kodaking" all the best sights. The popu-
lace, often backed by legal sanctions, reacted
angrily to what was seen as a loss of privacy.
Insulted readers of the *Glasgow Herald*, for in-
stance, commented in 1891 on the "infernal
machines," "the disgraceful attitude of photo-
graphing anyone against his will," and "a set of
cads who would not scruple to hawk the photo-
graphs around the country."[21] The *British Journal
of Photography* complained in 1898 of "the hand-
camera fiends who 'snap-shot' ladies as they
emerge from their morning dip at the seaside, or
loving couples quietly reading under a shady rock,
or surreptitiously photograph private picnicing
parties and then show the results at lantern
entertainments . . . when they have been caught
in the act, their cameras have been forcibly
emptied, and themselves unceremoniously treated.
With that class of hand camerists few will have
much sympathy."[22]

Not all of the sanctions were social. In Victorian
London, official permits were required to photo-
graph in many places, especially in the parks
where Martin took many of his pictures. These
permits were usually free and issued on request,
but often with restrictions, such as "Persons and
groups of persons may not be photographed." On
Sundays only hand cameras were allowed—no
tripods.[23] In 1902, a Mr. Archer was prosecuted

*The advent of the dry plate led to hordes
of amateurs and frequent infestations by groups from
the various camera clubs. The public was painfully aware of
the growth in popularity of this particular hobby.
From* The Amateur Photographer,
September 23, 1887, p. 136.

136 **THE AMATEUR PHOTOGRAPHER.** SEPTEMBER 23, 1887.

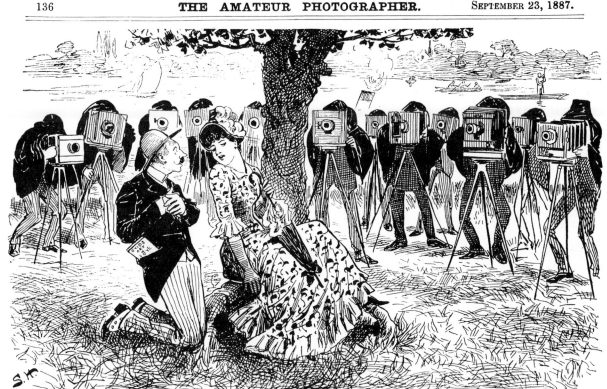

WHAT AN EXPOSURE !*

"The steam launch *Alaska* conveyed more than fifty members of the ———— Amateur Photographic Society to Clieveden Woods last Saturday."—*Photographic News.*

EDWIN HAD ENTICED ANGELINA FROM THE GIDDY PICNIC, AND WAS JUST PROPOSING BENEATH THE SHADES OF COSY COOKHAM AS THE FOE CLOSED ROUND:—"OH, DEAR HEART, I'M POSITIVE YOU LOVE ME. DON'T REPLY IN THE NEGATIVE."

[*He tried to buy up all the plates, but failed lamentably.*

88 THE BRITISH JOURNAL ALMANAC ADVERTISEMENTS.

Established in Lambeth in the Year 1856.

FALLOWFIELD'S PERFECTED "FACILE" HAND CAMERA

THE foregoing Pages embrace what may be termed the Apparatus Section. On pages 74-87 will be found fully set out General Material, &c. used in the Art. Compare Prices and Quality and you will admit the Goods supplied by the

CENTRAL PHOTOGRAPHIC STORES
Are unquestionably the most reliable.

146 Charing Cross Road, London, W.

[*See preceding pages.*

and convicted because his permit only allowed him to photograph scenery in Hyde Park and he was caught photographing a car that was about to depart on an around-the-world trip.[24] Martin never mentions the permits' getting in his way, but we know that they were required for many of the places that he photographed, including Richmond Park, Victoria Park, the Thames Embankment, Hampstead Heath, and Wandsworth Common.[25] This official attitude toward amateur photography might form part of the explanation as to why Martin took so many pictures of the working class. It was less likely that they could or would get him into trouble with the law.

Perhaps the term *detective camera* carried some of its own problems. It certainly implies at least a shady activity. Eventually some photographers tried to change the term to the more accurate and defensible *hand camera*.[26] The public and general press, however, were not quick to give up the more romantic label.

Obscured by the name problem was a basic concern with the redefinition of photography's ground rules. People didn't know when they might be photographed, or under what circumstances a photograph might be considered proper. The photographers were even more confused on this point than the general populace, because they also had to worry about the end product—would the hand-camera photograph be technically and, more importantly, "artistically" correct? For even though these massive changes in technology were occurring, the imagery of British photography in Martin's period had become stagnant, to say the least. The powerful photographic societies were very strict in their interpretation of what was suitable photography. Innovation was *not* the key to success. Tradition and the "proper approach" ruled.

The hand camera, however, bespoke several

changes. The mere fact that suddenly nearly everyone could easily take some sort of photograph was disturbing. Also, the flexibility of the camera led to a change in the approach to subject matter, and indeed, in the subjects that were approachable. The tremendous time and effort investment of the older processes had led to very carefully studied exposures of reliable subjects. The composition obtained with the hand camera was likely to be not quite so precise. What was more important, a hand-camerist might be tempted to "waste" one of the easily processed shots on a less than noble subject, such as an event from common life. This was a concern that had always plagued photography. Even in its most cumbersome days, photography was so much faster and cheaper than other graphic processes that pictures were sometimes taken of everyday objects. This led to some challenges of its merits as an "art." The hand camera promised to aggravate this already sensitive situation.

A group of amateurs in the 1890's, capitalizing on the catholicizing influence of the easy and rapid dry plate and the inconspicuous rapid hand camera, began to explore the intriguing and marvelous world of snapshots of the life around them. It was in this period of turmoil and opportunity that Paul Martin entered the world of photography.

Martin's Early Amateur Period

A bit of mischief with a schoolboy's lunch money got Paul Martin involved in photography. In 1874, at the age of ten, he was quite interested in chemistry and experimentation. One day, looking in a shop window near school, he saw a penny packet promising to teach "How to make your own Photographs." Lunch was a penny cheaper that day.

The packet contained a two-inch square piece of glass, a small piece of cardboard, and a "pinch of reddish grit." The instructions told Paul to dissolve the chemical in a teaspoonful of water, then float a piece of note paper on it and dry the paper in the dark. To make his photograph, he borrowed a piece of lace, bound it up under the glass in contact with the sensitized paper, and exposed the package to sunlight. After the paper had darkened, it needed only to be washed to reveal an outline of the lace on a dark ground. The reddish grit may have been potassium dichromate, which would have given a white image on a brown-colored ground, or a mixture of potassium ferri-cyanide and an iron compound that would have yielded the familiar blueprint. In any case, Paul was successful, but his ambition to make pictures directly from life was terminated when the instructions disclosed that that advancement would require a negative from a professional photographer, at a charge of ninepence, far too much to pirate from his modest lunch funds.[27]

Martin remembered his visits to professional photographers to have his picture taken as a boy. His comments betray a boyhood curiosity about the mysterious doings of adults. Each time he went to visit he poked in the corners, under the dark cloth, and watched with amazement as the photographer performed his machinations. "What he did underneath I don't know, but he bobbed up and down a good deal, and when he reappeared he asked us to keep perfectly still. We did, and after a moment he came out from under the cloth and disappeared head and shoulders into his other sanctum."[28]

Martin's next contact with photography was the most decisive. In 1883, in the last year of his apprenticeship, an unidentified friend showed him the first nonportrait photograph that he had ever seen. The budding woodcut artist could not believe it. Most photographs of the time, and particularly those that a typical young person might see, were portraits, in the form of either ambrotypes (direct positives on glass, usually mounted in a little case) or cartes-de-visite. This one, however, was a landscape picture—a pictorial representation of something from nature.[29]

That settled it. On his next trip uptown to deliver work for his boss, Martin stopped in a bookshop and picked up a copy of W. K. Burton's *A B C of Photography*. Martin found it easy to read, memorizing the entire process, but was discouraged at the advice on instant photography. In simple terms, it was "Don't bother trying it."[30]

Money was a problem to the apprentice making a peak salary of ten shillings a week, but by 1884 he had saved up enough by working overtime as a wood engraver to purchase his first camera, an inexpensive and popular quarter-plate[31] Le Méritoire made by J. Lancaster & Sons. This camera, the middle-price model in their lower-price line, had some movements for perspective correction but had no shutter and was supplied with a lens "not sufficiently rapid for instantaneous shutter, except under very favorable circumstances."[32]

Martin was quick to learn the commercial aspects of photography. He began almost immediately to sell prints to the firm that he worked for to use as a basis for woodcuts. The extra money was invested in a wide-angle lens with rotary stops —the lens that came with his camera having had a single fixed stop of f/22.[33]

The dry plates that he worked with were somewhat experimental even at this period. They tended to frill, occasionally were fogged, but in general still made the whole photographic process easier. Of his first dozen plates, only two pictures did not come out, a pretty good record for the time. He developed his plates at home in his bedroom, using a finger-staining pyrogallic acid and a very odiferous ammonia solution. Fortunately, his parents were used to the ammonia smell, since his father had been prescribed a concentrated solution for use in curing his rheumatism. Besides his bedroom, Martin's "darkroom" consisted of the coal cellar under the stairs, the darkness under his bedclothes, and a homemade red safelight constructed from a bottle and tin.[34]

The long hours that he worked, combined with the fact that he lived in a relatively poor district, may have contributed to Martin's entry in his diary that between 1884 and 1888 he did not meet a single other amateur photographer. They were around, and growing in number, but he had to content himself with learning the craft from his own experience and from the pages of such publications as *The British Journal Photographic Almanac and Photographer's Daily Companion* and an occasional copy of the commercially oriented *British Journal of Photography*. In 1886 his quarter-plate camera was traded for a more deluxe half-plate Lancaster Instantograph. This camera had a shutter and, since Martin followed the common practice of the day of contact printing his negatives, enabled him to make larger prints.[35]

Holidays were the main source of time and subject matter for Martin's photography of this period. This work is well represented in an orderly chronological album in the Gernsheim Collection at the University of Texas at Austin.[36] These pictures, with some exceptions, could best be described as inconsistent and of moderate overall

A typical page from Martin's early amateur
album ("Photographs taken by Paul Martin, 1884–88"),
showing interests in camping with his woodpecker friends,
instantaneous pictures, and pictorialism.

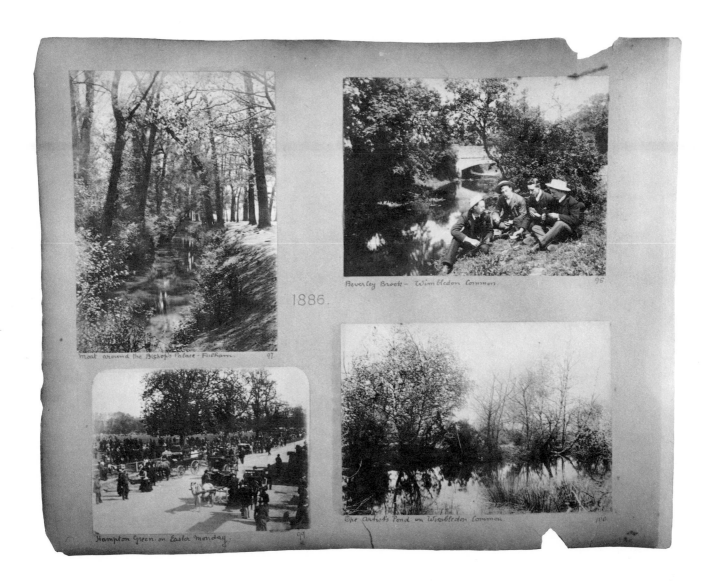

1886.

Moat around the Bishop's Palace - Fareham. 97.

Beverley Brook - Wimbledon Common. 96.

Hampton Green on Easter Monday. 99.

The Artist's Pond on Wimbledon Common. 100.

quality, showing an increasing mastery of technique but little definition of subject matter or approach.

The year 1888 was a "coming-out" time for Paul Martin in photography. By then he was working with a whole-plate (6½-by-8½-inch) antiquated, secondhand camera that at least allowed him to make prints large enough for exhibition. Like all of his cameras up to that time, it was tripod mounted. He found that he had "a very awkward

job changing the plates at night under canvas" on camping trips with friends. He owned only two dark slides, permitting only four exposures before he had to find a dark place to reload.[37]

In this same year, Martin discovered *The Amateur Photographer* magazine, which had been set up to help those like himself. A prime contributor was George Davison, one of about twenty people, including Paul Martin, who formed the West Surrey Amateur Photographic Society, holding their first meeting on May 7, 1888.[38] The membership grew slowly to thirty by 1889, holding monthly meetings, and taking field trips to find pictorial subjects.[39] Davison, a vice-president of the society, figured strongly in Martin's later development. He became an important trendsetter and later a manager of the Eastman Company in England.[40] Another founding member, Col. Joseph Gale, became the society's first president and an outspoken advocate for the anti–hand camera set.[41] The photographic societies were all-important to photographers at this time in England. The format of the meetings usually included the showing of photographs, lantern slides, and new equipment; notes and rumors on various processes were exchanged; outings were organized to secure photographs. The West Surrey Photographic Society, dropping the term *Amateur* from its title, prospered with an active membership, and Martin's involvement with photography can be seen to pick up in tempo and quality from this point.

A "River Scene with figures introduced" titled "Too Late," taken with Martin's whole-plate camera during an outing in 1888, won the silver medal in a monthly competition of *The Amateur Photographer* in 1889.[42] At the first exhibition of the West Surrey, at the end of March 1889, Martin's work was represented among the nearly three hundred prints hung. He had a separate screen

Whitby, 1885. Photo by Paul Martin.
Holidays and camping trips, while they meant
a loss of income to the hourly-paid woodcutter, were
a constant source of enjoyment to Martin and a major source
of subject matter for his pictures. Scenics were not
the only subjects—many of his best candids
were taken on these trips.

*Paul Martin at the age of thirty-one, climbing Mount Pilatus
in Switzerland, 1895. Photographer unknown.*

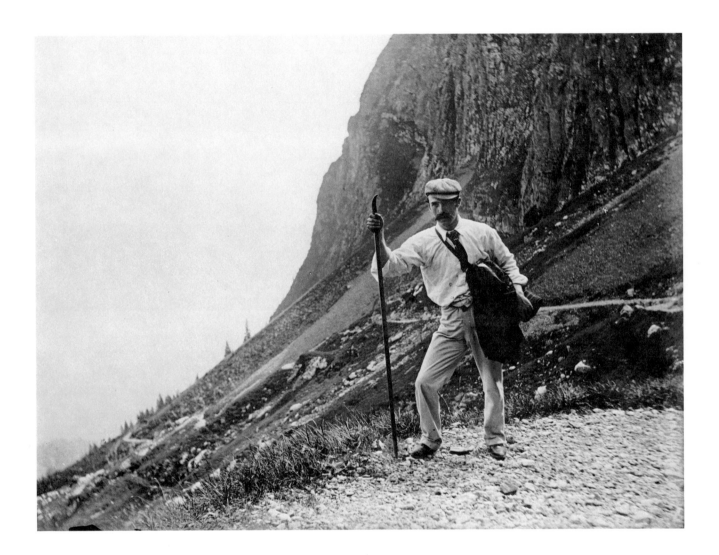

at the end of the room, covered with prints of Battersea Park "mounted in metallic rims in various shapes."[43] It was of this period that Martin stated: "My own great ambition in amateur photography was to produce something new to show our society, and in our exhibitions we were urged on by having some of the best workers in pictorial photography, notably Colonel Gale and George Davison."[44]

Colonel Gale's comments could be quite acidic. Once, while everyone else was admiring a picture Martin took of a hill on a particularly clear day, Gale remarked, "Yes, it would make a good map!"[45] Martin was to be criticized many years later for another set of pictures that lacked a feeling of atmosphere—this time by the American photographer and critic Alfred Stieglitz. Atmosphere was difficult to design into woodcuts, and it seems reasonable to attribute Martin's photographic prejudice to his vocational orientation.

At first, Martin exhibited frequently during this early period, occasionally drawing a comment from the photographic press: "Mr. Martin [exhibited] a large variety of well-finished photographs."[46] In general, however, he seems to have lost some interest in photography by 1890. His diary entries also start to thin out around this time.

His fellow club member George Davison took the photographic world by storm in 1890 with the exhibition of his famous pinhole picture "The Onion Field." British photo-historian Cecil Beaton, mirroring contemporary accounts of the picture, rated it as the "first piece of modern photography in landscape . . . its horizontal ruthlessness was considered quite revolutionary in 1890."[47] P. H. Emerson's *Naturalistic Photography* already had everyone on edge—Davison's photograph (and some doubted that it was even appropriate to call

it a photograph) further fanned the blaze. Debates of the nineties centered not so much around the merits of a photograph as around the validity of the school to which it belonged. H. P. Robinson was still exhibiting cut-and-paste compositions, Alfred Stieglitz toyed with tinting some of his exhibition pictures, the f/64 School (not to be confused with the later one formed by Ansel Adams et al.) was dying but still around, and talk, talk, talk was the order of the day.[48] Forces were swirling in the photographic world that were beginning to undermine its whole basis in subject matter and treatment. The old guard, openly challenged by the likes of Davison, took scarce notice of the growing cults of hand-camerists. Colonel Gale, asked about the possibility of his doing some hand-camera work, scathingly replied, "I have not descended to that level yet."[49]

Amidst all this aesthetic debate, other uses of photography besides art began to be recognized. Photographs were seen as one of the best ways to preserve the history of the day. The photographic journals of this period are full of announcements of buildings to be torn down, areas to be altered, and photographic "record societies" being formed. The most famous and most organized of these was Sir Benjamin Stone's National Photographic Record Association. Its steering committee, heavily biased toward the upper social strata, included historians and many influential people of the photographic community. Stone, himself a Member of Parliament, stated, "As early as 1889 I took my camera with me on my trips through England, always with the same object—to show those who will follow us, not only our buildings, but our everyday life, our manners and customs."[50] At first glance, the NPRA would appear to have been ideal for Paul Martin, especially since George Scamell, its secretary, made a specific plea to

*"The Onion Field," by George Davison.
Photogravure, 1890. Davison's controversial "Onion
Field," originally titled "An Old Farmstead," and his other
impressionistic photographs upset the traditional Royal
Photographic Society. The ultimate result was the formation of
the rival Salon to display "art photography" (see p. 36).
Martin's association with Davison in the West Surrey
Photographic Society explains why he exhibited
with the renegade group.*

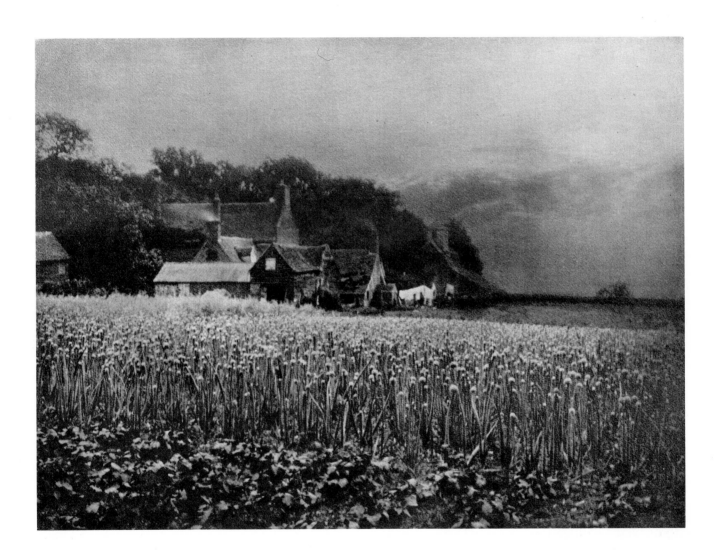

amateur photographers to donate their work.[51] This plea, published in the professional *British Journal of Photography*, failed to mention some of the restrictions: only permanent, and expensive, platinum or carbon prints were accepted for donation; whole-plate size was strongly preferred; members had to contribute at least six prints or half a guinea per year to stay in; a measured rule photographed in the scene or some other means of determining scale was suggested.[52] Clearly the bias of the NPRA was toward the rich amateur and the static photograph, not toward photographers like Paul Martin. However, another, more socially oriented form of record keeping existed in the shadow of the official organizations.

Interest in the on-the-street candid snapshot began to surface. In 1890 and 1891 some photographic societies created a separate division in their exhibitions for such categories as "Street and Town Life," "Street Trades," and "Street Characters and Incidents of Street Life."[53] A few writers ventured forth publicly in support: "Endeavour to secure street life in your own town. All things change in the course of time, and someday such pictures may become valuable" (1890).[54] "What better mode of recording for future reference the life and character than the hand camera—our street trades, such as the organ grinder, street artist, hawker, scissor grinder, etc., will soon be objects of the past, and pictures of them will be of as much value to the future artist and historian, as a set of pictures of old houses" (1895).[55] Even the manual that came with the first Kodak camera in 1888 encouraged the taking of street scenes, illustrating this with an example of two boys walking down the sidewalk of an urban area.[56]

No early advocate of this sort of photography, or of the hand camera in general, was more persistent or convincing than converted cycling enthusiast Walter D. Welford. " If so be a hundred years hence it may be asked what has photography done, is the reply to be that it has produced pictures . . . and pictures only? Certainly not. We can point to its use in astronomy, microscopic, medical, and many other directions, including the preservation of historic buildings and spots of interest. But will it not be asked at once, why did you not, with the ample means at your command, preserve for us the dress and fashion, the characters and incidents, the everyday life and bustle of the street?"[57]

The hand-camerists were in one corner; the other mavericks—the impressionists—were in another. The old pictorialists still thought they had the only show in town. Nearly fifty years later Martin looked back on this period and said:

Had I independent means, I should probably have pursued exactly the same roads as the other pictorial workers of the nineties, whose ambition it was to make their photographs look as much like a painted picture as they could. Careful composition, superimposed clouds, soft printing and other technical tricks were used to produce effects which were certainly beautiful, but which took the photographer further and further away from life. I was for a time as keen as anyone and fairly competent, but it was an expensive hobby and never really had the same interest for me as the real snapshot—that is, people and things as the man on the street sees them.[58]

A paper by A. R. Dresser, delivered before the West Surrey Photographic Society in 1892, gave advice on the use of the hand camera and admonished the audience that "he hoped they would not at any time bring discredit upon hand-camera work by 'snap-shotting persons' under conditions which might cause unpleasantness," meaning that the photographers should obtain the permission of

From The Amateur Photographer, *October
15, 1897, p. 322. Expensive framing and crowded
displays were probably part of the reason that Martin chose
to exhibit in lantern slide form.*

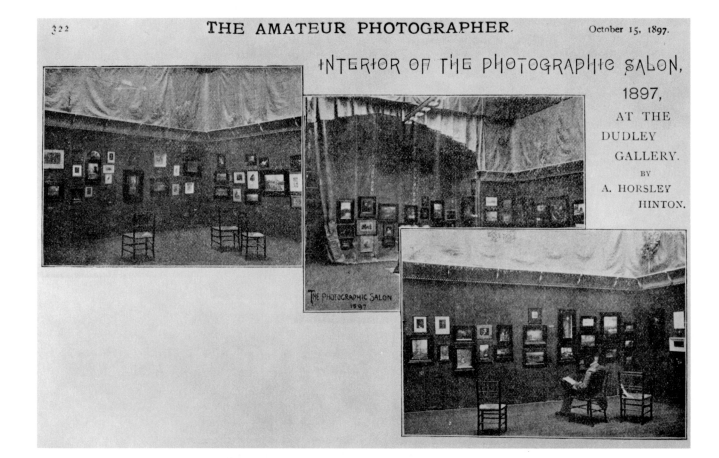

their subjects before trying to take their picture.[59] Martin was undoubtedly interested in Dresser's views, for he had just that year bought a Facile hand camera. Fortunately, he had already ignored Dresser's advice on candid pictures. The relatively easy and flexible tripodless camera had already blown life into Martin's photography. He was about to emerge as a leading photographer of people going about their normal daily lives.

Martin's Mature Amateur Period

A holiday at Yarmouth with his friend Ted Smith in 1892 marks the start of Martin's most successful period of photography. His new Facile, freeing him at last from the cumbersome tripod, seemed to inject new enthusiasm into Martin and especially into his pictures. The world suddenly became alive to him—the years 1892–1898 spawned the bulk of his photography that we remain interested in today.

The Facile camera that Martin purchased was one of the most popular on the market, enjoying an "enormous sale" by 1890.[60] Late in 1890 he had probably watched a Mr. Swingler demonstrate the Facile and show work from it at the West Surrey meeting.[61] Although noted for its simplicity, the Facile could not really be said to live up to its name. Based on 1889 patents by F. Miall and manufactured in mahogany by Fallowfield & Co., the camera measured 9⅛ by 5½ by 8⅜ inches and weighed in at well over four pounds when loaded. It was of the magazine camera style, charged with twelve glass plates of the quarter-plate (4¼-by-3¼-inch) format. The plates could be changed by rotating a knob which removed the previously exposed plate and caused a fresh one to drop into position with a loud "clunk." Numerous models were made, all evolving directly from the

From The British Journal Photographic Almanac, *1891, p. 83.*

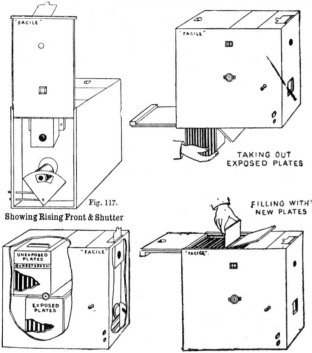

'FACILE.'

A FEW ILLUSTRATIONS THAT EXPLAIN THEMSELVES.

Fig. 117.

Showing Rising Front & Shutter

TAKING OUT
EXPOSED PLATES

FILLING WITH
NEW PLATES

UNEXPOSED PLATES

EXPOSED PLATES

PRICES COMPLETE.

With Rapid Landscape Lens, of Wonderful Definition, and Sunk Fitted
 Finder, giving Identical View £4 4 0
With 5 × 4 Rapid Rectilinear Lens, Four Rotating Stops, and Fitted Finder 5 5 0
Ditto, ditto, covered in Black Leather 6 6 0
 Can be used for Vertical or Horizontal Pictures by turning Camera on side,
 or holding upright.

original nonfocusing wooden box fitted with a 5½-inch rapid rectilinear lens with four rotary stops.[62]

The Facile that Paul bought was soon to be subject to the same detailed hand-work that he applied to his woodcuts. Martin later gave credit for many of these changes to the "predecessor of Heath Robinson" (a British Rube Goldberg), apparently in reference to the scores of home-brew modifications that filled the columns of the photographic journals.[63] One of these, suggested in 1890, was a spring improvement designed to help the operator avoid shaking the camera when the shutter release was pushed. The author of the idea was proud of the fact that he had a jeweler do the alteration for only one shilling. Martin, two years later, did the same modification himself even more cheaply with a safety pin.[64] He additionally modified the shutter by filing a slot in a lever to give him a time exposure feature[65]—a change which, as we shall see, was to help bring him the most fame that he ever received from the photographic community. The rather simple shutter was actually to prove a boon to Martin. The craze of the day (within the craze for the hand camera itself) was "instantaneous" exposures. The term *instantaneous* must be related to the time period we are talking about; in the 1860's it meant anything shorter than about two seconds, but by the 1890's it had come to mean exposures on the order of 1/50 to 1/500 second. But the plates and films and lenses available at the time were too slow to compensate for the extremely fast shutter speed. The result was normally gross underexposure and disappointment to the user. Another problem was the temptation to amateurs to imitate the motion studies of Eadweard Muybridge and others that came into prominence in the 1880's and 1890's. The professional motion studies, although often pleasing aesthetically, were intended for scientific

*The new Kodak camera took one hundred
round pictures on a roll of film—the customer
then shipped the entire camera into the factory to
have the film processed, prints made, and a new roll
loaded. The technical achievement of an entire amateur
system that permitted the user to just "push the button" was
supplemented by saturation advertising and heavy-handed
marketing techniques to push the Kodak into a position
of prominence. From* The American Annual
of Photography, *1900, adv. p. iv.*

and artistic research—not as final products for hanging in exhibition.[66]

The Facile had a characteristically simple solution to the dual problem of underexposure and the possible temptation to achieve a worthless technical *tour de force*—its economy shutter couldn't work up any speed faster than a twentieth of a second! Martin, in retrospect, felt that this was the reason he had so much more success than most of the other hand-camerists with their faster and more expensive shutters. He estimated that most of his exposures were made at between a quarter and a tenth of a second.[67] Examination of the blur of moving figures in his negatives leads us to agree with these figures.

The lens on Martin's Facile, a rapid-rectilinear design that he and his friends classified as of the "ginger-beer bottle type," was made just a year or so before the first of the modern design lenses, utilizing the newly discovered German optical glasses, were introduced.[68] Fortunately, Martin's 3¼-by-4¼-inch plates were rather large by to-day's standards and do not require much enlargement. The quality of his lens seems quite adequate for the pictures that he took, and Martin never really seemed to complain of any of its limitations. He was disturbed by its speed, however, which was marked by the maker as being f/8. Martin, a little dubious of this, had his suspicions confirmed when he measured it and found it to be only half as fast—f/11. Confronting Miall, the designer, with his findings, he must have felt the essence of "caveat emptor." Miall openly and blandly replied, "Why, you know why that is so, for if I stamped them F.11 I would not sell one."[69]

Martin couldn't (and Miall obviously wouldn't) change the speed of the lens, but he found that he could do something about another serious drawback of his Facile. As purchased, it was a fixed-focus instrument, allowing some degree of

*The advent of high-speed shutters encouraged by the
increased sensitivity of the dry-plate process brought about a
mania on the part of amateurs for stop-action "instantaneous" pictures.
Some of this was no doubt inspired by the important scientific studies of people
like Eadweard Muybridge, whose well-documented record shots often possessed a great
deal of artistic merit and significance. The amateur material was usually rather boring
and insignificant. Martin was kept away from this departure by the simple fact that
his inexpensive shutter operated at a top speed of 1/20 second. From Eadweard
Muybridge,* Animal Locomotion: An Electrophotographic Investigation of
Consecutive Phases of Animal Movement *(Philadelphia, 1887).*

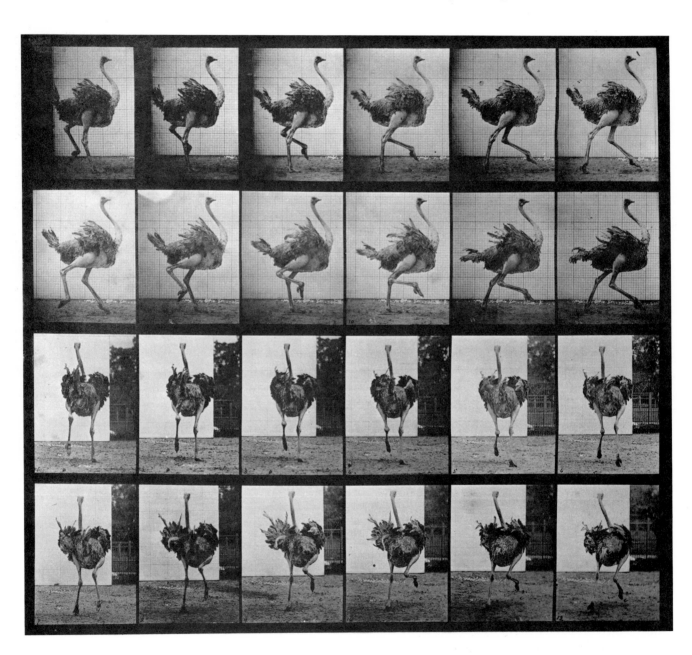

"Moment-Aufname," by Carl Hiller. From Photographische Rundschau, *June 1888, facing p. 211.*

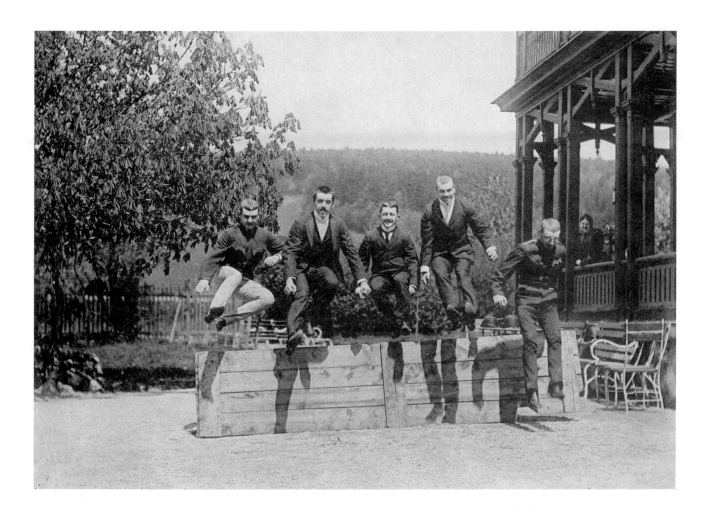

sharpness from infinity down to about twenty-five or thirty feet. Martin noted that the plate was carried forward toward the lens as it was advanced into shooting position, the same principle used in back-focusing cameras. By temporarily placing an opal glass focusing screen in his camera, he was able to determine how far to advance the plate to cause the lens to focus at various closer distances. He scratched these points into the camera body, yielding a focusing scale that he could quickly refer to in the future. Seven feet was his "blind spot"—at that point of advancement the next plate fell into position.[70] Other users felt the need for closeups, and later Faciles had a focusing arrangement built in as standard equipment.

Early-model Faciles were covered with brown wrapping paper, providing some disguise, but of course falling apart in wet weather. In addition, the paper "parcel" had to be unwrapped and rewrapped every time a dozen fresh plates were needed. An optional leather and canvas case was offered by Fallowfield in 1891 to overcome these problems. Martin said that he took his paper-covered Facile to a neighborhood harness maker to get a leather case made for it.[71]

The lens and viewfinder of Martin's Facile were exposed to the weather and, contrary to the style of the camera, were a giveaway to the identity of the package. Martin put a sliding ebonite (hard rubber) plate on the front to cover them when not in use. In addition, by partially lowering the shield over the lens during the taking of a picture, he could reduce the exposure in the sky area and take in clouds without a filter.[72] The rather simple reflex viewfinder encouraged only a general aiming of the camera toward the subject, producing in most of Martin's pictures a composition with the main subject more or less centered in the frame.

Martin's modified Facile, simple, bulky, and wired-together, was to take some of the most memorable pictures in British photography. Most of his pictures in this period were taken on his lunch hour and on his various vacation trips. He was living with his mother, his father having moved to Paris to take different employment in 1889.[73] He was able to save up enough from his modest salary and sales of prints to pay for his hobby and an occasional holiday. The holidays began to spawn a great number of candid photographs, and he wrote enthusiastically of the advantages of the hand camera: "It is impossible to describe the thrill which taking the first snap without being noticed gave one, and the relief at not being followed about by urchins, who just as one is going to take a photograph stand right in front shouting, 'Take me, guv'nor!' "[74] His sentiments on "urchins" were echoed in the journals of the period by many a frustrated photographer.

Unfortunately, the enthusiasm inspired by the Facile hand camera was quickly corrupted by the need for recognition in his exhibition work. The suburban clubs in London were fairly tolerant of strange photographic doings, but even so they "were not encouraging towards the type of subject which I was then taking. . . . many members regarded some of my studies as rather *infra dig.*, or even shocking. They felt that a plate demanded a noble and dignified subject, a cathedral or mountain or family party dressed up in their Sunday best."[75] In 1893 Martin discovered a gimmick to turn the snapshots that he had started to love into a form that would gain him acclaim. It was the first of his two big successes in photography.

Martin had been fascinated by lantern slides, probably partly because they were cheaper to make than mounted prints and partly because there was less competition in this area of exhibition. He was able to contact print his small hand-camera plates

on the platinum and albumen paper of the day, but their size worked against him in competition. Enlarging was not universally practiced yet; it was very tedious and the results often not too satisfactory. He had tried using a Lancaster enlarger on a board, pushing it out through the window in his bedroom and using a piece of tissue paper to diffuse the sunlight that acted as a light source, but the bromide enlarging paper of the day was not very satisfactory.[76] Making enlarged negatives and contact printing them was also a common approach. Lantern slides could be quickly and cheaply contact printed directly from the negative, looked quite brilliant on projection, and had the added advantage of being presented one image at a time on a screen. Prints were crowded together in massive groupings on the walls of galleries and were fighting each other for attention. Perhaps this is part of the reason that bold and simple compositions were favored.

One day Martin saw some lantern slides of statues in which the backgrounds were completely blocked out. He had the idea of substituting living subjects for the statues, recording that, "Whatever the result might be, I thought, anyway it would be a departure from the beaten track."[77] He then proceeded to take a series of street-character pictures, making sure that the figures filled the frame. "Knowing beforehand that the backgrounds were eventually to be blocked out, it did not matter much whether the surroundings were appropriate, a proceeding which materially facilitated operations."[78] After taking his subjects—we are now fortunate that the "distracting" backgrounds did not trouble him—Martin made a high-contrast copy negative of the original. Relying on his precise wood-engraving training, he was able to carefully paint out the negative around the figure, then paint in an artificial base with some color

similar in tone to the surrounding area. The result was a statuette on a dark ground.

Thus is destroyed any basis for directly comparing Martin's work with that of the snapshot artists of today, such as Lee Friedlander, who carefully if almost instantly plan and integrate an entire frame in the camera. Neither can Martin be classified with the socially concerned photographers with whom he is so often compared. His motivation was entirely different. The value of the contents of these pictures may be the same to us today, but Martin had none of the social motivation evidenced in the similar-appearing work in Henry Mayhew's *London Labour and the London Poor* (1851–1862), John Thomson and Adolphe Smith's *Street Life in London* (1887),[79] or the later but similar efforts in the United States by Jacob Riis and Lewis Hine. Martin's fascinating images of workers on the London streets were taken not as studies of people, but rather as a basis for manipulated graphics. In fact, Martin wrote, "Had I been more fortunately situated, I would have made a set of slides of animals at the Zoo. . . . They would, I think, be a novelty . . . "[80]

Martin took "the palm of the evening" when he sprang his "Dark Corners in Darkest London" on the West Surrey group on October 18, 1893. Nearly two hundred visitors gave his slides "well merited applause."[81] The members were so impressed that the work traveled around, with Martin receiving an Extra Silver Medal at the Leytonstone Camera Club Exhibition a month later. The title by then was moderated to "Characters from London Streets." A reviewer said, "We believe this award was made for the cleverness of treatment . . . a very distinct success is scored. . . . We congratulate Mr. Paul Martin on his work."[82] The young woodcutter, now nearing the age of thirty, had finally found the recognition that he had

*"Loading Up at Billingsgate Market," by
Paul Martin, ca. 1894. A street scene taken by
Martin with his Facile camera. We are given a great
deal of context for the subjects because Martin knew that
he was going to block out the backgrounds later. This
freed him from having to worry about
"artistic" arrangements.*

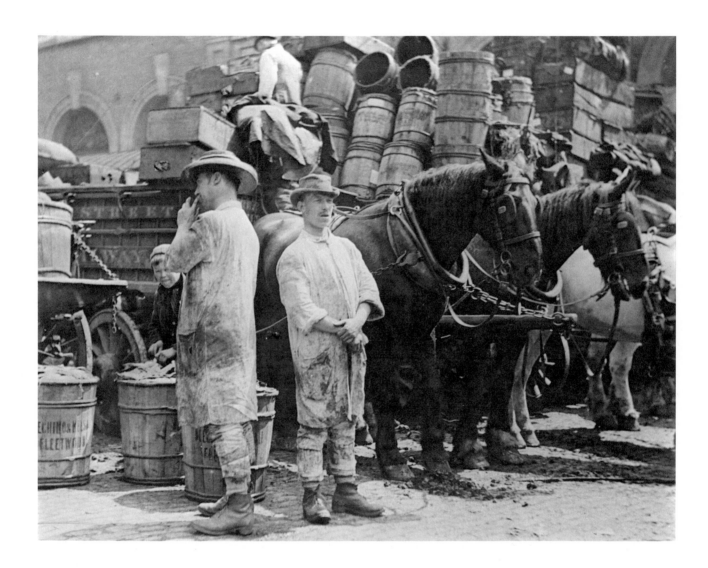

"Loading Up at Billingsgate Market:
Cut-Out Figures," by Paul Martin. The series of
cut-out figures was inspired by a similar treatment that
Martin had seen given to some pictures of statues. Many of
his famous street pictures were taken to provide
material for this series, not to serve
as social documents.

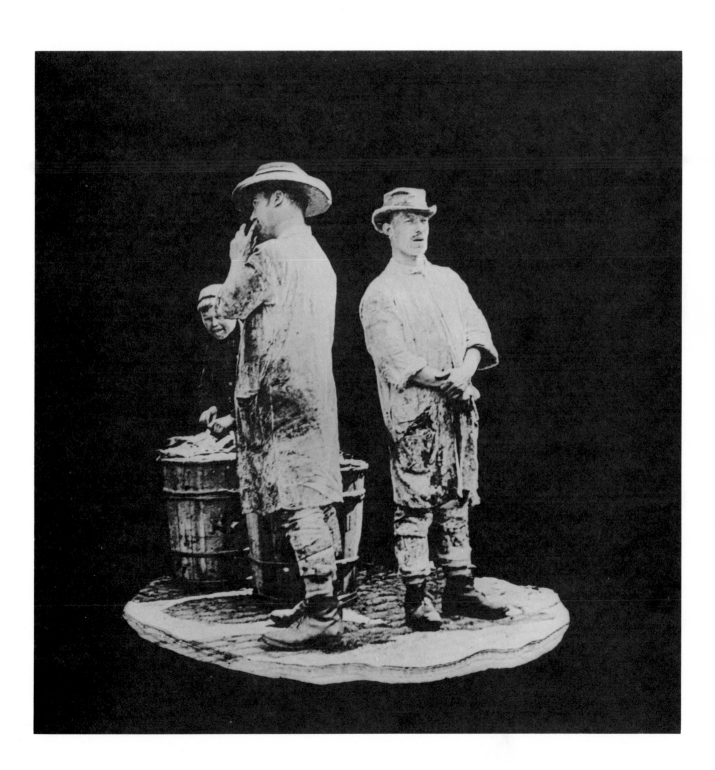

*"The Balloon Seller: Cut-Out Figure," by
Paul Martin. A rare, partially completed version.
Martin carefully painted around the figure with opaque
and then painted in a base in a similar tone. His
manual dexterity from woodcutting
was helpful here.*

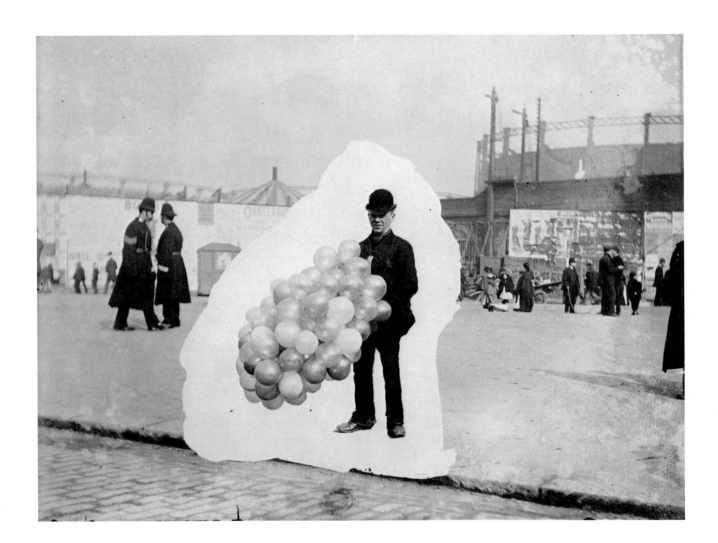

Woodcut, from a daguerreotype by Richard Beard,
from London Labour and the London Poor, *by Henry Mayhew,*
vol. I (1851), p. 97.
It is tempting to compare Martin's candid street photography to that of the social documentarians who came before him. Henry Mayhew used woodcuts based on daguerreotypes to illustrate his text— there was no way to reproduce photographs directly at the time. John Thomson (see p. 48) was limited by the bulky wet-plate process with its long exposures and need for a portable darkroom. His carefully posed pictures are probably an accurate re-creation of what he saw but are simulations of real-life situations. Martin had no real social concern but did record the lower-class life that he was a part of in his candid photographs. They are less organized and poorer technically than Thomson's, but still convey the flavor of a genuine situation.

sought for so long. Perhaps this acclaim gave him more confidence; perhaps his fellow members were more impressed now with all of his work—in any case, he concentrated his efforts in 1894 and 1895 on hundreds of snapshots, nearly all of working people, and nearly all including casual but highly informational backgrounds.

Why the concentration on working-class people such as street vendors and laborers? Martin certainly felt comfortable with these people and probably did not have to worry about their objecting too strongly if they saw him taking their picture. Upper-class Victorians might not have been so kind. A more practical answer to his motivation, however, is suggested by the pictures themselves. The bulk of Martin's street pictures of this period exhibit shadows falling nearly directly below the subject, suggesting a time near noon. As a wood-cutter, Paul was paid by the hour for a very long week—no work, no pay. We know from later comments that he worked until about seven at night at this time and that every holiday that he took represented a financial sacrifice. Martin must have taken many of his pictures on his lunch hour. This brief time would not permit him to stray far from work, so the choice of other people in this area of markets, businesses, and vendors must have been quite natural. He may also have slipped in a few quick shots with his Facile while making deliveries to the Fleet Street news area, and was also commissioned by the woodcutting firm that employed him to take some extra studies. He noted that his employer was "not slow in estimating the possibilities of my 'snaps' as material for the artists to draw from. They used to get me to go to various places and take 'snaps,' from which the artists would compose suitable drawings to be ultimately engraved. . . . Having developed the plates I would pass on to them the negatives to be

THE IRISH STREET-SELLER.
"Sweet Chany! Two a pinny Or-r ranges—two a pinny!"
[*From a Daguerreotype by* BEARD.]

"Halfpenny Ices," by John Thomson, from
Street Life in London, *by John Thomson and Adolphe Smith*
(1877), facing p. 53.

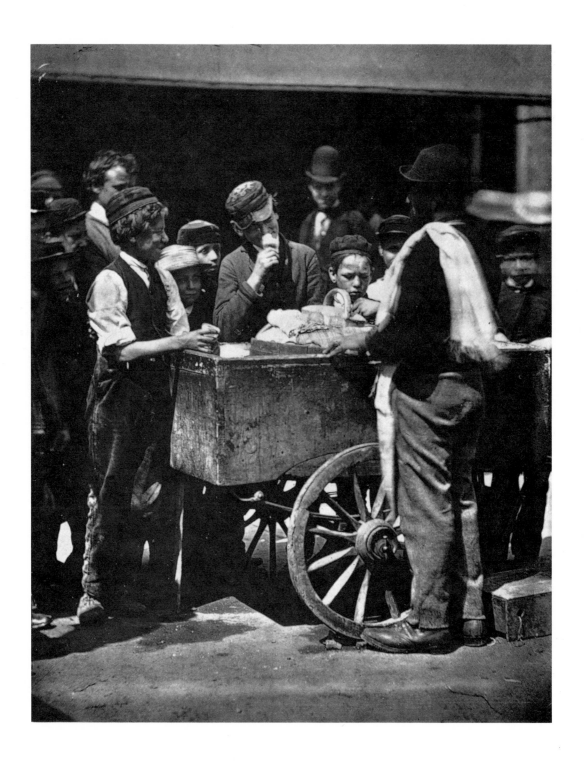

Photo by Paul Martin, 1893. Part of his series
"Children of the Poor in the Nineties."

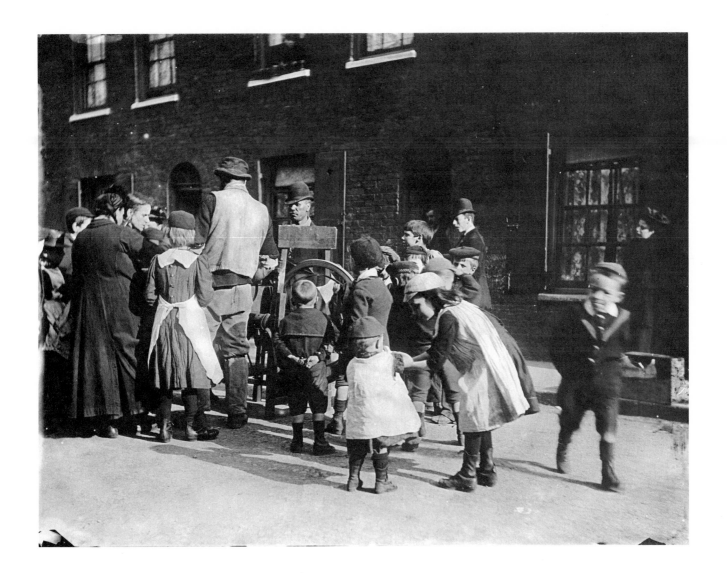

*The lure of the pictorial was always strong
for Martin. "The Upward Path" is a typical salon print
of the type for which he was likely to receive a medal. The
lettering and careful matting and the choice of a well-accepted, "pretty"
subject were reasonably good guarantees of recognition. Such prints were often
done by expensive processes and were relatively large. Powerful figures such as George
Davison and Col. Joseph Gale were difficult to compete with on these terms.
Martin turned to areas of less competition, such as lantern slides and
candid hand-camera street work. His most significant photography
comes from this motivation. From the Collection of the Art
Museum, University of New Mexico, Albuquerque.*

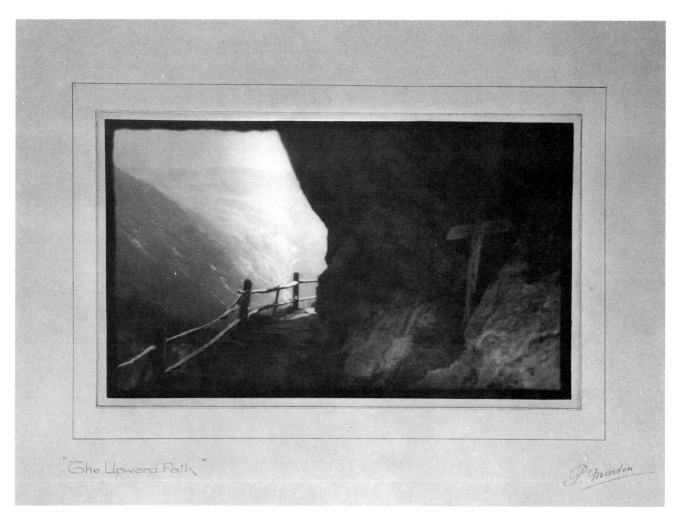

"The Upward Path"

P. Martin

"Street Arabs," by Paul Martin, 1893.

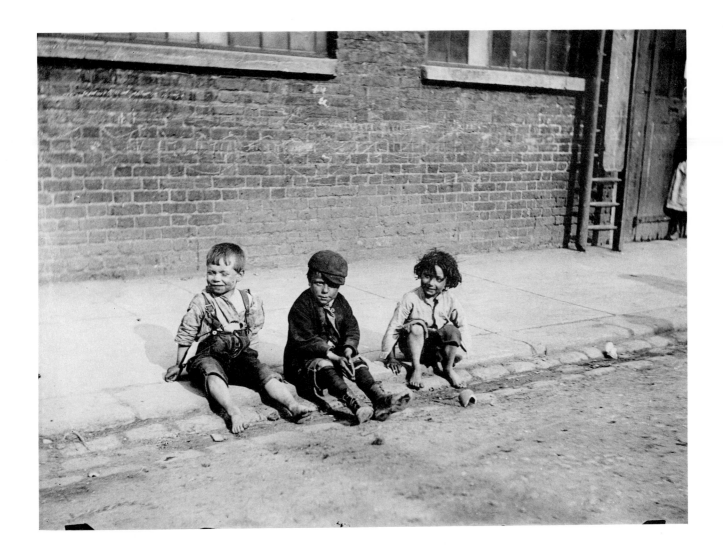

dealt with by them."[83] Perhaps some of his street snaps were unused or extra shots; perhaps the negatives were returned to him after fulfilling their temporary mission; or, unfortunately for us, these negatives may have been discarded after they provided inspiration for the artist.[84] The lack of hard news pictures in Martin's surviving work indicates the possibility that most of these unique images were retained by the illustration firm.

In photographic circles, Martin was becoming more and more successful in this period. At the sixth annual exhibition of the West Surrey, one which showed "a distinct improvement on the past exhibitions," Martin was said to have "undoubtedly the best exhibit in the whole room."[85] By the next year, Martin was one of only five exhibitors out of ninety that *Photography* magazine felt were "approaching modern exhibition form."[86]

His reputation started at about the time of another earthquake in British photographic circles. Ranking in importance to photographers as highly as the societies were the medals given in the various and almost continual exhibitions. The biggest and most prestigious exhibition in London in this period was the annual Exhibition of the Royal Photographic Society of Great Britain. Known popularly as the Pall Mall (a title taken from the art gallery that the society employed—The New Gallery at Pall Mall), commercially oriented with divisions in industrial, scientific, and pictorial areas, the traditional show went unchallenged for many years. Then, in 1893, a select body of leading British pictorialists, including a goodly number of the more powerful figures from Martin's West Surrey society, formed the Brotherhood of the Linked Ring and set up a rival and concurrent exhibition. Known the first year as the Photographic Salon, and held at the Dudley Galleries only about five hundred yards from the traditional Pall Mall, its stated purpose was to selectively

bring before the public "the best productions of photography solely from the pictorial point of view."[87] Its organizers claimed over and over that they did not seek to compete with the Photographic Society's show—merely to complement it.[88] No medals were to be given, and, in fact, several of the exhibitors had photographs in both shows simultaneously.

The Salon (as it soon became known) proved to be a mixed bag of pictorialists with emphasis on soft focus and modified processes, derisively referred to as the "fuzziness school." Nearly 800 pictures were submitted; from these 294 were selected from 108 photographers.[89] While handcamera, beginning amateur, and professional work was discouraged in favor of "serious artistic work," the exhibitors represented such a cross section of photography as to defy description. In the first year's show alone were photographs by J. B. B. Wellington, Frank M. Sutcliffe, Frederick M. Hollyer, H. P. Robinson, Colonel Gale, Alfred Maskell, P. H. Emerson, J. Craig Annan, A. Horsley Hinton, George Davison, H. H. H. Cameron, A. R. Dresser, Frederick H. Evans, and, significantly, two entries by Paul Martin.

Martin was not a member of the Linked Ring, but he had found the traditional exhibition "too full of professional work."[90] This, coupled with his recent success with the statuettes, plus his long association with organizers of the Salon such as George Davison, helps to explain why the handcamerist and tinkerer wound up in a show that would seem to be oriented in a different direction. The Salon was, however, such a conglomerate mixture that it would have been nearly impossible for anything not to fit in, so Martin probably felt no stress. The Salon continued to be controversial, but it was a pronounced public success and became a prime platform for Martin's work.

Martin had three pictures in the Salon in 1894,

A typical nostalgic slide used by Martin
in his later lantern lectures. Lantern slides were
3¼-by-3¼-inch glass photographic plates that were
frequently hand-tinted and retouched.

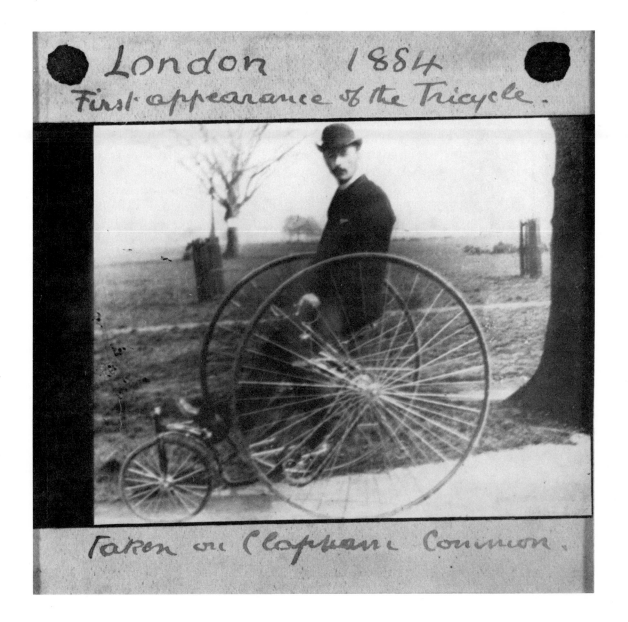

one of which ("A London Flower Girl") was reviewed as "amusingly and thoroughly realistic, but would have been even more so with a suitable bit of street background. The girl's open mouth is so suggestive of a shout, that we actually seem to hear it."[91] We do not know whether this was presented by Martin as one of his blocked-out background pictures, or was merely too stark in surrounding for the reviewer. Martin continued showing each year in the Salon until 1898. It was nearly forty years later that he finally returned to it.

Martin's second, and by far his biggest, impact on photography occurred in 1896 and led to his winning the Gold Medal of the Royal Photographic Society. A happy combination of events led to this coveted award.

By 1895 wood engraving as a business had been hurt so severely by process engraving that Martin's hours of work were reduced, sending him home at six o'clock rather than seven. "One evening, I was caught halfway along the Embankment in a downpour of rain, and I could not help noticing the effect of the reflected lights on the pavement. I was always looking out for new ideas, so the next wet night I was on the Embankment with my 'Facile' and my whole-plate tripod upon which I could rest it."[92] This was in February 1896, the year, coincidentally, that marked the centennial of gas lighting in England.[93]

Martin chronicled a series of frustrating and time-consuming failures that led up to the final results. His first plate, with a time exposure of thirty minutes on a bitter-cold, windy night, was hopelessly fogged. His second, made a week later with an isochromatic plate, had tremendous halation around the lights that suggested more of an "astronomical study of Saturn" to Martin than the soft effect of the street lights. Some weeks later he went out again with backed plates, designed to avoid the spreading in the emulsion of bright lights.[94] This time, instead of Saturn's rings, he got a comet streaking through the picture. It was some time before he realized that the cabs with their lights were moving through the picture area during the exposure. His simple solution was to hold his bowler hat over the lens whenever they came into view. His next attempt produced a technically perfect picture with the lights suspended in total blackness. Realizing that would not do, he next tried to expose just before twilight went away—the result looked just like a daylight picture, obtained with considerably more difficulty to the operator, but at last pointed the way to the final solution. He was now out on his sixth cold night after many weeks of difficult work. This plate, given a very brief exposure to the twilight to retain the outlines of the buildings, was a total success![95] No wonder that Martin later counseled that night photography required "first and foremost a good stock of patience and perseverance."[96]

Martin took his first print from a night negative to the London and Provincial Photographic Association, a group that he was soon to join. The editor of *The Photogram* magazine was so impressed that Martin set about to quickly capitalize on his achievement. He wanted the pictures "not only to create a new departure, but to kill the idea at the same time, for my set [of night pictures] numbered eighteen, and represented nearly all the promising subjects."[97] Production became almost a routine: remembering to pick subjects where there were reflections in the foreground (rain, snow, over water); using his backed plates with ten to forty-five minutes' exposure, depending on the amount of remaining twilight; and

Upper, *"Westminster by Night,"* 1895.
*This pioneering night picture by Walter Edmunds
was exhibited in the Royal Photographic Society Exhibition
the year before Martin showed his famous "London by
Gaslight" series. From Photograms of '95, p. 25. Lower, "Big
Ben (A Late Sitting) and Westminster Bridge," by Paul Martin,
1896. Martin's night scenes so captivated the photographic
world that for many years his influence was felt.
There was even formed a Society of Night
Photographers in London.*

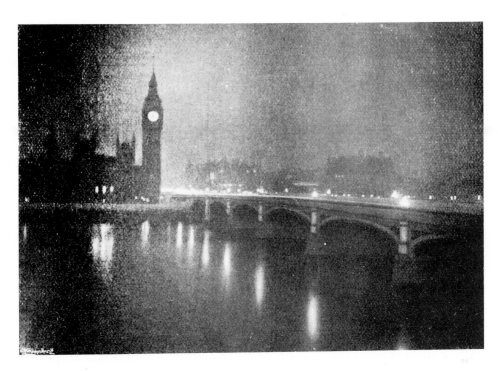

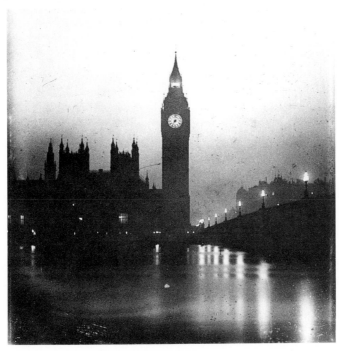

developing one plate at a time for half an hour in a diluted developer that is still familiar to photographers today—Rodinal.[98]

The cold, wet, lonely nights out with his Facile were not so bad for Martin. He said that the wet nights not only increased the pictorial effect, but had the side benefit of "decreasing the inquisitive onlookers."[99] He did encounter a number of amusing incidents, with the few people then out at night in London surely wondering what the strange man with the mahogany box could be up to. "One young man, thinking that there was the chance to appear as the principal witness in a suicide case, calmly watched me from behind a tree some thirty yards away until the exposure was over, which meant some twenty minutes as his share."[100]

Martin was fully confident of his results. He placed two of his night pictures in the Salon. He also participated heavily in the Pall Mall exhibition this year, perhaps because the Salon did not offer medals. Martin entered one of his pictorial shots in the print division, but concentrated most of his efforts on twelve lantern slides of "London by Gaslight." He tinted his lantern slides blue, binding them with a yellow-stained cover glass to recreate a semblance of the gaslighting. In later shows, he would sometimes place an orange-colored filter cell over the projector lens to give the same effect.[101] The Autotype Company simultaneously displayed two of his night scenes as enlargements in the commercial section of the show.

Martin's set of night scenes was the only set of lantern slides to be awarded the gold medal in 1896, and only two other medals were given for lantern slides in that entire decade.[102] At the meeting of the Royal Photographic Society on October 13, 1896, Martin was present and was awarded his long-sought medal by Capt. W. de W. Abney, the society's president. Abney, very technically oriented, said that he had a difficult time deciding between Martin's and two other entries that represented breakthroughs—some pictures by a Mr. Lodge that were the first to record birds in their nests, and the first pictures out of Germany illustrating the then little-known photographic powers of the mysterious X-ray.[103]

It is difficult today to fully appreciate the accomplishment and the impact of Martin's pioneering night pictures. They took the photographic community by storm, not only in the year that they were first presented, but for many years afterward, being praised in such terms as "among the most striking achievements of modern photography."[104]

Night photography was not an entirely new field in 1896. There are many references to night photographs in the journals of the early 1890's, but Martin's work, all made in the span of only a few months, set the standard for the genre.[105] He probably did use up most of the most picturesque spots in London as subject matter, and he certainly was the first to bring before the general public the notion of night photographs. The facts that he exhibited in lantern slide form, which had a longer tonal range than prints, and that he tinted his slides blue and yellow to match the visual sensation of the gaslight alone would have made his work stand out. His recognition of the need for reflections and especially the use of a little residual twilight are techniques that photographers still use today. His title, "London by Gaslight," captured the imagination, becoming nostalgic in a very few years when the romantic soft light gave way to the harsher and more numerous electric street lamps.

Martin reveled in the acclaim given him by photographers and the public press. He was almost universally praised. While he enjoyed this sort of public contact, however, he didn't appre-

*Martin published this picture as an
example of what he considered to be "an
early failure" in night-photography technique. He
was able to eliminate the halos around the lights by
using specially backed photographic plates. Alfred Stieglitz
praised Martin for his achievements in night photography and
for freely publishing his working methods, but criticized
him for being too successful at removing the halation,
and thus the sense of atmosphere, from his images.
From "Around London by Gaslight, Part II," by
Paul Martin,* The Amateur Photographer,
October 16, 1896, p. 314.

ciate another type that was forced on him. In October 1896 he recorded the last of his night-time experiences for a while. "Now commenced a scene which recalled to my mind Jameson's famous fight with which the papers were then filled, to the effect that when fighting commenced scarcely any of the enemy were to be seen, but a little while after they were surrounded on every side. I was in a somewhat similar position. Cabs and carriages came from every direction, to say nothing of the people who stopped just to drop a kind remark. . . . I felt so ashamed at being the centre of attraction for once in my life, that I somewhat curtailed the exposure, and resolved that this should be the last . . . this completely satiated my desire for night effects in the busy metropolis."[106]

Martin's stature in the photographic world grew. America took notice. Alfred Stieglitz, already well known and soon to emerge as the powerful arbiter of American photographic taste, wrote, "It is due to the splendid efforts of Paul Martin, of London . . . for which he was awarded the much coveted medal, and for his unselfishness in publishing his mode of procedure in several very interesting articles . . . that this branch of photography has become more popular. . . . Mr. [William A.] Fraser, of the Camera Club of New York, was the first American to take up work on similar lines to those laid down by Paul Martin . . . the writer having begun his experiments last year [1897] . . . has but little to add to the working instructions already given by these gentlemen."[107] Thus it can be seen that Stieglitz clearly credited Martin with prior discovery, a distinction that most later accounts confer on Stieglitz. He did go on to criticize Martin for having so thoroughly eliminated the halation, removing the atmospheric effect, a criticism that was echoed by other reviewers in critiques of Martin's night work in the Paris Photographic Salon of 1897 and the Philadelphia Salon of 1899.

The Photogram magazine, Martin's early supporter, organized a series of lantern slide lectures on various topics in 1902. Number 3, on "Night Photography" and mainly illustrated with Martin's work, was the runaway favorite.[108]

The Autotype Company took over copyright on eight of Martin's night views in 1896, blowing them up into normally handsome and permanent carbon prints and selling them on a royalty basis of 15 percent. *Photograms of '96* complained, however, that "these enlargements are reduced to the level of an advertising placard at a railway station, by reason of their large and all unnecessary titles, which . . . do their best to kill the effect which Mr. Martin has so admirably secured. As an instance of bad taste, these staring legends, on the very face of the prints themselves, cannot be passed over in silence."[109]

Inspired by Martin's example, night photography became more and more a common feature of the exhibitions. Later, there was even a Society of Night Photographers formed in London, holding an annual Night-Hawk's Dinner.[110] A tired *Photograms of the Year, 1899* referred to "a member of the Paul Martin school" and to night work as "the now well-worn theme," a lack of enthusiasm which serves to point out the volume of nocturnal photography then being produced.[111] Decades later, older members of the societies would still credit Martin's night photographs as being a strong inspiration for them.

While Martin was gaining in stature, apparently the West Surrey society was stagnating. In August 1895 the group found a new meeting place, but the vice-president found it necessary to open the meeting with a promise to make a "fresh start" and hoped for "happy results."[112] Possibly because of the troubles in the West Surrey, Martin joined the London and Provincial Photographic Association, being elected to membership October 8,

1896.[113] This was to prove an especially important contact. The London and Provincial was then considered the Fleet Street (news district in London) of the societies. Through his membership, Martin met many influential people in publishing and journalism.

The society asked its new member to give a "lantern evening" to show his work. Martin's strong identification with night photography is apparent from the review of the show: "Paul Martin, upon being called on to show his slides—'London by gaslight,' and other slides—said he hoped members had not made up their minds to see a lot of slides of London by gaslight; he had only a few. The majority of the slides to be shown were hand-camera pictures, street scenes, and others. Whilst all the slides showed good work, the 'London by gaslight' series were much appreciated."[114]

Martin's reputation was now secure. He was regularly mentioned in the journals from 1896 to 1899 as an exhibitor of a wide variety of photographs, a speaker before clubs, a judge of competitions, and an active society member, often asking technical questions of the speakers. The year 1896 was a busy and productive one for Martin. In addition to his widely acclaimed night work, he did a number of charming snapshots in Switzerland and London, and braved the sea at Hastings to produce pictures of a gale so fierce that they moved a reviewer over forty years later to comment, "Perhaps of all the slides shown, the most arresting were several depicting terrific seas breaking over the esplanades, for nothing better in their way has, probably, ever been done."[115] Martin's Facile survived the waves in Darwinian fashion by virtue of its simplicity, aided by the leather case and the ebonite lens cover that he had added years before. While nothing could guarantee Martin himself from being washed away by the waves, his health was at least somewhat protected by con-

stantly keeping a suit of clothes drying in the kitchen of his hotel.[116]

After 1896, Martin began to move toward more conventional types of photography, such as the creation of composite pictures by combining several negatives, much along the lines of the old H. P. Robinson school.[117] He was in demand as an author of magazine articles, but it became apparent that he was being absorbed into the mainstream of exhibition pictorialism.

Martin's fame, his membership in the press-oriented London and Provincial Society, and old friendships brought him other opportunities. George Davison, the former vice-president of the West Surrey Society, had been hired by George Eastman to manage the European operations of the Eastman Company. Martin was invited to participate in the Invitation Room of the 1897 Eastman Exhibition in London, along with such notables as Frank M. Sutcliffe, J. Craig Annan, H. P. Robinson, and Frederick H. Evans. Hundreds of photographs by amateurs were shown, and the Invitation Room alone had over two hundred fine enlargements by the Eastman Company from the participants' negatives. The average daily attendance at the twenty-one-day show was in excess of a thousand. The highly praised show traveled on to New York, was injected with new blood by the work of Stieglitz and others, and recorded an attendance of over twenty-six thousand people in only twelve days.[118] Martin enjoyed the same advertising boost that the makers of the Kodak sought and obtained.

Davison, knowing that woodcutting was on its last legs, offered Martin employment with the Eastman Company in 1898. Martin, however, had learned that "the prospects of the Kodak film were none too rosy, so I politely declined."[119] His evaluation of the future of Eastman probably appeared quite sound at the time. Roll film, still in its in-

*A preliminary sketch with photograph
inserted, by Henry Peach Robinson, ca. 1860.
The first step in the common practice of structuring
photographs by combination printing, a form
popularized in art photography by
Robinson and O. G. Rejlander.*

fancy, behaved like a spoiled child. It curled, sometimes went bad, and often disintegrated prematurely. It might well, in spite of its amateur popularity, have gone the way of many other good inventions that just did not prove out commercially. The photographic industry had certainly seen its share of these.[120] Eastman's promotional, price-setting, and acquisition policies in both England and the United States were drawing increasingly hostile—if later to prove futile—response from photographers and dealers.

Martin did participate in another way with the Kodak. Many leading photographers of the day were given free Kodaks and film in exchange for use of the resulting photographs for publicity. Martin tried several and secured some very good pictures, but was never really comfortable with the Kodaks. The shutters were too fast, the film too temperamental, and all the various innovations, such as rising front movements, added nothing to his pictures. A few of his last genuine snapshots were taken with these Kodaks, but the well-worn Facile remained the camera that he enjoyed. He did manage to squeeze out some memorable work from the fancier cameras, though. "Soon after the early exhibition of Kodak snaps . . . I happened to be passing down Cheapside and, noticing a large crowd of people looking into a window opposite, I went across to see what it was all about. To my great surprise it was a big enlargement of one of my Hampstead Heath snaps, one in which the girls are all dancing. Such a thing had never before been seen, and the comments were very entertaining and amusing. Some time afterwards I was talking to one of their travelers and told him about the Cheapside incident. 'You know what happened?' he said. 'The police told them they were creating an obstruction, so they had to take it in.' "[121]

Davison found some of Martin's results "prodigious" and asked him to reconsider joining the firm. Martin later bitterly recorded in his diary that this was a "unique chance thrown away." In later years he thought "still more of the good offer to join the Kodak firm that I turned down. They say that a chance comes only once in a lifetime, and I believe that now!"[122]

For Paul Martin, 1899 was a year of tough decisions. His photography had become a conglomeration of Kodak snaps, heavily worked-over pictorial images, and stand camera work with prints as large as 12 by 15 inches.[123] Wood engraving was a dead field, most particularly in the news area that Martin's employer had come to specialize in. In common with many other ex- or soon to be ex-woodpeckers, Martin tried his hand at the mechanical process engraving that was replacing their craft, but found the work not at all interesting. In 1897–1898, he attended the Bolt Court School of Engraving. This was a common, if not popular, route for the wood engravers to take in an attempt to stay near the field familiar to them.[124]

Martin was thirty-five years old, highly skilled in an obsolescent craft, and supporting an aging mother in a time of general economic depression. His avocation of fifteen years, in which he had gained a fair amount of recognition, was about to become his means of making a living.

From "A Composite Subject," by Paul
Martin, The Photogram, *March 1899, pp. 72–75.*
As we might expect, Martin used his manipulatory skill
gained from woodcutting to modify many of his photographs.
He followed this practice from as early as 1885 to well
into his lantern slide lectures of the 1930's.

Martin's Professional Period

On April Fool's Day, 1899, amateur-turning-professional Paul Martin entered into a partnership with a member of the West Surrey Photographic Society—Harry Gordon Dorrett—at 16 Belle Vue Road in London. Of Dorrett we know little. *The Photogram*, in its good-luck message to Martin as he entered business, characterized Dorrett as "one of the very best London technical photographers and lantern slide makers." In Martin's autobiography, about all he has to say about Dorrett was that "he had been apprenticed to one of the leading South Coast photographers." In all of the detailed British photographic journals that we surveyed between 1884 and 1930, Dorrett is mentioned very few times.[125]

From 1899 to 1901 the firm was known both as Dorrett & Martin and as Athol Studios.[126] After 1901, "Athol" seems to have been dropped. "Every kind of architectural, landscape, press, advertising, flashlight, and legal photographing" was to

be undertaken by the new firm, as well as "a specialty of developing, printing, and enlarging, etc., for amateurs, giving them the advantages of personal attention, versatility, and advice."[127] This orientation seems logical, since Martin by this time had a reputation as a technical virtuoso. He also could not have failed to notice that his one-time potential employer, the Eastman Company, was enormously successful in the field of service to the amateur.

Martin, of course, had not really chosen when to change occupations, but this was a very poor year in which to start a photographic business. The summer of 1899 was one of the hottest on record in England, leading to "a great rush out of London . . . everybody is doing nothing and nobody is doing anything."[128] Martin had the naïve notion at first of renting showcases at various commuter railway stations to display examples of what the firm could do for amateurs. In his own words, "it turned out to be a dismal failure . . . very few people visited us . . ."[129]

What happened next is not clear. The new firm was mentioned initially in the journals, and it advertised in the 1900 *British Journal Photographic Almanac*. We located no mention of either Dorrett & Martin or Athol in the editorial columns of the journals again until 1903, and the next major paid ad that we located was not until 1909. Martin says in his autobiography that since the new business was not doing well at the Belle Vue address they opened at 60 Strand, the former studio of John Emberson, to take up press work. A diary entry in 1901 states again that the photographic business was at 16 Belle Vue Road. Journal references in 1903 and late 1904 give the address only as 60 Strand. By 1907 the address is again given only as 16 Belle Vue Road.[130]

The free-lance press business initially went quite well. Martin had already been selling his "snaps" for years to the woodcutting firm, so he had a pretty good idea of what sort of pictures the newspapers required. The already rented railway cases were stripped of their amateur examples and refitted with press photography. Dorrett & Martin's Strand address was shared with a Mr. Cochran, a variety agent. So many of his clients were drawn to look at Dorrett & Martin's display that the police again complained about the obstruction that Martin's pictures caused.[131]

The first big national event covered by the firm was the funeral of Queen Victoria in February 1901. Martin was armed with his trusty Facile. Dorrett, in the spirit of ambitious news photographers before and since, clambered up a shaky ladder supplied by helpful Hyde Park officials, pulled up his camera, and somehow managed to get both his body and the tools of his trade up to the top of a slippery marble arch that overlooked the parade route. He remained up there seven and a half hours that day, securing for his considerable labors some exclusive photographs taken over the crowd's heads.

Numerous delays and problems cropped up in getting the prints from the event out. The modest firm of Dorrett & Martin was equipped only with one daylight and one artificial-light enlarger, so production was found to be too slow. Quickly making enlarged negatives, the pair sent them off to a company that specialized in making prints in a hurry. The resulting quality was so poor that Dorrett & Martin's clients refused the prints. Far less profit was realized from this critical venture than had been hoped for.[132]

Martin's beloved Facile, almost ten years old and caught in a fast-paced technological evolution, did not prove suitable for competitive press work. For the coronation of King Edward VII in 1902, Martin designed and had built a half-plate single-lens reflex camera "after the style of something I

*Dorrett & Martin, or Athol Studios,
started out with the idealistic goal of helping
amateurs. Practical realities soon turned them to the
field of supplying pictures for the illustrated papers. The
most successful activity of the firm finally turned out to be the
manufacture of photo-buttons and other supply items for
the trade.* Left, *an example of the firm's printed
statement forms, from the Gernsheim
Collection.* Right, *from* The British
Journal Photographic Almanac,
1900, p. 319.

had seen at a sale." This type of camera utilizes a mirror at a forty-five-degree angle to reflect the image up to a viewing screen. At the moment of exposure the mirror flips up, allowing the image to reach the film. The precise framing and ease of use make them almost universal today.[133]

Coping with the trials and tribulations of press work was not the only new experience that Martin faced in this period. On October 26, 1900, the thirty-six-year-old bachelor (still living with his mother) married Clara Emily Ackery. The Martins' first son, Albert, was born "during a thunderstorm" almost a year later. Their second and last child,

Ernest, came into the world in December of the following year.[134]

Press photography was not a secure field in those days for a new family man. In later years George E. Brown, then editor of the *British Journal Photographic Almanac*, reminisced about the Illustrated Press Bureau that he had started with H. Snowden Ward in 1900. "There was not the business for an independent concern at the time before the establishment of the purely picture papers and of the picture pages in almost every daily."[135] Dorrett & Martin apparently came to the same conclusion near the end of 1902. Martin

From The British Journal of Photography, *1905, adv. p. vii.*

PHOTO BUTTONS
FOR THE
GENERAL ELECTION

THE demand for **Photo Buttons** for electioneering purposes is certain to be **very great**, therefore it is essential to place your order **early** to save disappointment.

Make a point **now** of seeing the representatives of your candidate and endeavour to secure the order early.

Orders will be executed strictly in rotation. In the meantime send for particulars and Free List to—

DORRETT & MARTIN,
60, Strand, W.C. Tel. No. 6646 Gerrard.

wryly observed, "Fortunately for us, we became very busy in another direction of our business, necessitating giving up Press work."[136]

That "other direction" was a far cry from the candid snapshots and innovative night work that Martin had been doing just a few years before. He had totally given up taking this kind of picture by 1902 and had also stopped participating in exhibitions or even photographic society meetings. A trade column review in 1903 lists Dorrett & Martin as a specialty house which supplied photographic jewelry to the dealers and to amateurs directly. Jonathan Fallowfield, the same firm that had sold Martin his Facile camera, started marketing materials for photo buttons, a craze that had recently emigrated from America. A paper print was laminated under a celluloid face and pressed into the button shell by a simple machine, an operation "calling for no skilled labor." The "well-known Strand firm of Dorrett & Martin" had been suppliers of buttons to other photographers "for some time past with much success."[137]

The button craze went into full swing as Dorrett & Martin began to produce them. Their use in elections was especially widespread. "Photographic buttons have, it is believed, been produced in increased numbers, and, in some metropolitan constituencies especially, have been almost universally worn."[138]

This line of work was apparently in the end financially successful but very time consuming for Paul Martin. His holidays, which he had managed to take with regularity since apprenticeship and which nurtured so much of his photographic work, had to be suspended. He does not record a single one in his diary from 1904 to 1907.

The year 1908 finally brought a holiday with the children. By 1909 Dorrett & Martin's Electric Photo Works had a full-page ad in the *British*

Left, *from* The British Journal Photographic Almanac, *1909, p. 384.* Upper right, *from* The British Journal of Photography, *December 25, 1914, adv. p. x.* Lower right, *from* The British Journal of Photography, *June 27, 1919, adv. p. xviii.*

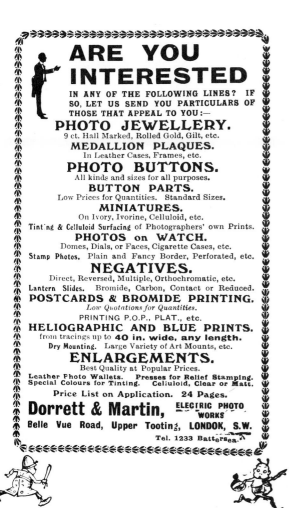

The photo-button craze emigrated from America and provided the one really financially important break for the Dorrett & Martin firm. Initially the supplies they sold to the trade were manufactured by the firm of Jonathan Fallowfield, the same one that had first sold Martin his Facile camera. Dorrett & Martin started manufacturing their own photo-buttons at a boom time in the market. From The Photogram, *October 1903, pp. 299 (upper), 298 (lower).*

FIGS. 2, 3, and 4.—Circular print. Button shell and button at first stage.

FIGS. 5 and 6.—Pin-back, and button complete.

Journal Photographic Almanac, offering a wide variety of lab-type services and advertising a twenty-four-page price list. Electricity, as well as the telephone, was a relatively novel device in photographic studios and labs then. Dorrett & Martin had both, not at all surprisingly, since Martin nearly always attended the exhibits of scientific curiosities.

Martin took very few photographs during the following years[139] but did enjoy frequent holiday trips. His main hobby during this time seems to have been his garden, lovingly attended to and expanded in 1919 by the erection of an aviary.

The experimenter's sense was still in him. He built an enlarger in 1920. Improving on the design, he undertook construction of a self-focusing enlarger in 1921, finishing it early in 1922. This was another busy year for him. At the first British Industries Fair in August, Martin spoke to several major photographic manufacturers about his enlarger design, apparently without any takers. He also attended the exhibition at the Royal Horticultural Hall and another one dealing with the wireless. He started construction on his first crystal set and listened in for the first time on New Year's Eve.[140]

In July 1923 he secured a British patent for his "Self-Focussing Vertical Enlarger." The O. C. Sichel Company considered purchasing the design but contented themselves with inspecting Martin's prototype and returning it. They brought out a modified version, without paying royalties to Martin, in 1924. In any case, self-focusing enlargers rapidly became so commonplace that Martin sold his patent to a Mr. Overton in 1924—we have no evidence that it ever made it into production. Martin's developmental work on the enlarger was by no means a total loss. *The British Journal of Photography* in January 1923 commended Dorrett & Martin on their production facilities for enlarge-

From The Photogram, *October 1903, pp. 299*
(upper left), *298* (upper right); The British Journal of
Photography, *May 19, 1905, p. 393* (lower).

Photo-Medallions: a Side-line for Professional Photographers. Made
by Dorrett and Martin, 60, Strand, London, W.C.
Some pleasing and attractive form of portrait which can be shown
to a client at the time of the sitting or when proofs are examined
should be sure of attention from the professional photographer. True,
there has been no lack of such novelties in the past, but fashions alter,

ments utilizing a self-focusing enlarger to speed production and cut costs. The enlargements were available to portrait photographers as a service on a twenty-four-hour basis, at apparently the lowest prices in town.[141]

In 1926, at the age of sixty-two, Martin had had his fill of making photo buttons and cheap enlargements and post cards for other photographers. Dorrett & Martin closed down on the last day of the year.[142] With time on his hands and apparently in possession of sufficient funds, Paul Martin was ready to enjoy his hobbies and travel. He took some photographs, tinkered with his wireless and maintained his garden, attended various exhibitions, and even went to see the arrival of Charles Lindbergh. In 1928 he again started exhibiting in the Salon, by now no longer the controversial organization that it once had been. At some point he bought a Zeiss Palmos roll-film camera.[143]

His photographic participation again began to step up. Now, counted as one of the grand old men of photography, he joined the Wimbledon Camera Club in 1928 and was a favorite speaker at many society meetings.[144] His grand white mustache would have been enough to make him an attraction. With his bowler hat and stock of stories about the "old days" he regained some of the recognition that he had enjoyed back in the 1890's. The Battersea Museum requested some of his prints in 1929. Nostalgia put him in demand for slide lectures about Victorian times and also created a great demand for his pictures among publishers and print agents. His print filing envelopes in the Gernsheim Collection are covered with neat records of the agents that he sent pictures to. His long life, his woodcutting background, and this late-in-life organization of his work for lantern slides and publication files helps to explain why his work is so well known today. The old Facile "snaps" can be found peppering the books and periodicals of this period. In 1937 he presented an album of his wood engravings to the Victoria and Albert Museum; their library also acquired forty of his London studies for their permanent collection. That same year saw examples of his amateur period work featured in the first of the modern photo-historical exhibitions, "Photography, 1839–1937," organized by Beaumont Newhall at the Museum of Modern Art in New York.[145] Nine of Martin's photographs of everyday life in England, also dating from his amateur years, were featured in the historical section of the Centenary of Photography Exhibition held at the Victoria and Albert Museum in 1939.[146] That year Martin also contributed to the celebration of the first hundred years of photography by bringing out his autobiography, aptly titled *Victorian Snapshots*.

World War II was breaking out, and Martin was again a French citizen in a foreign land. Two notices of intent to become a British citizen were published in the *Daily Telegraph* on September 13 and 14, but the man who had lived on English soil and contributed to the nation's economy and art for sixty-five years did not obtain citizenship. His sons were to have added difficulty in obtaining commissions in the military as a result.[147]

Martin was now aging rapidly. Fewer photographic societies were meeting during the war, and publications were limited by paper shortages. His diary pages are completely empty from 1941 to 1944. On July 7, 1944, Paul Martin died at the age of eighty.[148]

It is pitiful that the shy "woodpecker" who had stimulated so many with his ventures into new photographic areas should have slipped into oblivion. His entire life had been a struggle, living in both vocation and avocation on the edge of the relentlessly shifting technology that obsoleted his achievements as soon as they were made.

We were unable to locate any obituary in the

Paul Martin in 1942 at the age of
seventy-eight, two years before his death. In the
background is the garden that became one of his major
hobbies later in life. Photo by Kurt Hutton.

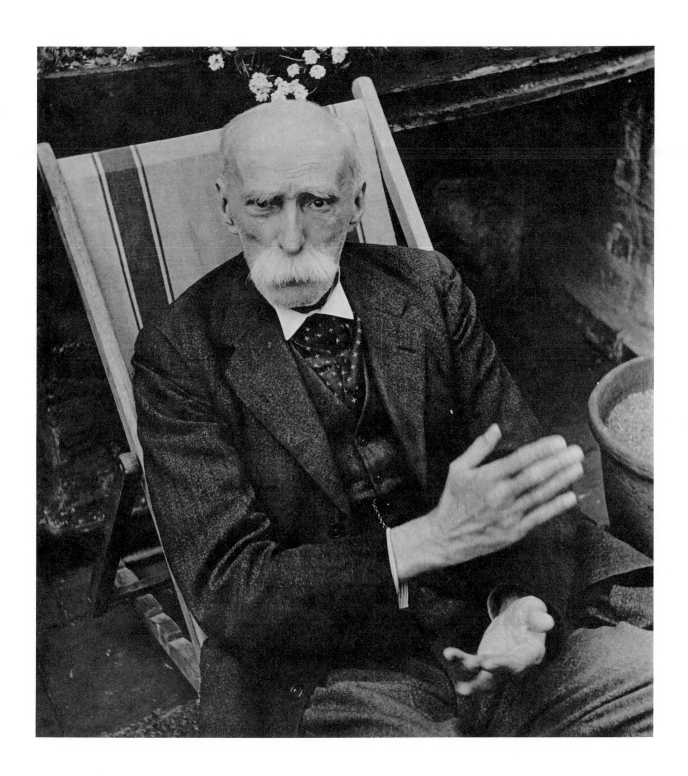

*"View from Wengen," by Paul Martin,
1895. This image, secured by Martin while on
vacation in Switzerland, was used years later in his
lantern lectures. The "birds" are a modification
painted onto the slide by Martin.*

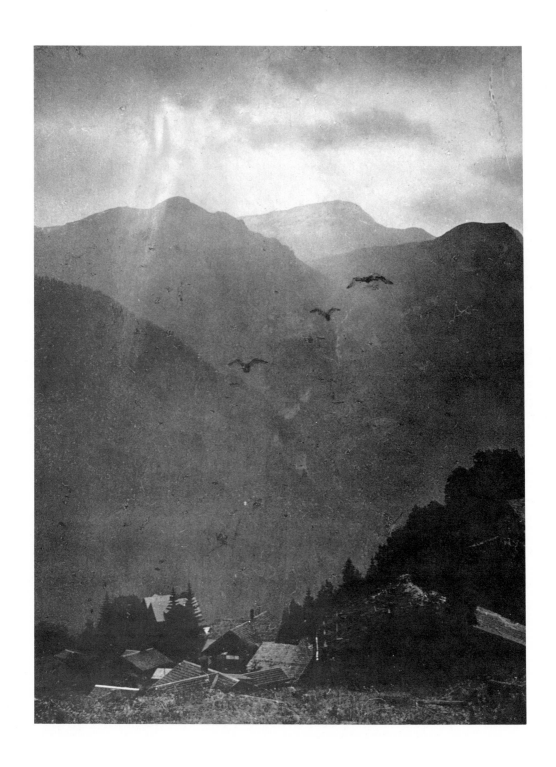

*At some point during his professional
career Martin purchased this model of a Zeiss
folding camera to use during his vacation trips. The
photographs taken on these trips never equaled the spark of
quality of his amateur work from the 1890's, but he did become
a popular lantern slide lecturer. From* The British
Journal Photographic Almanac, *1928, p. 680.*

THE MINIMUM PALMOS

IS a great favourite with the pressmen. The focal plane shutter gives exposures to 1/1000th of a sec. and time exposures. The body is all metal. The focal plane shutter is adjusted from the outside, and in the case of the Vest Pocket and 3½"×2½" sizes, of the self-capping type.

PRICES

	2⁵⁄₁₆"×1¾" or 4½×6 cm.	3½"×2½"	4¼"×3¼" or 9×12 cm.	10×15 cm.
F/4.5 **Zeiss Tessar**	—	£29 7 6	£32 15 0	£39 5 0
F/3.5 „ „	—	34 10 0	39 5 0	46 15 0
F/2.7 „ „	31 2 6	37 10 0	—	—

Including three double dark slides, except the Vest Pocket, which is equipped with three single slides.

photographic press. It was wartime, the journals were limited, Martin had not been seen much in over four years, people had other things on their minds—all of these reasons make it more understandable, if no less sad, that the photographic community to which he had so strongly contributed did not note his passing.

Conclusion

As we look back from a vantage point many decades later, Martin's photographs take on a tremendous documentary value about a time and a class of people of interest to us. Martin was in many ways unique, yet in many ways symbolic of the concerns of photography near the turn of the century. In placing him in context with other photographers, we must realize that his first trade of wood engraving differentiated his experiences from those of many of his contemporaries. Approaches to pictorial representation in woodcuts were highly stylized, highly conventional, and strongly oriented toward traditional graphic concepts. The aesthetic tradition passed on to photography by the other graphic arts had a tight and personal hold on Martin. It is surprising, then, that his photographic images are refreshingly unstilted compared to what might have been expected. But there is a more significant way in which the woodcut can be seen to have affected the basic tenor of

his photography. A woodcut is a harsh, clear-lined, hard-edged representation of a subject. Soft focus or subtle atmospheric effects are contrary to its fundamental nature. Since Martin often employed his photographs as a basis for woodcuts, it is not surprising that he sought photographic techniques that his mind and his sharp knives could readily translate into the print medium. The greatest effect of his woodcutting trade on his photography, however, can be seen in his choice and treatment of subject matter. His selections were in distinct contrast to much of the accepted art-photography tradition. Woodcuts, for all their "woodenness," were in fact the best representation at the time of the ebb and flow of life in Martin's London and around the world. The hard lines of the wood block, however much fantasized and modified by the artist, still essentially showed life as it was. This is the essence—the very core—of Martin's significant photography, whether it be a

picture of a street vendor or the soft night lighting of the gaslight scenes. This was the everyday, the news and features that now pass by us constantly on our television screens and in our newspapers. Three decades after his productive period, Martin might have been a photojournalist in the classic traditions of people like Brassaï, Henri Cartier-Bresson, or W. Eugene Smith. In more recent times perhaps he would have been a television news cameraman. His orientation towards mass communication instilled in him an active documentary sense.

Martin produced most of his best work as an amateur, for the audience of the camera clubs and the ribbon-studded photographic exhibitions. He did achieve considerable success in this tight-knit little world. The pressures of conformity, enormously stronger in his day and place than in our own, warped and eventually swallowed the spirit of investigation in him. He was not a radical by nature—quite the contrary, he sought after convention and acceptance. He did not have the independent wealth that might have allowed him the mental and physical freedom to explore whatever area interested him. His amateur photography is somewhat like the boyhood photographs of Jacques Henri Lartigue, full of spirit and life—later corrupted by success into much more stoic representations.

Martin as an amateur photographer was unaware at the time of much of the real import of what he was creating. Most of his exploration was motivated by a desire for recognition. He could not equal, on their terms, the powerful figures that he joined in photographic societies with—men like George Davison and Colonel Gale, who are now largely, if undeservedly, forgotten, but who were absolute bastions of power and taste in Martin's day. If Paul Martin had worked in a small

town with no real competition he would probably have made only banal amateur landscapes and pictorials of little interest to anyone but himself. The several hundred photographs of his that we have examined that were taken after he left the camera clubs and started making photo buttons for a living are quite ordinary. They are the same type of vacation pictures that we all take from time to time, when we would really probably be better off buying a post card. In his most productive days, Martin chose to involve himself with the very competitive and stodgy photographic salons in London. He had to compete on different terms, with "oddities," just to survive. This was undoubtedly the reason for his exploration of such areas as night photography. As we have seen, his pictures of people on the street came partly from accessibility of subject matter within the confines of his job and partly from a desire to find subjects for his blocked-out lantern slides. He was not concerned with, or particularly sensitive to, the context of the background in these pictures. It is precisely this surround that makes the images so interesting today.

His camera, the simple Facile, with its very slow shutter, enabled him to achieve better technical quality than many of his peers. It also kept him away from commonplace freeze-action pictures. His sense of timing was superb. It had to be, for he charged himself with capturing candid action with exposure times often as long as a quarter-second in a camera that held only twelve shots.

A very important factor in his approach was his shyness—the desire to avoid the notice of the people on the street. His comments regarding "street urchins" and the discomfort shown when people stopped to talk to him during his night exposures betray a desire to remain removed from people. This immediately differentiates him from

several other well-known workers.

On the surface, Martin's pictures are similar to those of his contemporary Frank M. Sutcliffe, a well-recognized and accomplished Whitby photographer. But in Sutcliffe's photographs, termed "genre" pictures, the subjects were carefully controlled and asked to act out something similar to a scene in real life. Sutcliffe's very famous "Water Rats" is a clear example of this. In Sutcliffe's own words: "This soap box was too small to hold a dozen boys playing truant . . . the lads were sent to the other side of the harbour for an empty ship's boat . . . the big lad on the bow of the boat was most useful in pulling and pushing the rest of the crew into their places . . . the boys were paid a penny each."[149] Sutcliffe's is a fine image, made with a dry plate and a shutter, but could hardly be said to be an authentic, candid, documentary picture in the same sense as much of Martin's work.

Martin shared some characteristics with Eugene Atget, a quiet, shy Frenchman who worked in Paris about a decade after Martin's amateur period. Atget also documented street life, but employed a stand camera on a tripod. Martin and Atget shared an apparent comfort and naturalness in photographing working-class people. And they both produced pictures as records for others; Atget for artists and architects, Martin for woodcuts for the illustrated press. But Atget was far more concerned with subtle and complex visual relationships than Martin. He extended his efforts beyond pictures of people to pictures of the environment that people both created and lived in. Very little of this precision and insight shows in Martin's work.

There are also some similarities between Martin and Alfred Stieglitz. Stieglitz won his first big competition in *The Amateur Photographer*, three years before Martin won in the same magazine.

Both men became concerned with extending the range of the definition of artistic photography. Stieglitz did so out of a concern for establishing photography as a separate and equal fine art. Toward that end he is credited with many significant achievements besides his personal photography, such as the journal *Camera Work* and his famous "291" gallery. He soon was in a position of having people flock to him from around the world for counsel and was a dominant force in realigning photographic taste. Martin never achieved such power, nor did he have the ability or desire to captivate people as Stieglitz did.

Martin's concern with breaking with tradition in photography was more personal. He wanted to succeed, but on very modest terms. Both Martin and Stieglitz approached similar subject matter at so close a time as to make discussion of who was first meaningless. They both were enamored of the hand camera at a time when "serious photographic artists" shunned it. Stieglitz credited the bicycle craze with finally drawing the general public out of the fad of photography into a new fad, thus freeing the hand camera from some of its problem of excess public awareness.[150] Martin and Stieglitz took pictures under night and weather conditions that were considered impossible or not worth trying for. Both succeeded admirably. It is fascinating that two people so entirely different in character found so much common ground in their photographic interests.

It is clear that Martin was not a social crusader and probably was not much concerned with social issues. While his pictures may convey some of the same content, he was not a Jacob Riis. Like Riis, he showed his photographs of the working class in lantern-slide lectures before the public, but he did so to satisfy a nostalgic interest rather than a political one. The strength of his work lies in its

"Water Rats," by F. M. Sutcliffe, 1884.
"Genre pictures," typified by this fine example
from Sutcliffe, were widely popular in late Victorian
England. The overall appearance is similar to that of many
of Martin's images. There is an essential difference, though, in
that Martin's are true candid shots. Sutcliffe paid the
boys to go across the water and bring over the
boat, then used the services of the leader
to bully all the others into position.

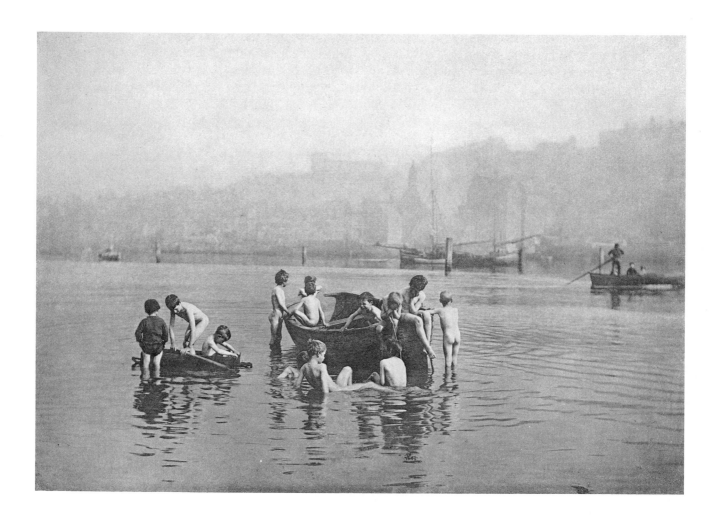

"The Urdey Gurdy Organ," by Paul Martin,
1893. Martin did not have the money to pay subjects
and also was very shy about meeting people. He blessed the
day that he acquired the disguised hand camera which freed
him from discovery by the street urchins. He did his
best work when the subjects were not aware
of his presence.

ability to record, not in the consciousness that he brought to bear. He was very sympathetic to his subjects. They were generally of the same class as he was, and all of his remarks betray an uncritical enjoyment of the life around him.

Paul Martin is unique because he was able to produce, under social, technical, economic, and personal conditions that would stifle most people, photographs that have that peculiar flavor of real life that is the foundation of true documentary work. His pictures are timeless, yet historical; casual, yet very accomplished. His body of work in total forms a miniature museum of the times in both the photographic and the real world.

Late Victorian London and Its People

by Standish Meacham

London's working class—the men and women of Paul Martin's photographs—was the subject of volumes of forthright scrutiny in the 1880's and 1890's. Social scientists and social reformers, public servants and private philanthropists joined to investigate and then to deplore the overcrowding and underemployment that produced conditions they argued were no less than intolerable. The English had learned to expect chaos and confusion in the wake of industrialization: Manchester, the "shock" city of the 1840's, had taught them that unsettling lesson. Yet, after mid-century, conditions in Manchester and in the other raw cities of the industrial north gave the appearance of improving, whereas, in the 1880's, the state of London seemed both appallingly bad and appallingly the same.

Andrew Mearns's *Bitter Cry of Outcast London*, published in 1883, awakened English men and women to the wretched lives of the majority of Londoners. Further evidence, compiled in the 1880's by individual investigators and by various public committees and commissions, testified to the extent of the destitution within the city and to a sense of general inability to do much about it. Two studies published at the end of the century, Charles Booth's majestic and innovative *Life and Labour of the People in London* (1896) and C. F. G. Masterman's impressionistic and almost despairing *The Heart of the Empire* (1901), suggest the dimensions of the problem as it was perceived by thoughtful men and women. Booth had undertaken a survey of London's East End in order to prove socialists wrong when they stated that 25 percent of the city's workers could not earn enough to live. What he discovered—that in fact one-third of London's working class endured life in a state of chronic poverty—failed to convert him to socialism. His conclusions, nevertheless, jolted him into a recognition that London's social

and economic illness was of such magnitude that it could only be cured by massive doses of state intervention.

Masterman's interest lay in understanding the psychological impact of London life upon its working-class inhabitants. He wrote of a deadening existence within what he called "the Abyss," the deteriorating landscape that spread from the city's inner ring of slums. "Like some gigantic plasmodium huge, blunt arms sweep forward, mansions are cut up into tenements, vegetation disappears, gardens vanish into long lines of small houses. . . . Soon the two arms it has thrust towards the west will snap together like a vise; a ring, shining not with jewels and gold, but illuminated, perhaps, though not to eyes too dull to see it, with the heroic patience of innumerable lives, will completely encircle the Imperial City." Masterman feared the new city breed the Abyss was casting up. Like other middle-class reformers, he called for social action to prevent social upheaval. He viewed the town dweller with alarm: "stunted, narrow-chested, easily wearied; yet voluble, excitable, with little ballast, stamina, or endurance—seeking stimulus in drink, in betting, in any unaccustomed conflicts at home or abroad."[1] Such an unstable creature, Masterman believed, might easily fall prey to the exhortations of political radicals. Better that the state expend the effort and money necessary to improve his lot than run the risk of destruction at his hands.

Paul Martin's photographs must be examined in the knowledge of this somber background of social diagnosis and prediction. Though there is evidence of misery and destitution in some—in the tattered clothing of street urchins or in the seamed, careworn face of a news vendor—most reflect a kind of sturdy good humor which was as much a part of Cockney life as were the monotony and destitution that worried the social critics. If

we look at Martin's photographs as we read Masterman's essay, we become aware that the two of them were unwittingly participating in an exercise one historian has called "selective Victorianism."[2] Masterman wrote to make his particular point and chose his evidence to suit that purpose. Martin photographed to make a far different kind of point, and it is well to understand his point as clearly as we can, if only to evaluate his photographs as evidence of life in late Victorian England.

Martin's interest in London's working class stemmed from his much deeper fascination with the processes and possibilities of photography. He was no Jacob Riis, whose photographs grew naturally from his anger at the conditions in which New York slum-dwellers lived. Nor was Martin a chronicler of city life in the fashion of the reporter Henry Mayhew or the photographer John Thomson, with whom he is often compared. Mayhew set out to record in minute detail the life and work of mid-nineteenth-century London laborers and succeeded in producing one of the most valuable social surveys in the English language, *London Labour and the London Poor* (1851–1862). Thomson, accompanied by professional reporter Adolphe Smith, attempted to repeat Mayhew's achievement on a far more modest scale twenty-six years later. Their *Street Life in London* (1877), while falling short of Mayhew's masterful account, was nevertheless conceived with a similar intention: to force the nation to look at life in London slums in hopes that awareness might produce change.

Martin was simply interested in taking pictures. His decision to move about the streets of London taking "cockney snaps" was the result of his fascination with the candid camera. He was an artisan whose craftsman's instinct and ability led him naturally from engraving to photography. His interest in "instantaneous" work, evinced at the very beginning of his career, drew him out into London for subjects. Living and working as he did in central London, what could be more natural than to walk the short distance into the lively and occasionally disreputable thoroughfares of working-class districts such as Lambeth? Had he wished to record the conditions of working people as a class, he would have carried his disguised camera into the alleys and courts of East London —the heart of Masterman's Abyss—or into the midst of trade-union demonstrations, which after the great dockers' strike of 1889 marched with regularity across the face of London. Instead it was expressions and occasions that attracted his attention, as they attract the attention of any devoted photographer. His claim to our interest today rests upon his ability to record the spontaneous, upon his success in capturing a face as it traced an emotion or an occasion as it absorbed the attention of its principal actors—the careless laughter of a holiday crowd, the immediate confusions of a street accident.

Spontaneity is the enduring point of Martin's photographs.[3] Historians can only remain grateful that he decided to make his point in the way that he did and with the people that he did. His work is as "valid" historically as are the committed social surveys of Mayhew and Thomson, Booth and Masterman. But, like those surveys, Martin's achievement must be read in terms of his intention, if it is to be read correctly.

To read correctly, however, takes more than an awareness of intent. We must examine those individual countenances Martin brings before us against a general understanding of the forces that shaped the lives of London working-class men, women, and children at the end of the nineteenth century.

*London. 1893. Three street urchins. Detail
of a photograph by Paul Martin.*

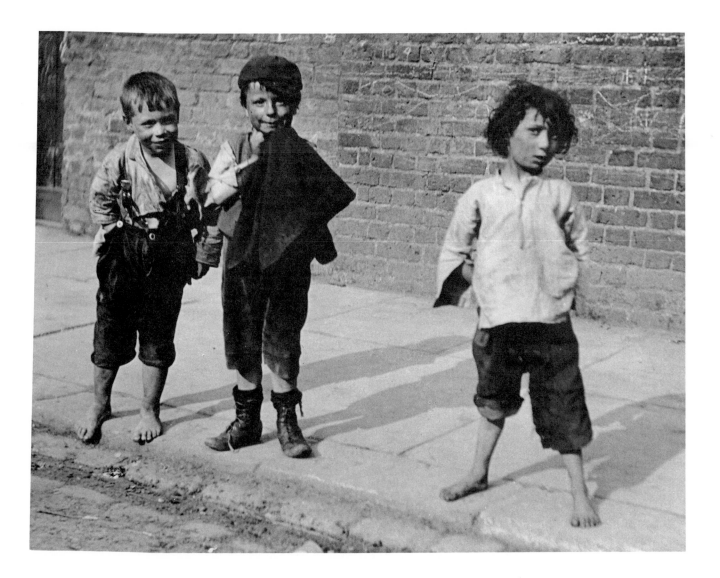

*Yarmouth. 1892. Part of the crowd
listening to the concert on the Yarmouth Sands.
Detail of a photograph by Paul Martin.*

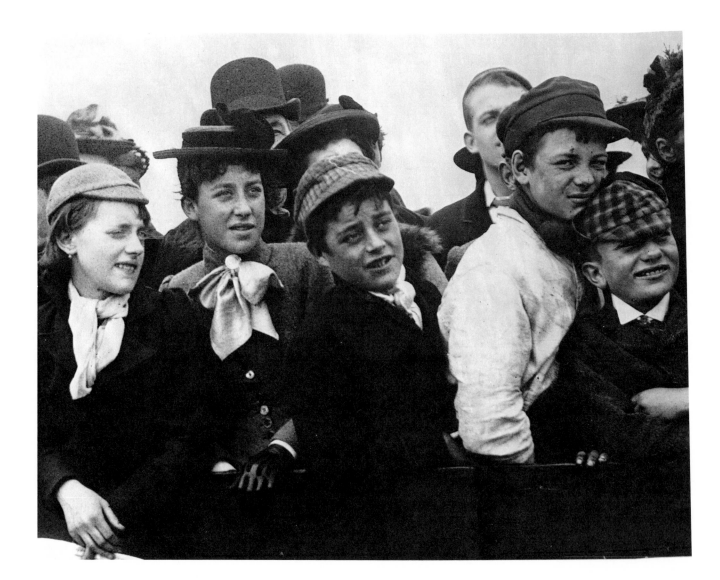

*London. 1894. "A Street Cab Accident in High Holborn.
Overturned Cab." Photograph by Paul Martin.*

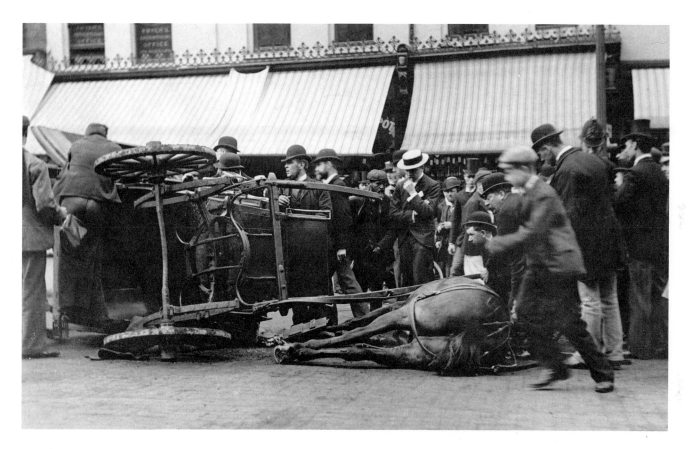

London employed more laborers than any other city in Great Britain. They worked at jobs and in trades reflecting the city's position as epicenter of the nation's political and social life and of the world's expanding capitalist economy. Unlike the towns of the north that had shaped themselves around large factories and often looked for their livelihood to one or two dominant industries, London was a place of small workshops and of special trades and skills. The several large-scale industries based in London before 1850 had moved elsewhere by 1900. Some left for lack of space, others because of steep rents and the scarcity of raw materials nearby. Still others sought to escape London's notoriously high wage bill. Engineering firms, tanners, printers, and bookmakers all moved their operations to the provinces, where conditions better suited their particular methods of mass production.

The exodus, as one perceptive historian of London, Gareth Stedman Jones, has observed, accentuated the "preindustrial" characteristics of London's economy.[4] Specialty trades concentrated their efforts on the London market, manufacturing goods in London for consumption there. In the wake of specialization came the increasing practice of "sweating," the putting out of raw materials to be made up into goods for sale, either in small workshops or at home. The invention of the sewing machine afforded petty capitalists a chance to

London. *1893 or 1894.* "*Carrying Cases of Oranges from
Ship to Warehouse.*" *Photograph by Paul Martin.*

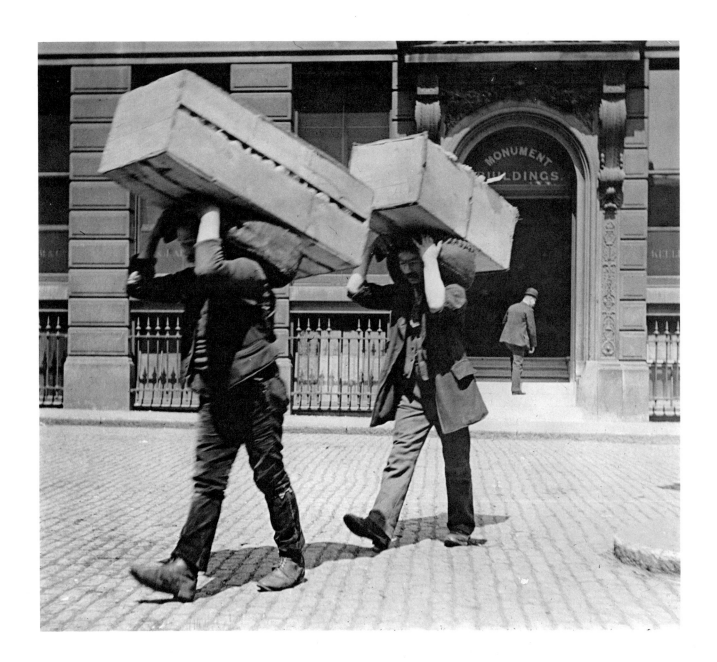

cut their overhead by farming out work, while insuring that workers would continue a prey to cyclical employment and low wages.

Cycles and seasons determined the patterns of labor for the majority of London's working class. A large proportion of the goods manufactured there were designed for a market patronized by a stylish or would-be stylish West End clientele. Furniture, clothing, jewelry, confections—all depended to a great degree upon fashion and upon season for their sale. Seamstresses, tailors, cabinetmakers, coachbuilders, cooks, and cabmen were bound alike to a cycle of employment that reached its peak in June, fell in August, rose again in October, and then slumped on through the winter months. Season also determined the patterns in London's other major industries—shipping and building. Coal, sent to London not to power steam engines but to heat houses, was a seasonal import. Grain and timber shipments into the port of London reached their peak in late fall, then fell away to almost nothing after Christmas. Builders who worked at their trade in the summer months often worked at something else or nothing at all in the winter, robbed by bad weather of a chance to practice their skill.

The result was a permanent epidemic of "casualization": underemployment, and the economic and social insecurity that followed as symptomatic corollaries. Employers estimated that nearly a quarter of those engaged in coal-portering represented a "casual," or underemployed, surplus. The figures were far higher among dockers. But in other, more traditionally skilled industries—shipbuilding, for example—the facts were much the same. As construction work gave way to repair work, and as the chance of a steady job dimmed in consequence, men who had grown up as skilled artisans with a particular trade found themselves dependent upon meager casual earnings. To sup-

plement their husbands' wages, wives undertook work in sweated industries, thereby contributing further to the chronic economic sickness of London's inner city.

Many hoped that wholesale rehousing of the poor might effect at least a partial cure. Departing industry had left in its wake an army of underemployed workers. If demolition and renewal were to deny many of them a place to live, might they not follow the only path open to them: out of London's central slums and into its working-class suburbs or away to another town? So reasoned politicians and businessmen, as they proceeded to rip the city apart to accommodate railways, docks, warehouses, and thoroughfares. Stedman Jones has estimated that almost 100,000 persons were displaced by the reconstruction that occurred between 1830 and 1880.[5]

Those workers who could afford to relocated themselves in areas like East Ham, whose population trebled itself every ten years in the latter part of the nineteenth century. Others, not so fortunate, found themselves scurrying into whatever habitation they could find, in the face of the relentless press of redevelopment. Nor was their plight the result alone of commercial and industrial entrepreneurship. The government, in an attempt to rid London of its worst slums and with them some of their most unwanted residents, passed an Artisans' Dwelling Act in 1875 designed to clear land and facilitate construction of workers' housing. Instead, the act produced further overcrowding and chaos. Those displaced were most frequently casual laborers: dockers, costermongers, hawkers—the men and women so frequently the subjects of Martin's photographs. They were the least likely to secure accommodation outside the central district where they had always lived and where they had to live if they were to find even casual employment. Nine years following passage of the act,

twenty-three of the forty acres cleared remained vacant. Most of the twenty-three thousand persons displaced crowded as best they could into already crowded districts close to the river. Lambeth, one of Martin's favorite haunts, accommodated many. Nearby Battersea, where Martin lived, experienced an invasion of its respectability by poor families squeezed a mile or so from the center nearer the periphery. One result was Martin's own eventual removal into lower-middle-class Clapham.

By 1900, Londoners lived within a general pattern of concentric economic circles. Booth produced a map with his survey, shaded from dark to light to illustrate degrees of poverty. The darkest areas—those with a poverty percentage of 70 or over—lie clustered together at the center. With one or two spotty exceptions, the rainbow strips of mauve, then rose, then pink reflect the demographic shape imposed upon London by the facts of its economic life. The result was a city of contrasts, rendered even more pronounced by the willingness of rich Edwardians to flaunt their wealth. "There was never in the history of the world," George Orwell without much exaggeration declared, "a time when the sheer vulgar fatness of wealth, without any kind of aristocratic elegance to redeem it, was so obtrusive as in those years before 1914."[6] Martin recorded little of this world of *luxe*; his photograph of "Society at Tea" at the Earl's Court Exhibition (Plate 93) catches a fragment. By choosing to take "cockney snaps," and thus to confine himself to cockney—or working-class—neighborhoods, he isolated his subject matter as effectively as London's economy had isolated its inhabitants. The rich lived in one place the poor lived in another. Their lives touched little if at all.

Martin's determination to capture faces and attitudes has given us photographs that only incidentally tell us something about the neighborhoods of working-class London. Marketplaces and parks attracted Martin, since there he could be sure to find a crowd of subjects to his liking. But streets, houses, and tenements appear only occasionally, and then as background to some lively, human episode. "Dancing to the Organ" (Plate 8), for example, shows a row of three-story houses, built, from the looks of them, sometime in the early nineteenth century. Originally one-family dwellings, by Martin's time they had most likely been cut into flats, to accommodate a clientele forced by circumstance to take what lodgings it could find. "A Policeman's Funeral in Lambeth" is shot against the grey, forbidding backdrop of what appears to be a model tenement, wedged up against a row of older, smaller houses, imposing grim authority along with heavy shadow upon the neighborhood it had been built to "improve."

Both photographs attest to a more general point: the extent to which population pressure in central London had pushed workers this way and that into whatever spaces could be found for them—or that they could manage to find for themselves. By 1890, many of the worst human warrens had been obliterated in the course of slum-clearance projects. London was a patchwork of the "ventilated" and the "unventilated," as the housing reformers put it. Some neighborhoods were close courtyards or "turnings" (lanes); others were blocks of flats or tenements; still others were stretches of monotonous two-story dwellings.

Middle-class visitors to working-class neighborhoods commented upon their "foreign" atmosphere: foreign, that is, to the comfortable suburbs to which the visitors would return. Sounds were different. In the more disreputable neighborhoods, children played noisily in the streets. The clatter of machinery, the hoot of a factory whistle, the rattle of a train across a nearby embankment meant that there was seldom stillness. Smells were

*London. 1892? "A Policeman's Funeral
in Lambeth." Detail of a photograph by Paul Martin.
Martin explained that the policeman, Constable Daniels, "died
whilst helping another constable to arrest a thief, by
his false teeth getting into his throat."*

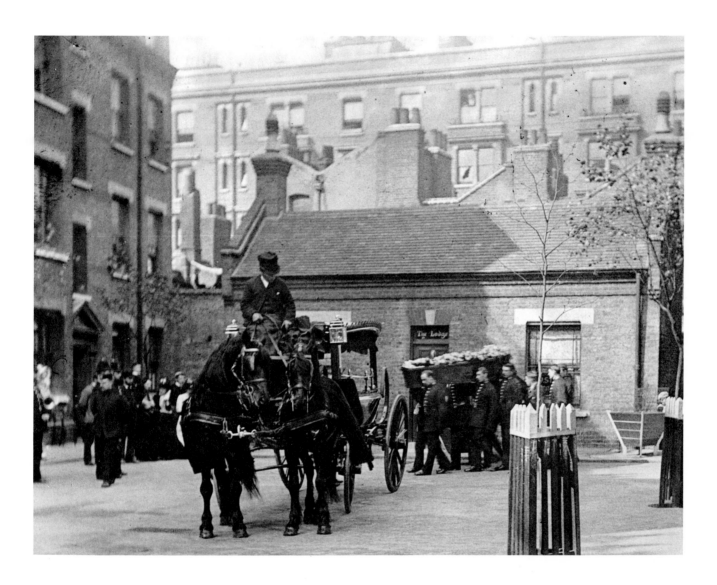

different too. Soap factories sent a sickly sourness into the air over one set of streets, jam factories an equally sickly sweetness over others. Outdoor earth closets were frequently shared by more than one family and emptied only occasionally by municipal authorities. In poorer neighborhoods trash found its way into the streets. More depressing was what one investigator called the odor of poverty itself, the smell of "grinding life, of shut windows and small, inadequate washing basins, of last night's rain, of crowded homes and long working hours."[7]

London's workers lived in houses that at best met their immediate needs and at worst contributed directly to their physical and psychological deterioration. Overcrowding remained the biggest problem. Booth found 109,390 Londoners living three or more to a room in 1889. Twenty-five years later critics lamented that England was continuing to do no more than "warehouse" its poor.[8] M. S. Pember Reeves, a social worker who surveyed South London in 1913, set out the facts of overcrowding with detail enough to suggest its effect in human terms:

Man, wife, and six children; four rooms; two beds, one sofa, one banana-crate cot. Wage 22s. One double bed for four people in very small room, crossing the window; cot in corner by bed. One single bed for two people (girls aged thirteen and ten years) in smaller room, 8 feet by 10 feet, with head under the window. One sofa for boy aged eleven years in front downstairs room, where police will not allow window to be open at night. The kitchen, which is at the back, has the copper [boiler] in it, and is too small for a bed, or even a sofa to stand anywhere.[9]

Houses such as these might be grouped about a central court whose most prominent features were the earth closet and the ash pits. The tiny rooms were often either too hot or too cold; window sashes made from cheap, green wood rattled as drafts blew in around them, or swelled shut to trap the heat and smell of eight human beings in four rooms. Water came from an outside tap or from one in the hall. Washing and cooking, hard enough in these cramped quarters, were doubly difficult when two families shared a kitchen. Scarcity of housing drove rents higher in London than in any other city in the country. Eight shillings a week— as much as a third of many working men's weekly wages—would pay for little more than three rooms and a scullery.

Skilled workers able to afford better accommodations might find them in one of the newer suburbs to the east. Here neighborhoods wore a different face. "Every house possesses a curtained bow window, and every curtained bow window a palm, and every palm emerges from the center of a china pot. Each door glistens with varnish, at any rate for a time, and boasts an immaculate letter-box surmounted by an immaculate brass knocker."[10] Streets were cleaner and quieter, their unbroken rows of houses imposing a terrifying monotony. Arthur Morrison evoked the landscapes in his collection of *Tales of Mean Streets*:

Of this street there are about one hundred and fifty yards—on the same pattern all. It is not pretty to look at. A dingy little brick house twenty feet high, with three square holes to carry the windows, and an oblong hole to carry the door, is not a pleasing object; and each side of this street is formed by two or three score of such houses in a row, with one front wall in common. And the effect is as of stables. . . . The hundred-and-fifty yards is only a link in a long and mightily tangled chain—is only a turn in a tortuous maze. This street of the square holes is hundreds of miles

long. That it is planned in short lengths is true, but there is no other way in the world that can more properly be called a single street, because of its dismal lack of accent, its sordid uniformity, its utter remoteness from delight.[11]

With the introduction of tenements into London, reformers and speculators managed only to substitute vertical for horizontal monotony. George Gissing, in his novel *The Nether World*, described the Farringdon Road buildings much as Morrison had described his street:

Vast sheer walls, unbroken by even an attempt at ornament, row above row of windows in the mud-colored surface, upwards, upwards, lifeless eyes, murky openings that tell of bareness, disorder, comfortlessness within. . . . An inner courtyard, asphalted, swept clean—looking up to the sky as from a prison. Acres of these edifices, the tinge of grime declaring the relative dates of their erection; millions of tons of brute brick and mortar, crushing the spirit as you gaze.[12]

Tenants objected not so much to the barracklike design as to the regulations promulgated to keep the army of inhabitants in line. They were forbidden to let rooms to lodgers, to wash any but their own family's clothes in the communal laundries, to allow children to play on staircases and balconies. At the same time proximity afforded them little escape from fellow tenants whose habits might mark them as less than ideal neighbors.

The ideal neighbor "kept himself to himself." What appears a paradox was in fact a successful formula derived over generations by men and women forced to live without much distance between each other. Denied the sustaining benefits of a welfare state, the working class naturally relied heavily upon kinship and neighborhood networks to help guarantee economic and physical survival. Crises of sickness and unemployment were more easily endured with the assistance of relatives or friends. Friendship, however, did not mean intimacy so much as it meant reliability. A housewife had little inclination, because she had so little time, to "cultivate" a friendship. Neighbors did not visit back and forth. There was precious little room for even one additional adult in most working-class kitchens. Women were reluctant to open themselves or their houses to close inspection. Poverty compelled too many makeshifts; unrelenting hard work brought with it too often a sharpness of mind and temper that could not easily accommodate to the affability and affections that friendship—in the accepted middle-class sense—demands. A good neighbor kept to herself until that emergency that required her assistance. Then she offered it, whether a cup of sugar or a night of nursing, knowing that custom would insure repayment when it came her turn to ask.

Custom of that sort could take root only in neighborhoods of long standing. In the last years of the nineteenth century and the early years of the twentieth, when so many London working-class families were on the move, many a wife, new to a particular district, was left to face emergencies with no one but her immediate family to rely upon. A 1915 survey of the experience of working-class mothers in childbirth elicited the facts of isolation and loneliness in a dramatic fashion. "I had spent all my youth in the country," wrote one respondent, "and came as a stranger into a strange place, knowing no one but the man I married."[13] The poorer a family, the less its chances to settle for long in any one place. Households followed in the wake of a wage-earner's search for employment, or, in times of desperation, moved off one jump ahead of the rent-collector. Even when the very poor settled in one place, they could seldom

afford the investment of energy necessary to establish themselves as part of a neighborhood; hardship—and pride, as well—forced them back upon themselves.

The task of binding a neighborhood together was subtle and time-consuming; its accomplishment was left to the women, who attended to their work at one or more commonly acknowledged meeting places: a nearby open market, a corner shop. Dingy and often unpleasant in themselves, they took on a liveliness, even an excitement, when awash in humanity. "Hideous buildings that try to hide themselves in the shadows," wrote a visitor to one Saturday-night South London market in 1909. "Flaring hissing tongues of flame and glimmering feeble lamps that tear them from their hiding place; row after row of coster barrows weighed down with tempting or deceitful offerings; line upon line of shoddy shops where reeking masses of meat and vegetables and over-ripe fruit poison the air, and women struggle and fight for tomorrow's dinner."[14] The Saturday night tableau lost its sinister cast in the light of Sunday afternoon. Booth had earlier described another nearby marketplace: "Flowers smartly arranged for bouquet or buttonhole; fal-lals of ladies dress and cheap jewelry for either sex; patent medicines or racing tips; tame rabbits or fancy birds. . . . Those who 'think it fine to walk up and down with a fowl under each arm,' and perhaps a flower between their teeth, and who spend money gaily, have probably pushed a barrow themselves all the week."[15] Descriptions such as these breathe life into our understanding, much as do Martin's photographs. We hear, just as we see, women squabbling at the stalls, young blades calling to their girls. Common vitality and good-humored toughness kept neighborhood life from sinking out of grimness into despair.

Markets were for weekends; for everyday communion, women used the corner shop. Here, in what the writer Edwin Pugh called "small-talk exchanges," householders established useful connections. Meeting on common ground, they took each other's measure, not only as to favors they might do for each other, but also in terms of comparative respectability. Mutually agreed-upon standards of what was "respectable" and what was, by contrast, "rough" held a neighborhood together, by allowing it to form a good opinion of itself. Respectability was not always gauged in terms of weekly wages, although to achieve it on twenty shillings a week was far harder than to achieve it on thirty. To be respectable was to put the best face possible upon the dreary certainty of semi-poverty, by scrubbing the doorstep and struggling to stay out of debt. Respectable families forced to live in neighborhoods considered to be rough worked with a special will to keep to themselves, until such time as they could move to a more respectable quarter. They subscribed to a carefully constructed litany of don'ts: no swearing, except perhaps on the job; no drinking, except perhaps a pint or two of beer on weekends; no gambling; no noisy quarreling—indeed, no public actions of any sort that might draw attention to their presence in a street or neighborhood where they believed they had no business and from which they hoped to escape as soon as they could.

The contest was fiercest on those blocks where rough and respectable lived side by side. Robert Roberts, whose memoir of his own childhood in a Manchester slum depicts the life there with clear-headed perception, describes the system of constant re-evaluation.

Drunkenness, rowing or fighting in the streets, except perhaps at weddings and funerals (when old scores were often paid off), Christmas or bank holidays could leave a stigma on a family already

registered as "decent" for a long time afterwards. Another household, for all its clean curtains and impeccable conduct, would remain uneasily aware that its rating had slumped since Grandma died in the workhouse, or Cousin Alf did time. . . . In this lay much envy (envy was the besetting sin), bitterness and bad blood which, stored up and brooded over, burst on the community in drunken Saturday night brawls. . . . Pursed-lipped and censorious, the matriarchs surveyed the scene, soaking it all in, shocked by the vulgarity of it all, unless, of course, their own family was engaged. Then later, heads together and from evidence submitted, they made grim readjustments on the social ladder.[16]

Few wished to climb the ladder into the middle class. Pursuit of the respectable did not force men and women to deny their working-class consciousness. Maintaining respectability was no more than maintaining self-respect. Living with constant economic uncertainty, families needed to reassure each other with a set of familiar social prescriptions. "Do this," "don't do that," they instructed themselves, "and you can hold your head high, no matter how poor you are."

The code of respectability wove itself into a larger pattern of assumption and ritual that helped give working men and women a sense of themselves as a class. Many of the assumptions had their basis in economic facts. Ritual helped sustain these people in the face of those facts. Recollection of former days in tales retold and events recalled persuaded them of their ability to endure. Habits of daily work and celebration of seasonal festivities defined their lives for them in terms of a comforting, rhythmic predictability. "There is a rhythm," Richard Hoggart writes,

but it is the rhythm of a brick world, to which those of the seasons or of the great religious festivals are only incidental. At each weekend, perhaps, there is Friday night's shopping with Mother down a shopping street that is all bustle and warmth and gregarious spending, and the trains rattle and flash past constantly. There is the whole weekend ahead, with the pictures on Saturday, or a chapel concert with a hot supper in the Sunday school room; bacon and eggs for Sunday breakfast, the big Sunday tea. Then, throughout the year, Pancake Tuesday, Voting Day, which is always a holiday, Hotcross Buns on Good Friday, the Autumn "Feast," Mischief Night, and all the weeks of cadging and collecting for Bonfire Night. It is a truly urban fire, with very little wood that has known a tree for the past few years. . . . As the fireworks run out, you bake potatoes round the fire's edges.[17]

The London working class in the years before the First World War lived on the defensive. Technological change further jeopardized the position of skilled workers,[18] their livelihood already threatened by patterns of increasing casualization. State intervention, though designed to assist the worker, instead as often confused him, as he tried to thread his way through the alien maze of middle-class bureaucracy. Leaders of the working-class agitation that in these years manifested itself in bigger unions, more strikes, and the establishment of an independent Labour Party spoke of progress and a brighter future. Not so their rank and file. The people in Martin's photographs picketed and voted because of what had been, not because of what might be. Their lives denied them the luxury of optimism. Most managed to escape despair. They did so armed with a fatalism that looked backward; history promised only that, if life got a bit better one day, it might get a bit worse the next. "It'll be all the same, all the same, a hundred years

from now"; that popular music-hall refrain mingled hope with expectation. Martin's men and women, living at the mercy of pressures and events over which they had no control, depended on routine and habit, ritual and rhythm for security and certainty they could find nowhere else.

Confronted by the compelling evidence in Martin's photographs, historians will not unnaturally be tempted to compose verbal "snapshots" of their own, as an accompaniment to Martin's. The four which follow are not, like his, taken from life. They are composites and for that reason are not "true." Yet they embody many of the truths about life within the London working class. They illustrate the manner in which the general conditions of London working-class existence shaped the lives of those actual men and women who did really exist, and whose habits and expressions Martin has preserved for us. They are an answer—by no means the only possible answer—to the questions one is bound to ask when looking at Martin's work: who were these people; how did they live; and what did they think? [19]

The woman edging close to the egg stall in Martin's photograph of the New Cut Market in Lambeth appears to be a respectable sort. She has fastened a beribboned hat upon her head; she wears a jacket and not a shawl. If it is Saturday, she has come with a portion of her husband's wages to shop for a Sunday dinner and for the coming week. Her house is in nearby Wootton Street, two blocks to the north and one block south of the elevated tracks of the Charing Cross Railway. She dislikes the street; it harbors far too many disreputable families and lodgers who together have given it a bad name. Yet she acknowledges to herself that she would have to look hard to find more spacious accommodation than she now en-

joys for the rent she pays: four rooms and a scullery for eight shillings sixpence a week. The rooms are small: the largest ten feet by ten feet six. She, her husband, and their four children squeeze themselves each night into two of the three bedrooms: husband, wife, and eight-month-old baby into one; two girls and a boy, aged two, four, and five, into a second. The third bedroom is let to a quiet lodger for two shillings. Her sister, who lives farther to the south in Peckham, has urged her to take a house in her block that has come vacant for the same rent. Although in a more respectable neighborhood, it contains one bedroom less. Nor is it near the brewery where her husband now works; his transportation back and forth would become an expensive problem. Much as she would welcome escape from the loneliness of her life among "rough" neighbors, and enjoy the companionship of her sister, she recognizes the economic advantages of Wootton Street: the lodger's two shillings; the proximity of the brewery. For the time being she will stay put.

She prides herself on her ability as a good manager. She acknowledges, at the same time, the debt she owes her husband for his steady job. Without his twenty-nine shillings week in, week out, her resolve to keep the family out of debt would amount to no more than constantly broken promises to herself. She thinks of the pathetic young girl next door whose docker husband may bring home as much as forty shillings one week, but as little as fifteen the next. Easy enough to advise her to save from a big pay packet; difficult advice for her to follow, with her sickly baby needing expensive fresh milk and her rowdy husband as often as not keeping back as much as six or eight shillings for drink. No wonder the girl is so often at the pawn shop.

There was a time when she feared that drink might bring her own family down. Until two years

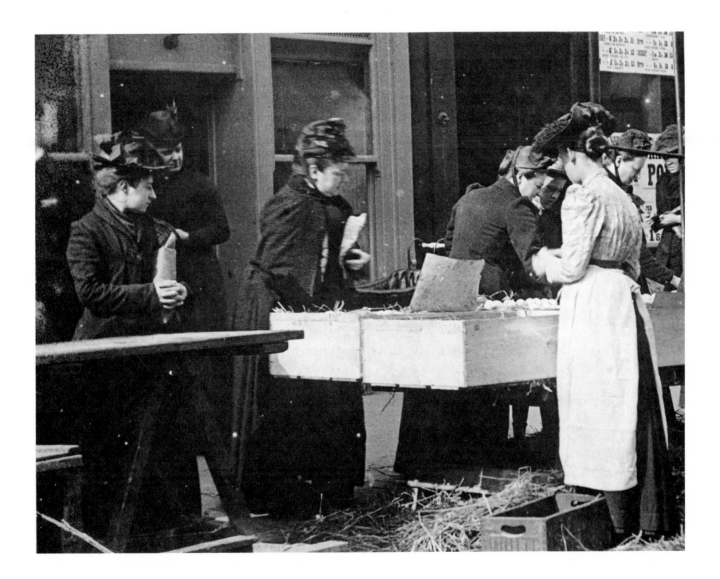

London. 1892 or 1894. Market stalls in the New Cut. "New Laid Eggs." Detail of a photograph by Paul Martin.

ago, the brewery countenanced a long-established custom of allowing its workers a glass of gin to start the morning. That practice, and the free ration of two quarts of beer per day given to every employee, had pushed her husband to the edge of chronic alcoholism. She had for a time tried to sympathize and then to ignore the problem. He is a "stageman," working on the "stage," or brewery floor, forced to clean out the steaming mash tuns, exposed to extremes of heat and cold. Though a big man, he is exhausted at the end of a twelve-hour day—six in the morning until six at night. He argued that without drink he could not stand the pace. She understood, but understood as well that unless he stopped they would all go under.

Two unrelated circumstances have now brought a partial change. Two years ago, she presented her husband with his first son. His pride in that fact led him to resolve once more—as he had on many a previous repentant occasion—to cut down on his drinking. His determination was aided when the brewery owner's daughter, a socially conscious disciple of Charles Booth, persuaded her father to substitute early morning coffee for early morning gin. The stageman now limits himself to three pints of beer each workday. Weekends he drinks twice that much and more at his pub. His wife, thankful for the improvement, accepts his moderated soaking much as she accepts the less than welcome attentions he pays her upon his return home Saturday night: as part of the bargain that is marriage. She tells herself she has struck a good bargain. She can depend on his steady income; she need not go to work herself. He treats her considerately, mends the children's shoes, cooks and carries meals to her when she is confined. She would look blank if asked: "Do you love him?" But she cherishes the unacknowledged affection they share for each other. And she seldom tries to imagine how she would manage without him.

From his income of twenty-nine shillings he has as usual this Saturday withheld three shillings for drink and tobacco; the rest he has handed his wife. She has set aside the eight shillings sixpence for rent, three shillings for fuel and clothing, and another sixpence for the burial society to which she belongs. (Even in those years when her husband kept back far more than he does now for drink, she never missed a payment. Provision for "decent" burial helped her maintain her self-respect.) Adding her lodger's two shillings to what remains, she has left home to purchase a week's food with sixteen shillings. Her budget will allow her the luxury of a roast for Sunday dinner. She will stew leftovers with vegetables for one or two more noonday meals. Faggots of pigs' entrails, cooked with rice, are a favorite with her husband. She likes to give him that dish at least once a week. By Thursday or Friday, she may find herself serving meatless dishes—a pudding with vegetables. She can recall only two occasions when she was reduced to serving nothing but bread, butter, and tea: both times when her husband had been too sick to work for a week or more.

Last week she worried for a day or so that she might be forced to bread and butter once more. Her husband and the two oldest children came to her with a request for new shoes. She had six shillings saved for such an emergency; but work boots for her husband cost nine. In the end, he managed to patch up the children's to last a month or two, and to find a secondhand pair for himself within the budget. Because she can spend no more than three or four pounds on clothes per year for herself and her family, she has learned the art of making do: turning collars and cuffs; looking out for secondhand bargains. Her hat is the one extravagance she has recently allowed herself: two shillings sixpence brand new. Her jacket is a gift from her

London. 1893? *"The Swing in Our Alley." Detail
of a photograph by Paul Martin.*

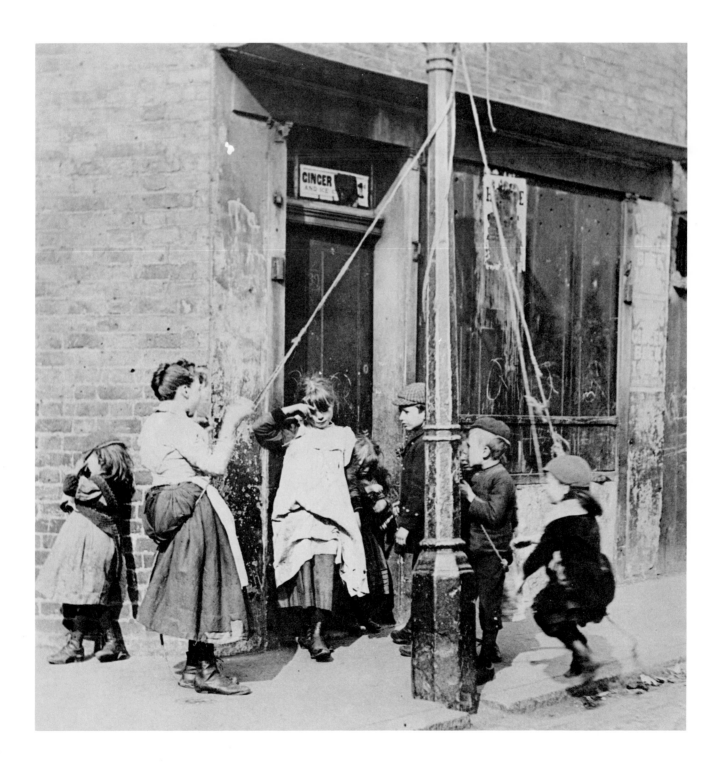

sister, who had it in turn from a woman to whom she was once lady's maid. The sister, who is pregnant, is too stout for the jacket and passed it on.

Saturday shopping provides a break in the housewife's routine, which seldom varies. Cooking, cleaning, and caring for her children occupy her time from five in the morning, when she rises, until ten at night, when she retires. Because her kitchen is equipped with a built-in range—oven, broiler, and grates—she is able to bake at home and save money doing so. Yet, because there is no living room but the kitchen, she has little space to spread herself when cooking, and even less when doing the weekly wash on Mondays. Despite the unceasing and unvarying nature of her domestic labors, she does not particularly resent them. She looks forward to the day when her daughters can give her more help; not simply because she will welcome their assistance, but because she knows she will enjoy the chance to pass her housewifely skills on to them. She realizes that she is too often short-tempered with the children when they dirty the house she tries so hard to keep clean and "decent." Yet she is fond of them, proud of them, and willing to indulge them when time and money allow.

She is most at peace with herself when polishing her front step. She wields the sandstone as an artist might wield a brush; indeed, she considers her polished steps—by far the whitest on the block —a work of art. Every Saturday morning, her task completed, she rises, puts her hand to her aching back, smiles briefly in satisfaction as she glances up and down the street, then turns into her house and shuts the door.

The two street vendors—costermongers—snapped at the Islington cattle market discoursing on the finer points of their "new purchase" are cousins and partners in a trade passed to them by their fathers, who had it in turn from their father. Together they own three barrows and two donkeys— this new one a replacement for a beast deemed no longer fit for service and sold off a week ago to the knacker for disposal. Each man works the streets with a barrow and donkey; the third barrow they rent to an acquaintance.

Costermongers, by tradition, enjoy membership in a closed society; these men are no exception. They have inherited not just a calling and the equipment to pursue it. They are heirs as well of a web of presumptions and prejudices that extend back through generations into preindustrial custom and tradition. Mayhew described London costers of their grandfather's generation as members of wandering tribes living among a more generally stable working-class population. He discovered they possessed values that differed markedly not just from those of the middle class but from the code of the "respectable" poor as well. The cousins' grandparents never bothered to marry. They felt no shame for having failed to do so; more than half the children in the turning in which they lived were raised in families united without benefit of clergy. They were almost all costers, hawkers, or porters on that street, a community bound together, despite frequent arrivals and departures, by shared understandings and uncertainties.

The cousins retain this sense of themselves as part of a world within a world, resenting the growing invasion of their calling by casual laborers. They pity them and at the same time laugh at their pathetic ineptitude as they attempt to master a trade these men now practice by instinct—knowing when to expect the first of the very cheapest fruit; how long it can safely be kept without spoiling; where favorite customers live; which thoroughfares are safe from unfriendly police.

No policeman is a friend. Mayhew wrote in 1851

London. 1893? Costermongers at the Cattle Market. "The New Purchase." Detail of a photograph by Paul Martin.

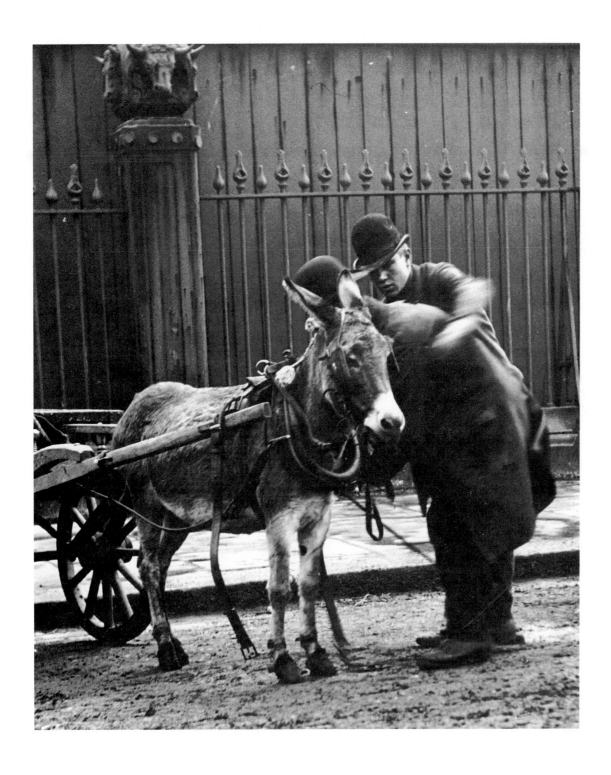

of the coster's pride in his ability to "serve out"—to beat up—policemen.[20] Police invaded a man's privacy to tell him he could not gamble, or carried him off to jail for taking too much to drink. Far worse, police bullied costers at their work, forbidding them to set up their pitch where they wanted, compelling them to move on, confiscating their barrows, and fining them as much as ten shillings for obstructing traffic. They were shock troops in an army of "Them"—the governing class, the almost palpable presence that forever threatened the existence of "Us." "They" turned the grandfather and grandmother out of lodgings in Drury Lane to make way for Model Dwellings no coster could afford. The tale of that removal, away from convenient proximity to Covent Garden market, and of the financial hardships the family suffered in consequence, are part of a tradition that fuels the cousins' active antagonism toward "Them" in general and policemen in particular. It took a generation to reassemble kin within the same neighborhood. Now the cousins live near each other and inside a colony of aunts, uncles, brothers, and sisters. One cousin, married and with two children, occupies three rooms on Great Queen Street. The other, unmarried, lives with his widowed mother in a ground-floor flat in Smarts Buildings, off High Holborn. The rooms are unpleasantly dark, but one is large enough to permit storage of the two barrows and whatever stock may remain unsold at the end of the day.

To make money, costers must know what to buy, when to buy it, and where to sell it. They must be early at the market to spot bargains in fruits and vegetables. They can afford only the cheapest goods, since their working-class customers can likewise pay for nothing better. A strawberry seller, interviewed in the 1870's by Adolphe Smith, described the precariousness of the coster's trade: if he could purchase cheap stock and sell it all off within the day, he could clear a profit. If not, he might do well to break even.

Strawberries ain't like marbles that stand chuckin' about. They are wot you may call fancy goods. On a 'ot night I'd rather sell 'em than eat 'em! You should never let 'em know you've got fingers, leastwise fingers like mine—all thumbs. They don't like it. They must be worked without touching, and kep'—them on top—as fresh as they was pulled. They won't hardly bear to be looked at. When I've got to my last dozen baskets they must be worked off for wot they'll fetch. They gets soft, and only want mixin' with sugar to make jam. They won't stand a coster's lodgin', not a single night. They like it so bad you'd find 'em all muck and mildew in the morning. There's no trouble in sellin', folks will buy anythink if its cheap and can be swallered. I can tell you in these times my profit goes like winkin'.[21]

When the cousins set themselves up at a pitch, as part of an authorized or unauthorized street market, they must keep an eye on competition. As the only costers with raspberries or red currants to sell, they are in luck. When others arrive with more of the same, they must adjust their price accordingly, to insure that they are not left at the end of the day with goods that no one will want tomorrow.

During the winter, the costers adapt to the season by selling whatever wares they can obtain. Toys, cheap knickknacks, bootlaces—goods of this sort tide them over. Both rely, as well, upon their membership in a "drawing-out" club, an institution which their fathers helped organize. Capital subscribed during the summer is withdrawn at interest at slack times. Profits are shared out in the form of food and drink at a Christmas-time celebration; the local publican who keeps books for the

men offers them the use of his rooms for the occasion. More prosperous than most costermongers by virtue of their inheritance, the cousins earn nearly forty shillings per week in the summer months, about twenty-five per week in January and February. They accept uncertainty as part of their calling. Experience has given both of them a sense of timing and an understanding of human nature they recognize as essential to the successful practice of their trade. But both agree that all they know would be as nothing without their rightful share of luck.

"Baby, feed the swan!"* Father and daughter enjoy their ritual Sunday stroll in Victoria Park. The one large patch of green on the map of East London, the park is a place where working-class families can enjoy themselves unselfconsciously among their own. "No West-End face is to be seen there, no well-dressed man or woman; only workers bent on enjoying their one day of relaxation, on making the most of the few hours they can call their own during the week."[22] Martin's photographs of the Sunday church parade, with gentlemen in top hats and women in fashionable dress, establish that the park is, in fact, a retreat for more than just the proletariat. Booth's map shows middle-class neighborhoods to the north—Groombridge Road, Penshurst Road, Southborough Road: the homes of the stylish promenaders. To the south and east, however, lie Bethnal Green, Bow, Mile End, and Old Ford, rows of working-class houses pressing to the edge of the park, streets of families for whom the park means a chance to stretch a bit, to look at a tree, to purchase an ice, to run with a pack, to sit by yourself, to make mischief with friends—or to feed the swans with your baby daughter.

*See photograph on page 100.

Father is a cabinetmaker, living with his wife, baby, and two older children in Parmiter Street, two blocks west of the park in Bethnal Green. His workshop lies a mile farther to the west, on Gossett Street, at the center of the Bethnal Green furniture industry. He is a skilled worker; a "first-class journeyman," he would call himself. His employer acknowledges the fact with a wage that seldom falls below forty shillings a week, more than that of any of the other fifteen workers in the shop, and more than all but about twenty cabinetmakers in Bethnal Green now earn.

The workshop is one of the very few still turning out well-designed, carefully made pieces. Competition, resulting from an increased demand for cheap goods, has brought the failure of several workshops in and around Gossett Street over the past few years. Friends of this cabinetmaker, his equal as craftsmen, now work for as little as twenty-five shillings a week in nearby factories; others for even less as chairmakers. He too has had to compromise with competition. Not for over a year has he built furniture to his own design. He works to standard patterns; originality, his employer remarks with a sigh, no longer pays. Neither does the use of quality stock. Once he veneered with only the best Spanish mahogany on a mahogany base; now he veneers with a cheaper mahogany on deal (pine).

He does not blame his employer. Indeed he knows that the man's weeekly profit from the business is generally only four or five shillings more than his own weekly wage. He respects the man as an honest businessman and as a craftsman as well. He was apprenticed to him twenty years ago; from him he learned to do what he now does so well. No more apprentices in the shop now; no apprentices anywhere in Bethnal Green. Boys manage to "pick up" enough in a year or two to turn out the sort of rough work that passes for

London. 1897 or 1898. Victoria Park. "Baby,
Feed the Swan!" The lake was one of the park's chief
attractions. Detail of a photograph by Paul Martin.

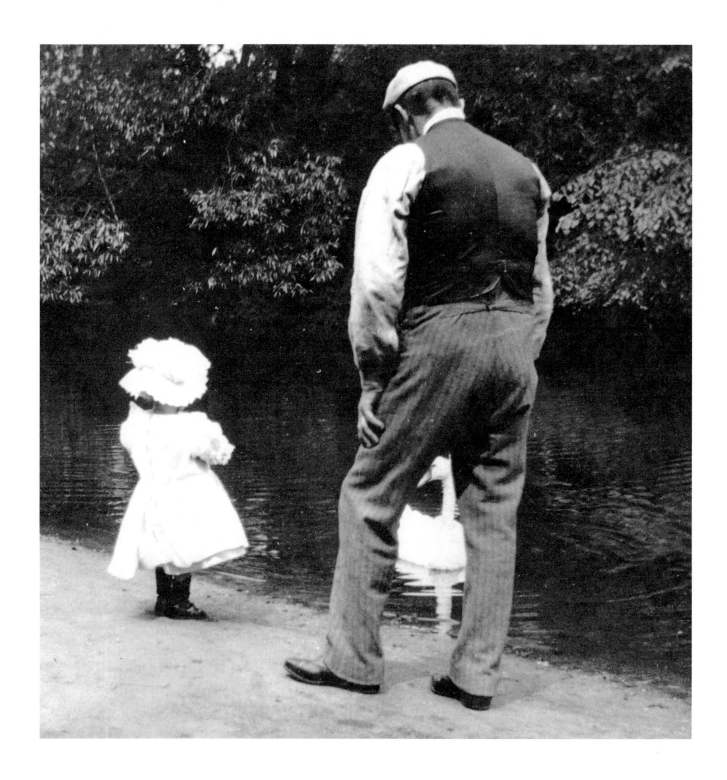

London. 1895 or 1898. Victoria Park. "Waiting for the Signal to Bathe in the Lake." Photograph by Paul Martin.

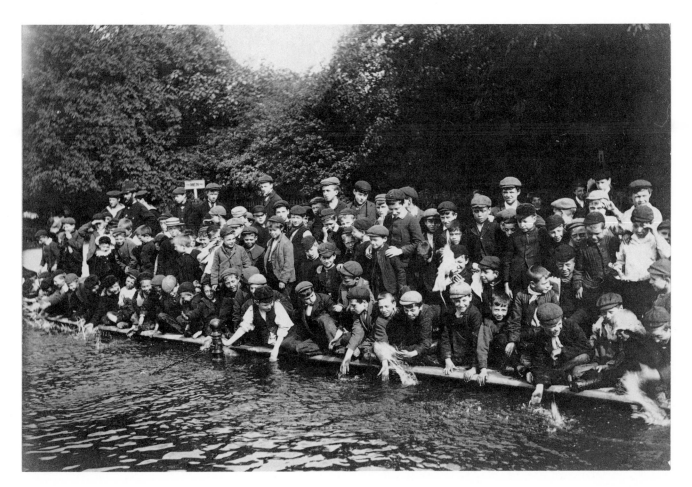

cabinetmaking these days.

Who is to blame? He does not really know. He wonders if his union, the Alliance Cabinet-Makers Association, might have tried harder to keep factories to the older standards. But he acknowledges that a union of only seven hundred men could hardly have stemmed the changes that he fears will eventually overwhelm him, as they have his acquaintances. His employer is fifty-six. He is in good health; but he won't last forever. What then? Who will inherit the business? Will the business be there to inherit?

It's no one man's fault; it's the fault of the sys-

tem. He has taken to attending meetings of the local branch of the Social Democratic Federation. Competition is the result of capitalism, they tell him; socialism is the solution. The argument appeals to him. He is impatient with the Liberals, for whom he has voted out of habit. Workers must think for themselves and no longer depend on the middle class to do their thinking for them. He finds himself agreeing, and vows to join the SDF next week.

He notices that it is past two o'clock and time to walk home for Sunday dinner. His worries fade as he anticipates the meal his wife, with the help of

their two older daughters, has been preparing. He senses, although he does not consciously acknowledge to himself, that the unvarying routine of Sunday after Sunday is a celebration of his role as breadwinner and head of the family. It is a day dedicated to him. He is never wakened, as on other mornings. The children, after a hushed breakfast, are shooed out to a nearby Baptist Sunday School. Their mother admits she encourages their attendance as much for the peaceful interlude their absence imposes upon the house as for the instruction they receive. She herself does not rest, however. She dusts the front room, which she aired on Friday and which will be opened to the family this afternoon as it is each Sunday afternoon. Her husband stirs; she returns to the kitchen to prepare his breakfast of bacon, eggs, and toast. She will have a cup of tea with him as he eats. Both enjoy the chance to talk by themselves. The children return. He departs with the baby for his walk. She sits with her older daughters, who have changed into work dresses, and together they peel vegetables for the dinner. The joint goes into the oven at twelve; the pudding at one. Mother and daughters retire upstairs to freshen up and change into Sunday clothes. Father and baby return. The family assembles together in the kitchen. Mother carves and serves—her husband first, then the children, finally herself. There is little conversation. After dinner father removes to the front room with his paper while mother and children wash up. They join father, who is asleep, the paper over his face. He awakens and asks the eldest girl to play him a tune on the piano. She obliges, then asks to be allowed to run off to the park. She knows the answer. She may go, but only if she agrees to take her sisters with her. They depart. Silence descends; father sleeps on; mother mends.

The pattern repeats itself Sunday after Sunday. Its sameness reassures not just father, but mother as well. She is content to acquiesce in this ceremonial acknowledgment of her husband's lordship. She is secure in her place at the heart of her household. She does not begrudge him his place at its head.

The girl of seventeen, celebrating Bank Holiday by dancing to mouth-organ music on Hampstead Heath, tries to forget that tomorrow she must be back at work. She accepts her job in a South London jam factory as something she must put up with in order to enjoy herself in the evening, on weekends, and on occasions such as this one, when she dons her plush and ostrich-feather hat, her fringed jacket, and kicks up her heels with her girl friends. Though she gets no particular satisfaction from her work, she stays with it for the money it brings her—nine shillings a week, about the average wage for women in the confectionery trade. Her routine is monotonous, though it varies with the seasons. From January until April she works with lemons and oranges, sometimes on the squeezer, sometimes on the pulper. The rest of the year she spends either filling, covering, or labeling jam jars. Her neat, quick work, now almost second nature to her after four years, leaves her foreman little to complain of. She nevertheless dislikes and mistrusts him. He is a spy set upon her and her coworkers by the boss. He is fresh with the girls— though not with her any more; she has put him in his place. And he is too ready to fine them for what he says is carelessness but what she and her friends argue can't be helped when human beings are made to do the work of machines.

The factory is not a pleasant place to work. The smell of boiling jam sickens her. She hates to be put to pulping. No one bothers to clean the pulp hole from week to week; its stench keeps her from her dinner. With all the monotony and unpleasantness, though, she'd far rather spend her days in

London. 1896 or 1898. "Bank Holiday on
Hampstead Heath." Detail of a photograph by Paul
Martin. Martin noted an excerpt of the festivities: " 'appy
'ampstead. 'ere's 'arriet wot ho she bumps
on the earth."

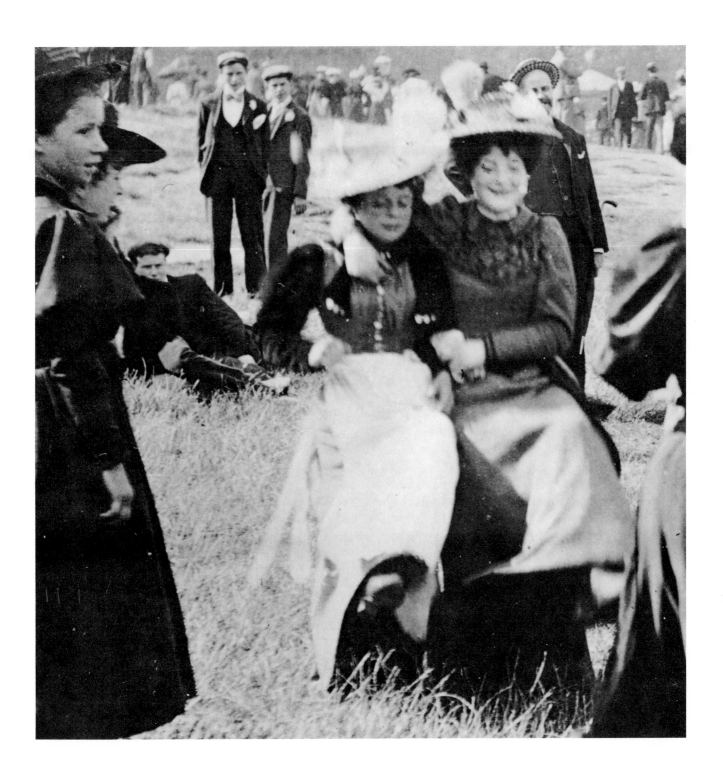

the factory than at school, her only other experience of life away from home. The discipline and drudgery of those days were unrelieved. Classes in cooking and needlework, introduced by a "progressive" school board in hopes of arousing her interest, instead mystified and later antagonized her, since she was being taught to prepare dishes never eaten in working-class homes and to sew clothes few working-class families could afford.

The end of school meant the beginning of a life of freedom in the world of adults. Her mother had briefly contemplated sending her out to domestic service; a neighborhood acquaintance had heard of a place in a household not more than two miles away and reputed to be thoroughly respectable. But she would have none of it. She had not emerged into freedom only to don the hated cap of a parlor maid. Besides, she'd heard stories from a cousin about what young men of "respectable" upper-middle-class families expected of young servant girls, and she fancied that sort of business not at all. Before her mother had had a chance to pursue the plan, she took herself off to the jam factory where two friends already worked and signed herself on.

Four years later she is still living at home in Lambeth, paying three shillings sixpence of her nine shillings each week for her share of room and board. She is pleased that her contribution has made life easier for her mother, who must budget for a family of seven on a total of thirty-two shillings. A younger brother, out of school as well, finds occasional jobs for himself as a messenger and adds a shilling or two to the total when he can. She expects to use her influence to find her sister a job in the factory when she leaves school at the end of the year. It does not occur to her to surrender a larger share of her earnings to the family, any more than it occurs to her mother to ask for more. She reasons that her hard work gives her the right to spend what she wants on whatever she wants. Her mother fears that if she asked for more, her daughter might take it into her head to move out and live with a girl friend, or find herself a beau and marry.

With more than five shillings a week at her disposal, she suits her fancy and has her fling. She tries to lay by one shilling a week in a fund that she hopes will help buy her furniture when she decides to marry. The rest she spends on herself: on clothes and entertainment. She dresses far better than her mother. Last year she spent over three pounds on dresses, blouses, and skirts for herself; her mother could afford only eight shillings for a ready-made skirt and two shillings for a blouse. She owns a hat, a scarf, and two pairs of gloves; her mother owns none of those luxuries. In the evening she may join her girl friends at a nearby music hall. Tickets are threepence; a packet of sweets, a penny; a pint of beer—she indulges in this treat only rarely—threepence. Saturday nights she and her friends promenade, usually at a nearby market, swinging along in groups of three or four, admiring each other's finery, casting occasional glances at the young men, who cast glances back at them. Several times recently she has allowed a boy to walk alongside her and chat her up; once she let him take her home. But she is in no hurry for all that. Another year, perhaps, and she will feel different. Right now she is happy laughing and larking with girls.

Her fondest memory is of a Bank Holiday trip she took last year to Yarmouth with two friends. It was her first time away from London. Her standard of comparison was the Whit Monday fairs she had attended at Epping Forest and Wanstead Flats or, as now, on Hampstead Heath. But at Yarmouth there was so much more of everything: swings, shies, fried-fish stalls. And there was the ocean as well. Off went stockings and shoes, up

Yarmouth. 1892. "Trippers Having a Paddle."
Detail of a photograph by Paul Martin.

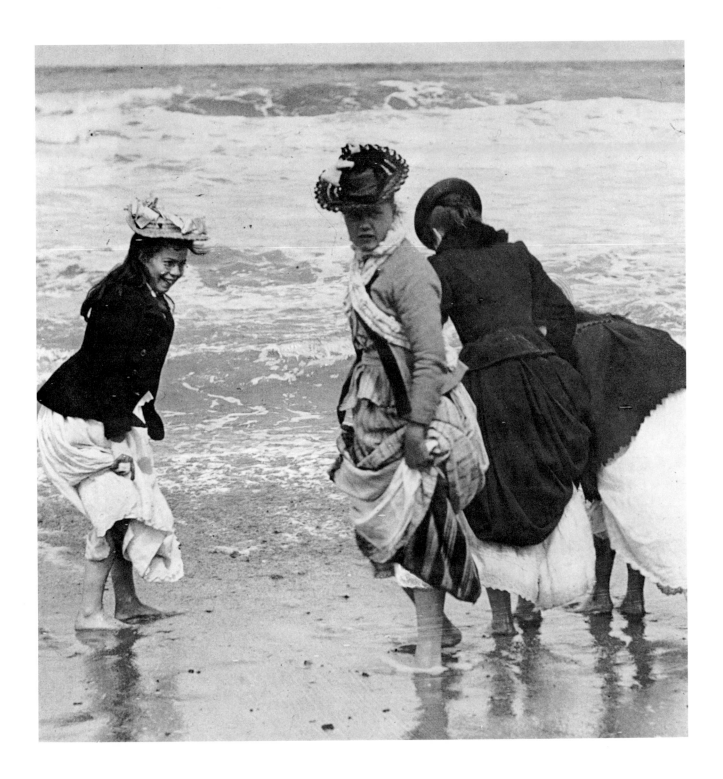

went skirts, and in they plunged, giggling and screeching. In the train home, dizzy from beer and from sun, hat askew and one glove lost forever, singing and shouting with her companions in a carriage full of strangers, she told herself she had never had more fun and might never have so much again.

She knows her life will not always be dancing on Hampstead Heath. Because she understands what lies ahead for her, she is more than ever determined to enjoy herself while she can.

Twelve years later, married to a baker, living in four rooms with as many children on thirty-two shillings a week, her health none too good after a recent miscarriage, she encounters one of those two friends who went with her that day to Yarmouth. Together they agree to a spree the following Friday night. She leaves her children in charge of a neighbor—her husband works nights—and heads to a nearby music hall. Her friend is there to greet her. They enjoy a pint of beer, then ascend to their seats in the gallery. She hears Marie Lloyd's latest hit, sung by a lesser comedienne who tries without much success to give it the special devilish innocence that only Lloyd can impart. She and her friend laugh and, with the rest of the audience, join in. Her lusty singing celebrates a view of life which, to her good fortune, is as much with her tonight as it was years ago on Yarmouth Sands.

I never was a one to go and stint myself,
If I like a thing I like it, that's enough;
But there's lots of people say that if you like a thing
* a lot,*
It'll grow on you, and all that sort of stuff!
Now I like my drop of stout as well as anyone,

But a drop of stout's supposed to make you fat,
And there's many a lardidardi madam doesn't dare
* to touch it,*
'Cos she mustn't spoil her figure, silly cat!

I always hold in having it if you fancy it,
If you fancy it, that's understood!
And suppose it makes you fat?
I don't worry over that,
'Cos a little of what you fancy does you good.[23]

Paul Martin's photographs are of special value to historians because they so clearly show us history: human beings within a social situation. Martin's subjects are not—except to the eye of a professional photographer, perhaps—"subjects" at all. Martin encourages us to take an interest in his men, women, and children as people within the social condition of which they were a part. In this he stands in contrast to his more famous Victorian counterpart Julia Margaret Cameron. Julia Cameron worked, as Roger Fry discerned, within a walled garden of "solid respectability." "Sheltered by its rigid sexual morality from the storms of passion," Fry wrote, "and by its secluded elevation from the shafts of ridicule," the garden's "pervading seriousness provided an atmosphere wherein great men could be grown to perfection."[24]

We can come to know a good deal, it is true, about the Victorians by examining those remarkable, penetrating studies by Julia Cameron of famous men and fair women. Yet, to a far greater extent than Martin's people, Cameron's remain "subjects." With Martin, we are outside Cameron's garden. Men, women, and children are on the move, confronting not just each other but the world—the place where historians must encounter them, if they hope to understand them.

Notes

Paul Martin: A Critical Biography

1. J. F. W. Herschel, "Instantaneous Photography," *The Photographic News*, May 11, 1860, p. 13.

2. Paul Martin, "A Diary of Events Personal and General, during the Life of Paul A. Martin, 1864 to 1944" [London, September 1935?]. Hereafter cited as "Diary."

3. Paul Martin, *Victorian Snapshots* (London: Country Life Limited; New York: Charles Scribner's Sons, 1939), p. 2. Hereafter cited as *Victorian Snapshots*.

4. Paul Martin, "Victorian Wood Engraving" (typescript [London, 1937?]).

5. W. H. Smith, "Photography and 'The Illustrated London News,' " *The Photographic Journal*, May 1942, p. 183. Additional sources of information and theory on the visual and typographical arts and their role in mass communications are William M. Ivins, Jr., *Prints and Visual Communication* (Cambridge, Mass., and London: M.I.T. Press, 1953); and Estelle Jussim, *Visual Communication and the Graphic Arts: Photographic Technologies in the Nineteenth Century* (New York and London: R. R. Bowker Co., 1974).

6. Problems such as the photographic chemicals' rotting the wood limited the application of this process for many decades. The most generally cited significant example of its use is to be found in the *Art Journal* for August 1854; it is a small wood-engraved reduction of James Nasmyth's map of the moon, photographed onto the sensitized wood block by the Rev. St. Vincent Beechy and engraved by Robert Langton. See also Adolphe Martin, "Méthode pour obtenir des épreuves photographiques, positives et directes, sur des planches de nature quelconque, et principalement sur celles qui servent à la gravure," *La Lumière: Revue de la Photographie; Beaux-Arts—Héliographie—Sciences*, April 30, 1853, p. 71.

7. M. G. Potoniée, "Nicéphore Niepce and the Invention of Photography," *The British Journal of Photography*, May 16, 1913, pp. 381–382. This journal will be cited hereafter as *BJP*.

8. For an excellent synopsis and technical description of the evolution of the processes, see Helmut Gernsheim, in collaboration with Alison Gernsheim, *The History of Photography, from the Camera Obscura to the Beginning of the Modern Era* (New York: McGraw-Hill, 1969).

9. J. Rees, "Journalistic Photography," *BJP*, May 5, 1899, pp. 279–280.

10. "Photography for the Press," *The Photogram*, August 1900, p. 253.

11. *Victorian Snapshots*, p. 10.

12. The first practical photographic process, the daguerreotype process, invented by the Frenchman Louis Jacques Mandé Daguerre, was announced to the general public January 7, 1839. The details of the process, which yielded a unique positive on a silver plate, were not made public until August 19. In the meantime, an English experimenter with some success with negatives on paper, William Henry Fox Talbot, heard of Daguerre's announcement and quickly published details of his process—completely different in nature—on January 31, 1839. This first, primitive process, Photogenic Drawing, is often confused with the more sensitive and practical Calotype process that Talbot made public two years later.

13. *Victorian Snapshots*, p. 14.

14. Beaumont Newhall, *The History of Photography from 1839 to the Present Day*, rev. and enl. ed. (New York: Museum of Modern Art, 1964), is very readable and probably the best single-volume survey; it has scanty footnoting. Gernsheim's *History* is biased toward nineteenth-century British photography, ponderous in detail, and difficult to read, but is the definitive technical/social work of the period. Robert Taft, *Photography and the American Scene: A Social History, 1839–1889* (New York: Dover Publications, 1964), is exactly what its title implies and has stood the test of time since its original printing in 1938; it is heavily and interestingly footnoted.

15. Gernsheim, *History*, p. 327. The British led the world in dry-plate technology at this time. Bur-

gess's pioneering plates were first advertised in *BJP*, July 18, 1873, advertising p. ii. See also "Correspondence," *BJP*, October 3, 1873, p. 477.

16. William K. Burton, "Wet and Dry: A Retrospect," *Photography*, November 18, 1897, pp. 721–722.

17. Gernsheim, *History*, pp. 423–424.

18. Gernsheim, *History*, p. 413.

19. *The Kodak Camera* (Rochester, N.Y.: Eastman Dry Plate and Film Co., 1888), p. 3.

20. Walter D. Welford, "Detective & Hand Cameras," issued as a supplement to *Photography*, March 23, 1889, p. 6. The paper disguise may actually have backfired. "A similar idea has recently been acted on by London publicans, who find, to their cost, that very often a person having a distinct desire to purchase and carry away a bottle of spirits hesitates to do so because of some shame as to being seen in the streets with a bottle of such well-recognised shape and size . . . the publican now provides stout paper casings . . . to enclose the ordinary wine or spirit bottle, making a package which the holder believes will not be recognised as containing liquor, but will be looked on as being a parcel of soap, fruit, biscuits, or other less compromising contents. The brown paper disguise of the detective camera soon ceased to be a disguise, and probably the same will hold good of the new covering for the spirit bottle" (*Photographic Work*, 1881, quoted in "Hand Cameras and Gin Bottles," *The Photographic Review of Reviews*, November 15, 1892, p. 400).

21. "Spirit of the Times," *Photography*, July 30, 1891, p. 480.

22. "Ex Cathedra," *BJP*, December 23, 1898, p. 818.

23. "Photographing in the Public Parks," *Photography*, December 26, 1889, p. 719; "Notes and Comments," *The Amateur Photographer*, July 5, 1901, p. 2.

24. "News and Notes," *BJP*, May 30, 1902, pp. 436–437.

25. "Photographing in the Public Parks," p. 719.

26. Some of photography's most important people entered into the fracus. Henry Peach Robinson found that "There is something in the sound of the word so mean, sneaking, and unutterably low-down that it quite choked me off having anything to do with the whole concern" ("The Hand-Camera Taken Seriously," *The Amateur Photographer*, March 27, 1896, p. 270). His archrival in photographic aesthetics, Peter Henry Emerson, stated in milder terms: "We may here remark that the name 'detective camera' is, in our opinion, undesirable; photographers ought not to have it even suggested that they are doing spying work with the camera, whereas the term 'hand-cameras' meets every requirement" (*Naturalistic Photography for Students of the Art*, 3d ed. [London, 1891], pt. 2, p. 16). Many other examples in the literature suggest a broad concern for the implications of the name both on the working method of the photographer and on the type of photographs taken.

27. *Victorian Snapshots*, pp. 12–13.

28. *Victorian Snapshots*, pp. 12–13.

29. Paul Martin, "Photographic Memories," *The Photographic Journal*, July 1934, p. 343. Hereafter cited as "Photographic Memories."

30. *Victorian Snapshots*, p. 14; "Photographic Memories," p. 344. We have been unable to locate the exact text that Martin refers to. He says that in 1883 the book was "just out" and that the last chapter strongly discouraged instantaneous photography. The third edition of Burton's came out in 1883. In Chapter 8, "Instantaneous Photography," Burton says, "So easy is it to take what are called instantaneous views, that there is no reason why such should not be included among the work even of the beginner." The last chapter makes no mention of instantaneous photography. Two possible explanations for the discrepancy suggest themselves. The first edition of Burton came out in 1882. We have been unable to secure a second edition, but it is possible that the second is the one that Martin bought and that it warns against instantaneous work. Another possibility is that Martin in later years confused his A B C's. Another *A B C of Photography*, later *The A B C of Modern (Dry-Plate) Photography*, was published by the London Stereoscopic and Photographic Company. Their 22nd edition, tentatively dated 1886, endorses instantaneous work, but it is very possible that some of the earlier ones did not. These books are extremely rare or extinct today in these editions. In any case, by the time

that Martin started photography in 1884 the then current edition of either *A B C* would have been more encouraging to him.

31. The plate sizes were based on Daguerre's original daguerreotype camera size, the "whole plate" measuring 6½ by 8½ inches. A "half plate" was 4¼ by 6½ inches, whereas the "quarter plate" that Martin employed for most of his snapshots was the relatively small 3¼ by 4¼ inches. Standard 35mm film negatives today are approximately 1 by 1½ inches, with pocket-camera sizes even smaller.

32. "To Correspondents," *The Amateur Photographer*, March 9, 1888, p. 159.

33. *Victorian Snapshots*, p. 15.

34. "Photographic Memories," p. 344; *Victorian Snapshots*, pp. 15, 16.

35. "Diary," 1886.

36. Paul Martin, "Photographs taken by Paul Martin, 1884–88" (photograph album [London, 1884–1888?]).

37. "Diary," 1888; *Victorian Snapshots*, p. 18.

38. "West Surrey Amateur Photographic Society," *The Amateur Photographer*, May 11, 1888, p. 302.

39. "Correspondence," *The Amateur Photographer*, February 15, 1889, p. 105.

40. Davison (1856–1930) was not very complimentary about Martin's choice of career. "The fact is the wood-cutting method is not suited to giving a free and spirited representation. Its general effect is rather that of woodenness" ("Wood-Engraving and Half-Tone Process," *Photography*, July 18, 1895, p. 451). Davison is another photographer whose work and influence have been largely neglected by photo-historians. While an official in the British Foreign Office in the late 1880's, he took up photography and came under the influence of P. H. Emerson's naturalistic school. His work became more impressionistic and—following the controversy surrounding the exhibition of "The Onion Field" in 1890—he began to find fame and notoriety in photographic circles. He joined many important photographic societies, lectured in many more, wrote numerous journal articles, and logically became one of the founding members of the Linked Ring in 1892. His fame grew on both sides of the Atlantic, and in 1898 he was appointed managing director of the then still young European division of the Eastman Photographic Materials Co., Ltd. For the next decade Davison's influence in photographic circles continued to increase; so too did his involvement with the growing number of anarchist groups which were appearing on Europe's unstable political scene at this time. When George Eastman finally discovered in 1912 that one of Britain's leading anarchists was heading up his European operation, he asked for, and promptly received, Davison's resignation. However, Davison was by then a wealthy man (largely because of his investment in Kodak stock). He built two large homes, one at Harlech, the other at Cap d'Antibes, France, where he divided his time between photography, supporting anarchist organizations, and caring for the children of the poor from both Britain and France.

41. Gale's attitudes toward the less cumbersome new systems would be fairly summarized by some remarks made by Charles E. Benham in reference to wet plates: "What true painter, if Satan offered him a medium more portable and convenient than his palette, brushes, and colour-box, would listen for a moment if the Evil One parenthetically hinted that he must not expect quite such perfect work with the simpler tools? 'Get thee behind me,' would be the sincere artist's immediate response. 'Add to the burden of technique if thou must, so that thou also teachest me to improve my work, but spare me not one bead of perspiration on my brow if at the same time thou wilt hinder the perfection of my art'" ("The Wet-plate Process: Is the Photographer's Ideal Quality or Convenience?" *BJP*, December 25, 1903, p. 1035).

42. "Our Views," *The Amateur Photographer*, June 7, 1889, p. 363.

43. *The Amateur Photographer*, April 5, 1889, p. 228; *Photographic Societies Reporter*, April 30, 1889, pp. 193–194.

44. *Victorian Snapshots*, p. 17.

45. "Photographic Memories," p. 345.

46. "Items of Interest," *Photography*, April 4, 1889, p. 244.

47. Cecil Beaton, *British Photographers* (London: William Collins, 1944), p. 30.
48. William M. Murray, "Picturesque Tonality in Photographic Work, and How It May Be Obtained in Transparencies and Lantern Slides (from *Camera Notes*)," *BJP*, July 29, 1898, p. 487; "Editorial," *Focus*, August 9, 1905, p. 147.
49. "Photographic Memories," p. 345.
50. "A Photographer who has Broken all Records: Sir Benjamin Stone, M.P., on his Remarkable Adventures and Experiences," *Focus*, October 25, 1905, p. 375.
51. "Ex Cathedra," *BJP*, August 12, 1898, p. 513.
52. "The National Photographic Record Association," *The Photogram*, May 1900, p. 131; "National Photographic Record Association," *BJP*, October 8, 1897, p. 651.
53. "The Liverpool Exhibition," *Photography*, March 19, 1891, p. 188; "The Birmingham Exhibition," *Photography*, January 23, 1890, p. 59; "Our Special Hand-Camera Work Competition," *Photography*, October 8, 1891, p. 647.
54. J. W. Charlesworth, "Hand Camera Work," *The Photographic Reporter*, August 1890, p. 31.
55. S. L. Coulthurst, "The Hand Camera and Hand-Camera Workers (Manchester Photographic Society)," *BJP*, December 27, 1895, p. 825.
56. *The Kodak Camera* (Rochester, N.Y.: Eastman Dry Plate and Film Co., 1888), p. 22.
57. Walter D. Welford, "The Influence of the Hand Camera," *Photography*, May 4, 1893, p. 278. Welford is especially interesting. An article in an 1897 *Amateur Photographer* noted, "Nowadays nearly every other cyclist we meet carries a hand-camera." The two fads had seen a number of crossover participants, but perhaps none proved more active in both fields than did Welford. An apparently tireless worker, Welford first devoted his attention to cycling, which began to gain great impetus in England during the 1870's and 1880's. Starting in 1878, he edited a weekly called *Cycling*, a chatty newsletter, consisting of announcements, news items, society reports, and how-to articles. Its format resembled that of amateur photographic journals in many ways— significantly, Welford chose to illustrate some issues with mounted photographs of noted cyclists and their machines. By the mid-1880's Welford was actively involved in photography. He joined several photographic societies, becoming an energetic participant, exhibitor, and lecturer/demonstrator at the meetings. He wrote at least four books on photography, with his manuals on the hand camera being the most memorable. He served at various times as editor, subeditor, or staff writer on a number of photographic periodicals in the 1880's and 1890's.
58. *Victorian Snapshots*, p. 18.
59. "Meetings of Societies," *BJP*, November 11, 1892, p. 732. Dresser was originally to have lectured, but was ill. Mr. J. L. Lyell read from Dresser's notes (*The Amateur Photographer*, November 11, 1892, p. 356).
60. "Editorial Notes," *The Photographic Reporter*, August 1890, p. 5.
61. "Summary of Societies' Meetings," *The Photographic Reporter*, November 1890, pp. 157–158.
62. Walter D. Welford, "Detective & Hand Cameras" (issued as a supplement to *Photography*), *Photography*, May 23, 1889, p. 6.
63. "Photographic Memories," p. 345; *Victorian Snapshots*, p. 20. William Heath Robinson (1872–1944) began his career as a book illustrator in London in the 1890's, the period during which Martin was an active wood engraver. By 1915, the world was well aware of the work of the artist who " . . . made droll fun of the machine in an age that was enslaved by it. He caricatured machinery, . . . by inventing absurd, complicated, jerry-built pieces of apparatus" (*Dictionary of National Biography, 1941–1950*, p. 730). In this respect his work is very similar to that of Rube Goldberg, the American cartoonist and humorist, whose designs of similarly outrageous contraptions gained national popularity in the 1920's.
64. "Spirit of the Times," *Photography*, July 31, 1890, p. 480; *Victorian Snapshots*, p. 20.
65. *Victorian Snapshots*, p. 23.
66. The introduction of the concept of motion in photography is covered in: *Eadweard Muybridge: The Stanford Years, 1872–1882*, rev. ed. (San Francisco: Stanford University Museum of Art, 1973): Gordon Hendricks, *Eadweard Muybridge* (New York: Grossman, 1975); Robert Bartlett

Haas, *Muybridge, Man in Motion* (Berkeley: University of California Press, 1976). Among the many books by another significant motion-study pioneer, Etienne Jules Marey, are *Animal Mechanism: A Treatise on Terrestrial and Aerial Locomotion* (London: H. S. King & Co., 1874); and *Movement* (London: W. Heinemann, 1895). The latter title has been reissued in facsimile form by Arno Press, New York, 1972.

67. *Victorian Snapshots*, pp. 20–21.

68. *Victorian Snapshots*, p. 21. The rapid rectilinear lens, tracing its origin back to a simple four-element design of Steinheil's in 1866, represented about the best lens available with the optical glasses then in use. New glasses were discovered in Jena, Germany, allowing P. Rudolph in 1890 to design the first of the anastigmatic lenses, superior in almost every respect to the rectilinears and much more akin to the quality that we expect of a lens today. Early commercial versions, all out of Germany, included Von Hoegh's classic 1893 double anastigmat manufactured by the firm of Goerz. The name of this lens was changed to the Dagor—it is still being manufactured today. Also see L. P. Clerc, *Photography, Theory and Practice, Being an English Edition of "La Technique Photographique,"* ed. George E. Brown (Bath: Sir Isaac Pitman & Sons, 1930), pp. 64–66.

69. *Victorian Snapshots*, p. 20.

70. *Victorian Snapshots*, p. 21.

71. "Our Editorial Table," *BJP*, May 15, 1891, p. 315; *Victorian Snapshots*, p. 22.

72. *Victorian Snapshots*, pp. 22–23. These last two modifications to Martin's Facile make the date of purchase of his camera somewhat confusing. His diary and all of the dated pictures that we have examined indicate clearly that he bought his Facile in 1892. Yet, in February 1892, a detailed review of the "Improved Facile for 1892" specifies a leather-cased camera with a strip of ferrotype metal to cover the lens and finder ("The Editor's Work-Table," *Photography*, February 25, 1892, p. 124). Martin may have been so unlucky as to have bought the old model in January, not knowing of the new one. Perhaps he bought a used, older-model instrument to save money. Or perhaps, even, he found one of the old models at a reduced price at one of Fallowfield's famous annual clearance sales. In any case, the inspiration for many of Martin's changes must clearly have come from, not have led to (as some writers have claimed) later manufactured versions of the Facile.

73. "Diary," 1889.

74. *Victorian Snapshots*, p. 22.

75. *Victorian Snapshots*, p. 41.

76. "Photographic Memories," pp. 344, 346.

77. Paul Martin, "Blocked-Out Lantern Slides," *The Amateur Photographer*, November 6, 1896, p. 374.

78. Martin, "Blocked-Out Lantern Slides," p. 374.

79. It is tempting to draw a line directly to Martin starting from Henry Mayhew's *London Labour and the London Poor*. The text was illustrated by woodcuts, many from sketches, but a total of over forty were based on daguerreotypes by Richard Beard and another eight on paper photographs. There was no way to reproduce these directly in their time. At first issued serially, the work was collected into book form starting with the first two volumes in 1851; a third volume appeared in 1861 and the fourth in 1862. It is considered to be the first major work studying the lower classes in Victorian London. All four volumes were reprinted in 1968 by Dover Publications, New York. The plates and text that make up Thomson and Smith's *Street Life in London* were originally published by the Woodbury Permanent Printing Company in twelve monthly installments starting in January 1877. Following the final installment, the pictures and text were gathered together in a single undated volume with the bulky title of *Street Life in London by J. Thomson, F.R.G.S., and Adolphe Smith, with Permanent Photographic Illustrations taken from Life expressly for this publication.* London-based publisher Sampson Low, Marston, Searle and Rivington put it out. In 1881, they reissued an edited version titled *Street Incidents*, made up of twenty-one of the original Woodburytypes with their text. It is interesting to note that, while the publications in 1877 were considered important social documents, the photographic press

of the day virtually ignored Thomson's strong images. The slow and cumbersome wet collodion of the period did not permit candid shots, but Thomson's carefully arranged figures suggest many of the same subjects that Martin was to take later. Many of Paul Martin's titles for his street work fifteen to twenty years later are identical to those used in these volumes. *Street Life in London* was republished in facsimile with an additional set of enlarged pictures in 1969 by Benjamin Blom, Inc., New York. Thomson's name is consistently misspelled as Thompson on the cover and in the text of this edition.

80. Martin, "Blocked-Out Lantern Slides," p. 375.
81. "Among the Societies," *Photography*, October 26, 1893, p. 670; *The Amateur Photographer*, October 27, 1893, p. 277.
82. "Leyenstone [*sic*] Camera Club Exhibition," *Photography*, November 30, 1893, p. 757.
83. *Victorian Snapshots*, pp. 23–24.
84. Raymond Lecuyer, *Histoire de la photographie* (Paris: Baschet et Cie, 1945), p. 143.
85. *The Amateur Photographer*, March 16, 1894, p. 187.
86. "West Surrey Society's Exhibition," *Photography*, March 28, 1895, p. 203.
87. "Photographic Salon, 1893," *BJP*, June 9, 1893, p. 363. See also *The Amateur Photographer*, April 21, 1893, p. 260; "Cosmos," "Jottings," *BJP*, May 26, 1893, p. 326.
88. "Correspondence," *Photography*, May 25, 1893, p. 329; also, "Correspondence," *BJP*, May 26, 1893, p. 335.
89. "The Photographic Salon," *BJP*, October 13, 1893, p. 653; "Correspondence," *BJP*, October 20, 1893, p. 680.
90. *Victorian Snapshots*, p. 17.
91. A. H. Wall, "The Salon and Its Suggestions," *The Photogram*, November 1894, p. 280.
92. *Victorian Snapshots*, p. 24.
93. Paul Martin, "Around London by Gaslight, Part I," *The Amateur Photographer*, October 9, 1896, p. 288; "News and Notes," *BJP*, November 20, 1896, p. 748.
94. The "ordinary" plates of the period were sensitive only to blue light. The newer isochromatic plates,

through the use of special dyes, responded both to blue and to green light, but still ignored the red. The backing was an opaque layer behind the emulsion that dissolved out in development. Commercially manufactured backed plates were then available, but it was not uncommon for photographers to back their own. Martin apparently used a mixture of glycerine, burnt sienna coloring, and alcohol (*Photography*, February 18, 1897, p. 105).
95. Martin, "Around London by Gaslight, Part I," p. 288.
96. Paul Martin, "Nocturnal Photography," *The American Annual of Photography and Photographic Times Almanac for 1898*, p. 60.
97. *Victorian Snapshots*, p. 27.
98. *Victorian Snapshots*, p. 25. Martin says here that he used "very weak" Rodinal, not giving the specific dilution. However, in another article, Martin refers to "very weak" Rodinal as a 1:25 dilution. This shows the high contrast to which negatives were developed in that period. A very weak dilution of Rodinal to today's photographers would be on the order of 1:100 or less, producing far less contrast.
99. Paul Martin, "Around London by Gaslight, Part II," *The Amateur Photographer*, October 16, 1896, p. 315.
100. Martin, "Around London by Gaslight, Part II," p. 314.
101. Martin, "Around London by Gaslight, Part II," p. 315; *The Optical Magic Lantern Journal and Photographic Enlarger*, March 1899, p. 34.
102. In 1892 E. G. Lee received an award for twelve lantern slides "from Negatives made with a Home-made Hand Camera" (*The Photographic Journal*, September 26, 1892, p. 16). In 1895 Ernest Marriage secured a Royal Photographic Society medal for a series of twelve lantern slides of various buildings and edifices in Italy (*The Photographic Journal*, September 28, 1895). Martin received his gold medal the following year.
103. "Ordinary Meeting," *The Photographic Journal*, October 31, 1896, pp. 48–50; *Victorian Snapshots*, p. 25. It is ironic that Captain Abney was

the one to award the medal. When Martin was taking his first picture by moonlight he based his initial exposure on something that he had read in a journal. "I had once read of somebody taking a moonlight exposure in the Alps with a one-hour exposure, so I decided to give this one hour" (*Victorian Snapshots*, p. 27). Martin was undoubtedly referring to an article written by none other than Abney (*Photography*, January 26, 1893, p. 50).

104. *Photograms of '96*, p. 83.

105. There are scattered references to night photography in many of the journals in the early 1890's, including some produced by George Davison. It was not uncommon in this period, however, for verbal descriptions to be misleading. In the absence of pictorial examples, we must assume that it is possible that some or all of these earlier night pictures may have been simulated shots or the results of heavy retouching. In the 1895 Salon, though, the Salon in which Martin exhibited snapshots and pictorials—"Critics," "Coombmartin," and three others—we find proof in the form of a published photograph that someone did in fact precede Martin in this field. "Westminster by Night," by Walter Edmunds, is virtually identical in treatment and at least equal in quality to the work for which Martin later received the gold medal. *Photograms of '95* praised Edmunds's work as "full of atmosphere and good contrasts of light and shadow" ("The Two Great Exhibitions," p. 72). *The British Journal of Photography* found it to be "uncommonly good and effective" ("Royal Photographic Society's Exhibition," *BJP*, October 4, 1895, p. 629).

Carefully reading the *Photograms of '96*, we find several guarded comments that indicate at least a memory of Edmunds. Referring to Martin's night scenes, the editors noted that, "if the scheme of the work is not new, it has been carried out with a completeness hitherto unknown . . . the views of the Embankment and Westminster, though not so new, are very well composed and full of charm" (pp. 26–27). A September copy of *The Photogram* recalled Davison's work of the year before and suggested that Edmunds could have picked a more picturesque position the previous year (Hallton East, "Beauty Spots, No. VI, London Town," *The Photogram*, September 1896, p. 206). *The British Journal of Photography* did not get its memory back until a 1919 article that credited Edmunds as first, followed by Martin a year later (Robert Dykes, "Night Photography," *BJP*, August 22, 1919, p. 485). Edmunds was not as thorough, did not utilize lantern slides as Martin did, and apparently soon gave up this line of work, but he clearly preceded Martin in this field.

106. Martin, "Around London by Gaslight, Part II," p. 315. Sir Leander Starr Jameson (1853–1917), known popularly as "Dr. Jameson," was a colorful Scottish physician at Kimberley, Cape Colony, South Africa. On December 29, 1895, against orders, he led a ragtag invasion force out of the British colony toward the Boer city of Johannesburg. The Boer forces surrounded his troops along the way, severely beating Jameson's band when they finally attacked.

107. Alfred Stieglitz, "Night Photography with the Introduction of Life," *The American Annual of Photography and Photographic Times Almanac for 1898*, pp. 204–205.

108. "What's What," *The Photogram*, November 1902, p. 348; December 1902, p. 379.

109. "Photograms of '96," *Photograms of '96*, p. 99.

110. A. H. Blake, "Some Difficulties in Night Photography," *The Photographic Monthly*, May 1909, pp. 105–109; "Brevities," *The Photographic Monthly*, December 1909, pp. 295–296.

111. A. C. R. Carter and "A Mere Technician," "The Two Great Exhibitions: The Royal," *Photograms of the Year, 1899*, p. 131.

112. "Societies' Meetings," *The Amateur Photographer*, August 2, 1895, p. 80.

113. "Meetings of Societies," *BJP*, October 16, 1896, p. 668.

114. *Photography*, January 28, 1897, p. 55.

115. "Croydon Camera Club," *BJP*, October 28, 1938, p. 687.

116. "Photographic Memories," p. 347.

117. Paul Martin, "A Composite Subject," *The Photo-*

gram, March 1899, pp. 72–75.

118. "The Eastman Exhibition," *BJP*, October 29, 1897, p. 698; "Letters to the Editor," *The Amateur Photographer*, November 12, 1897, p. 397; "News and Notes," *BJP*, February 11, 1898, p. 91.

119. Martin, *Victorian Snapshots*, p. 30.

120. A very insightful article into the commerce of the period, by George E. Brown, is "After 25 Years," *The British Journal Photographic Almanac* (hereafter cited as *BJP Almanac*), 1930, pp. 181–198. Part of this article chronicles some of the "revolutionary achievements" that became photographic dinosaurs. For example, there was the Waterloo plate, which had the developer in paste form dried on the back of the plate. After exposure one had merely to put the plate in the proper quantity of water to activate the chemicals and produce the negative. It failed because too many people did not measure out the proper quantity of water, thus diluting the developer and spoiling the negative. A German invention was a deep red fluid that one added to the developer to make the solution itself a safelight. That way a plate could be developed without a darkroom. Two problems killed this one: if you didn't have a darkroom, you couldn't get the plate into the developer safely in the first place, and the fluid stained everything, including the hands, an indelible bright red.

121. *Victorian Snapshots*, p. 33.

122. *Victorian Snapshots*, pp. 31, 33.

123. *Victorian Snapshots*, p. 18.

124. Paul Martin, "Half-tone Process on copper, Etched and Fine Etched by Paul Martin at The Bolt Court School of Engraving 1897–8" [London, n.d.]; *Victorian Snapshots*, p. 11.

125. "Diary," 1899; "Trade," *The Photogram*, October 1899, p. 319; *Victorian Snapshots*, p. 18. In 1896 Dorrett developed some plates in front of the West Surrey members while a Mr. Stewart spoke on the elementary principles of development ("Societies' Meetings," *The Amateur Photographer*, October 16, 1896, p. 324; *Photography*, October 15, 1896, p. 674). A month later at another West Surrey meeting, Dorrett used acetylene gas to illuminate an exposure of the forty members present (*Photography*, November 19, 1896, pp. 754–755). Again, someone else made the speech. In 1899, he was co-judge at a West Surrey competition on photographs of "Fruits and Vegetables" ("Some Still-Life Groups," *The Amateur Photographer*, February 10, 1899, p. 109). Finally, in 1901, he is listed as applying for membership in the newly formed Professional Photographers' Association in London ("The Professional Photographers' Association," *BJP*, July 5, 1901, p. 423). We are not even sure when he joined the West Surrey—it is possible that Martin had already gone over to the London and Provincial by the time Dorrett came in.

126. "Trade," *The Photogram*, October 1899, p. 319; "The Professional Photographers' Association," *BJP*, July 5, 1901, p. 423. The firm name of Athol seems a strange choice. It sounds like a name for one of the various developers that were being marketed at the time, but we have not found it to be so. An old English surname, its meaning is "dweller in the hollow" or "dweller in the hole" (Percy H. Reaney, *A Dictionary of British Surnames* [London: Routledge and Kegan Paul, 1958], p. 14). Why would two photographers ever choose a name like that? We can only venture a guess. Liberally corrupted, the term could be taken to mean that they worked in a hole—a dark place—a darkroom. A more likely and interesting explanation is that the used studio that they acquired was perhaps one of the many in London at that time that had its precious skylight shadowed by the growth of tall buildings. Artificial lighting in photographic studios was still a novelty then. The successful firm of Frederick Kingsbury moved from the Belle Vue address to 15 Rutland Street just before Athol moved in (H. Snowden Ward, *An Index of Standard Photograms* [London: *The Photogram*, 1901], p. A21). Perhaps the established firm chose not to do without sunshine, whereas the minimally financed Dorrett & Martin could not afford a better location, chose to make the best of what they could get, and injected a bit of humor into the business's name.

127. "Trade," *The Photogram*, October 1899, p. 319.

128. "Cosmos," "Jottings," *BJP*, July 28, 1899, p. 468.

Examples of business difficulty abound in the journals. See, for example, J. von Norath, "Photo-Ceramics," *BJP*, January 6, 1899, p. 7, where the author, in introducing his process and the potential need for it, states that "Photography is prostrate as an industry." In London suicides of photographers were reported almost weekly in the journals during this period.

129. *Victorian Snapshots*, p. 18.

130. *Victorian Snapshots*, p. 18; for evidence of Emberson's previous occupancy at the Strand address, see *The Post Office London Directory* (London: Kelly's Directories, 1899); "Trade," *The Photogram*, August 1903, p. 254; ibid., October 1904, p. 283; "Postal and Telegraphic Addresses," *BJP Almanac*, 1907, p. 1246.

131. *Victorian Snapshots*, p. 18.

132. *Victorian Snapshots*, p. 36.

133. *Victorian Snapshots*, p. 37. The first photographic camera of this type to be marketed dates back to the wet-plate days. Thomas Sutton patented his in 1861, but found it not very successful at that time ("New Instantaneous Camera," *The Photographic News*, October 11, 1861, p. 483). Several cameras of this type were available commercially by 1900. Martin quite possibly patterned his design after the "Special Hand Camera for Instantaneous Work" introduced by W. Watson & Sons in 1899 (*BJP Almanac*, 1899, p. 1132). The ads credit the idea to F. W. Mills, a photographer who was doing candid street photography very similar to Martin's (Gernsheim, *History*, pp. 415, 455).

134. "Diary," 1900–1902.

135. George E. Brown, "After 25 Years," *BJP Almanac*, 1930, p. 186.

136. *Victorian Snapshots*, p. 41.

137. "Trade," *The Photogram*, August 1903, p. 254; "Photography for Profit: Photo-Buttons," *The Photogram*, October 1903, p. 299.

138. "Photography and the General Election," *BJP*, January 28, 1910, pp. 59–60.

139. Martin's diary does not mention any photographic activity in this period. A "P. Martin" was a member of the Woodford Photographic Society in 1914, but we cannot determine from his print titles if this is the same person ("The Affiliation of Photographic Societies," *The Photographic Journal*, January 1914, pp. 35–36).

140. "Diary," 1920–1922.

141. "Patent News," *BJP*, July 20, 1923, pp. 450–451. Complete specifications were accepted February 14, 1922, for Martin's "Self-Focussing Vertical Enlarger," British patent no. 197,726. "New Apparatus," *BJP*, March 7, 1924, p. 147; "Diary," 1924; "Trade News," *BJP*, January 19, 1923, p. 43.

142. The separation was not entirely a happy one. On March 4, 1927, *The British Journal of Photography* published a notice that "Mr. H. G. Dorrett, formerly of Dorrett & Martin . . . is continuing the business of the latter firm . . . new plant and machinery have been installed, enabling him to undertake the trade service and production of various specialties for which Messrs. Dorrett and Martin were previously widely known" ("News and Notes," *BJP*, March 4, 1927, p. 126). Two weeks later a contrite journal printed a retraction and apology: "Mr. H. G. Dorrett is continuing in business on his own account . . . and not as a resuscitation of the firm of Dorrett & Martin" ("News and Notes," *BJP*, March 17, 1929, p. 157). No more of Dorrett is heard in the journals. Further evidence of an unhappy breakup with Dorrett is suggested by Martin's "Diary," compiled in 1935 after he had left the business. Since many people's personal lives are mentioned, we would expect to find his partner of nearly three decades well represented in its pages. Instead Martin virtually never mentions Dorrett, not even during the years representing their partnership, and never documents anything about Dorrett's personal life.

143. *Victorian Snapshots*, p. 21. In his faulty article, "The Candid Victorian," *Modern Photography*, January 1961, pp. 90–91, 142, Nat Herz says that Martin, in his later years "fell in love with the Leica, welcoming the new as he always had." This might be taken to imply that Martin worked with a Leica later in life. Martin briefly mentions the Leica in *Victorian Snapshots*, but does not say anything about actually having worked with it. We find no other evidence to suggest that he ever used the legendary miniature camera. His

smallest camera that we know of was the Zeiss Palmos, a strut-type bellows press camera which took 2½-by-3½-inch negatives.

144. "Diary," 1928.

145. Beaumont Newhall, *Photography, a Short Critical History*, 2d. ed. rev. (New York: Museum of Modern Art, 1938).

146. Victoria and Albert Museum, *Catalogue of an Exhibition of Early Photographs to Commemorate the Centenary of Photography, 1839–1939* [London, 1939?], p. 5.

147. "Diary," 1939.

148. "Diary," 1944. We believe that the actual year of his death (which most histories cite as 1942)

was first correctly pointed out by Bill Jay, *Victorian Candid Camera: Paul Martin, 1864–1944* (Newton Abbot: David & Charles, 1973), p. 41.

149. Quoted from a letter from Sutcliffe reproduced by J. L. Hankey, "The Frank M. Sutcliffe Memorial Lecture," *The Photographic Journal*, August 1942, pp. 293–294.

150. Alfred Stieglitz, "The Hand Camera—Its Present Importance," *The American Annual of Photography and Photographic Times Almanac for 1897*, pp. 18–27. This is an excellent summary of the shift in attitude toward the hand camera as a serious tool.

Late Victorian London and Its People

1. C. F. G. Masterman, "Realities at Home" in *The Heart of the Empire*, ed. idem (London: T. Fisher Unwin, 1901), pp. 13–14, 8.

2. W. L. Burn, *The Age of Equipoise* (New York: Norton, 1965), p. 36.

3. This despite the fact that Martin himself was interested for a time in treating his subjects not as live people against a particular background but as photographic statuettes. See the preceding essay.

4. Gareth Stedman Jones, *Outcast London* (Oxford: Clarendon Press, 1971), p. 26.

5. Stedman Jones, *Outcast London*, p. 169.

6. George Orwell, "Such, Such Were the Joys," in his *Essays* (Garden City, N.Y.: Doubleday, 1954), p. 40.

7. Alexander Paterson, *Across the Bridges* (London, 1918; 1st ed., 1911), p. 7.

8. Charles Booth, *Life and Labour of the People in London* (London: Williams and Norgate, 1896), 9: 6–9; B. Seebohm Rowntree and A. C. Pigou, *Lectures on Housing* (Manchester: The University Press, 1914), p. 13.

9. M. S. Pember Reeves, *Round About a Pound a Week* (London: G. Bell and Sons, 1913), p. 49.

10. Reginald A. Bray, "The Boy and the Family," in *Studies of Boy Life in Our Cities*, ed. E. J. Urwick (London, 1904), pp. 19–20.

11. Arthur Morrison, "A Street," in *Working-Class Stories of the 1890s*, ed. P. J. Keating (London: Routledge and Kegan Paul, 1971), pp. 1, 6–7; previously published as the introduction to Morrison's *Tales of Mean Streets* (1894).

12. George Gissing, *The Nether World* (London: Smith, 1889), p. 58.

13. Women's Co-operative Guild, *Maternity* (London: G. Bell and Sons, 1915), p. 56.

14. Winifred Blatchford, "The Borough," *Woman Worker*, September 1, 1909, p. 199.

15. Booth, *Life and Labour*, 4: 91.

16. Robert Roberts, *The Classic Slum* (Manchester: Manchester University Press, 1971), pp. 9–10.

17. Richard Hoggart, *The Uses of Literacy* (Boston: Beacon, 1961), p. 59.

18. Martin was himself a potential victim. He abandoned wood engraving for professional photography when he realized that technology had made his former trade obsolete.

19. The four verbal "snapshots" that follow are based generally upon evidence contained in Booth, *Life and Labour*, esp. 1: 309–369; 7: 115–131, 160–171; M. L. Eyles, *The Woman in the Little House*

(London: G. Richards, 1922); Henry Mayhew, *London Labour and the London Poor* (London, 1851–1862; reprinted, New York: Dover Publications, 1968), vol. 1; Paterson, *Across the Bridges*; Pember Reeves, *Round About a Pound a Week*; John Thomson and Adolphe Smith, *Street Life in London* (London, 1877; reprinted, New York: Benjamin Blom, 1969); Women's Co-operative Guild, *Maternity*.

20. Mayhew, *London Labour and the London Poor*, 1: 20.
21. Thomson and Smith, *Street Life in London*, p. 98.
22. John Law, *Out of Work* (London, 1888), p. 44.
23. "A Little of What You Fancy Does You Good," words and music by George Arthurs and F. W. Leigh, © Copyright 1915 by Francis Day & Hunter Ltd.; sole selling agent MCA Music, a division of MCA Inc., New York, N.Y. Used by permission. All rights reserved. Reproduced in Peter Gammond, *Music Hall Songbook* (Newton Abbot: David and Charles, 1975), pp. 140–142.
24. Roger Fry, "Mrs. Cameron's Photographs," in Julia Margaret Cameron, *Victorian Photographs of Famous Men and Fair Women* (London: Hogarth Press, 1973), p. 24.

A Selected Bibliography

by Roy Flukinger and Larry Schaaf

Unpublished Works by Paul Martin

"A Diary of Events Personal and General, during the Life of Paul A. Martin, 1864 to 1944." [London, September 6, 1935?] An unpublished manuscript diary in Martin's hand, owned by the Collection of the Fine Arts Library, University of New Mexico General Library, Albuquerque. It is clearly retrospective, being accurate in its nature but not necessarily in its specifics. In general, all the events that we have been able to check did happen, though not necessarily exactly when Martin noted that they did. Pagination is mostly by year, each page and its facing leaf usually sharing one year, and runs from the year of Martin's birth to the year of his death. All entries are in Martin's handwriting, with a few clear exceptions, these presumably having been added by his wife, Clara, or one of his sons. The last entry in his hand is dated 1940; someone else wrote in the facts concerning his death and interment in 1944.

"Engravings on Wood, by Paul Martin, 1883–6 for R. Taylor (17 New Bridge St)." [London, n.d.] An album of samples of engraving work compiled by Martin and now owned by the Collection of the Fine Arts Library, University of New Mexico General Library, Albuquerque. There are few manuscript captions by Martin and little or no indication of where most of the illustrations were reproduced. The Martin manuscript note at the bottom of the title page reads, "In 1886 I joined the regular indoor staff until the collapse of Wood Engraving in 1898."

"Half-tone Process on copper, Etched and Fine Etched by Paul Martin at The Bolt Court School of Engraving 1897–8." [London, n.d.] An unpublished collection of process proofs which makes up the second portion of the album "Wood-Engravings" (see below). Martin's manuscript note at the bottom of the title page reads, "In 1897 it became evident that the days of Wood-Engraving were numbered, so joined The Bolt Court School of Engraving."

"Photographs taken by Paul Martin, 1884–88." [London, 1884–1888?] A personal photograph album, apparently compiled by Martin as a running venture from 1884 to 1888, spanning the period from his first year in photography to his critical entry into the West Surrey Amateur Photographic Society. The sequence of the photographs correlates with the "Diary" entries for those years in terms of dates, locations, and camera plate sizes. The albumen contact prints are mounted in careful groups, identified in ink on the pages. Information provided is generally the year and the location. A few lightly drawn embellishments in pencil suggest a base for later inking that was never completed. The front pastedown bears the following handwritten inscription: "Photographs taken by Paul Martin 1884–88. 55 Hosack Rd Balham. S.W. 17." The signature corresponds to Martin's as found in his diary and on the verso of some of his prints in the Gernsheim Collection at the University of Texas at Austin. The album is in the Gernsheim Collection.

"Victorian Wood Engraving." [London, 1937?] An eleven-page typescript with manuscript additions and corrections, owned by the Library of the Victoria and Albert Museum, London. It was probably donated to supplement Martin's donation of an album of his engravings to the museum in 1937. It is essentially Martin's account of his own experiences in the field of wood engraving. Sections of Martin's autobiography, *Victorian Snapshots*, are heavily edited derivations of this script. Martin's own writing style, as evidenced in this manuscript, is substantially different from that displayed in his autobiography.

"Wood-Engravings, by Paul Martin, 1883–86." [London, n.d.] Another album of samples of engraving work compiled by Martin, in the holdings of the Collection of the Fine Arts Library, University of New Mexico General Library, Albu-

querque. There are some manuscript captions by Martin denoting either where certain engravings were reproduced or which engravings are from his photographs. "Half-tone Process on copper" (see above) is bound in the same volume.

Published Works by Paul Martin

MONOGRAPH

Victorian Snapshots. London: Country Life Limited; New York: Charles Scribner's Sons, 1939. This slim volume, published in photography's centennial year, is Martin's autobiography. Besides its 41⁺ pages of text, it contains an introduction and commentary by "Charles Harvard" (pseudonym for C. H. Gibbs-Smith) and is illustrated with numerous small photographs by Martin and his contemporaries. This book was reissued in facsimile form in 1972 by Arno Press, New York, as part of their Literature of Photography series.

SELECTED ARTICLES

Largely technical in nature and all published during the latter half of the 1890's, these articles stemmed from Martin's work, beginning with his famous series of night photographs. They are listed in chronological order of publication.

October 9 and 16, 1896. "Around London by Gaslight." *The Amateur Photographer*, pp. 288 (Oct. 9), 313–315 (Oct. 16). Gives an account of Martin's night work while his memory was still quite fresh.

November 6, 1896. "Blocked-Out Lantern Slides." *The Amateur Photographer*, pp. 374–375. Details the process of making his human statues, including revealing comments on why he took many of his candid street pictures.

September 1898. "The Thames Embankment." *The Photogram*, pp. 275–278. A thinly veiled excuse to again reproduce his night pictures, with some daylight and snow scenes mixed in.

December 1898. "Hand-Camera Work in Winter." *The Photogram*, pp. 375–377. Martin was by now an expert at taking photographs under unusual conditions.

1898. "Nocturnal Photography." *The American Annual of Photography and Photographic Times Almanac for 1898*, pp. 59–62. Supplied Americans with Martin's views.

March 1899. "A Composite Subject." *The Photogram*, pp. 72–75. Represents a sad decline, as Martin carefully explains in great detail the process of creating a picture from several negatives, much along the lines of the old H. P. Robinson school. A seascape was the final product.

May 1899. "The Evolution of a Snap-Shot." *The Photogram*, pp. 135–138. Far from being a philosophical piece on his candid work. A simple donkey-head snapshot taken at the seaside is opaqued, masked, retouched, and otherwise contorted step-by-step into a neatly framed banality.

Also, a later article of historical and technical interest:

June 20, 1934. "How I Make My Exhibition Pictures." *The Amateur Photographer & Cinematographer* ("The Jubilee Edition"), pp. 554–555. Part of a historical series run by this journal in the 1930's, called "Methods and Ideals of well-known Pictorial Workers." Martin's brief contribution was a series of short reminiscences concerning the high points of his career in the 1880's and 1890's.

See also Martin, Paul, "Photographic Memories," in the following section.

Published Works about Paul Martin

Fryers, Austin. "Night Photography." *Pearson's Magazine*, June 1898, pp. 578–581. Written for the more general audience of *Pearson's* and therefore less technical in content than articles in photographic journals, this article related Martin's gradual perfection of night photographs and some of his experiences while taking them.

Herz, Nat. "The Candid Victorian." *Modern Photography*, January 1961, pp. 90–91, 142. An enthusiastic but rarely factual account of Martin's escapades. The author apparently used Martin's *Victorian Snapshots* as the basis for the article but often did not let the facts get in the way of his imagination.

Jay, Bill. *Victorian Candid Camera: Paul Martin, 1864–1944.* Newton Abbot: David & Charles, 1973. A very readable account of Martin's life. Jay especially gives insight into Martin's personal and family life, based primarily on interviews with Martin's two sons. He does mention some of Martin's contemporaries but still gives an impression that Martin was virtually the sole hand-camerist of his period. Many of the conclusions Jay draws are different from ours, and the lack of any specific footnoting makes analysis and comparisons very difficult.

Martin, Paul. "Photographic Memories." *The Photographic Journal*, July 1934, pp. 343–348. Though carrying Martin's byline, the article is essentially written about him by an unidentified author. It is based on an illustrated lecture, "Old Photographic Memories," which Martin delivered at a meeting of the Pictorial Group of the Royal Photographic Society on April 20, 1934. It is basically a series of personal reminiscences about his career in photography from its beginning through his amateur years.

Welford, Walter D. "London by Gas Light: A Chat with Mr. Paul Martin." *Photographic Life*, February 3, 1897, pp. 1–2. Welford stresses Martin's shyness here, as well as giving several revealing quotes about Martin's attitude toward the blocked-out-background lantern slides.

Photographs taken by
Paul Martin

The following plates have been
selected from Paul Martin's work in
the Gernsheim Collection, Photography
Collection, Humanities Research Center, The
University of Texas at Austin. Any cropping follows
that done by Martin himself. Wherever possible, the
whole negative has been reproduced. No attempt
has been made to cover the effects of time and
handling. The signature on the previous
page is the cover sheet to his album
"Photographs taken by Paul
Martin, 1884–88."

PLATE 1
London. 1886. "A Scene in St. Paul's
Churchyard." "This policeman was reputed at the time
to be the only person from whose hand
[the pigeons] would feed."

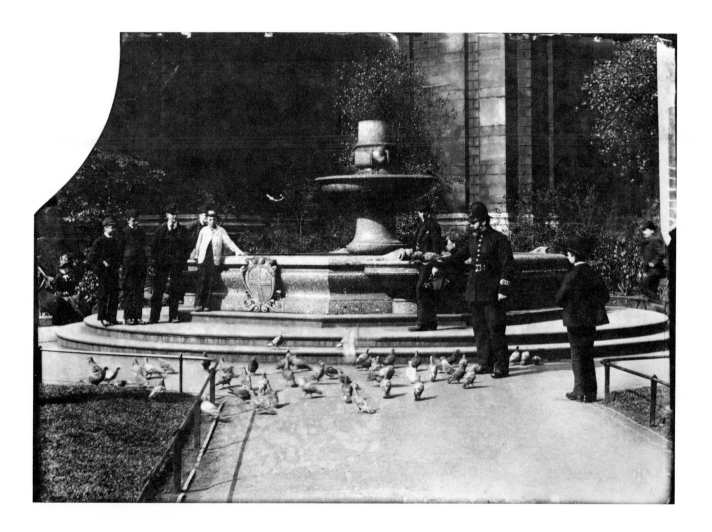

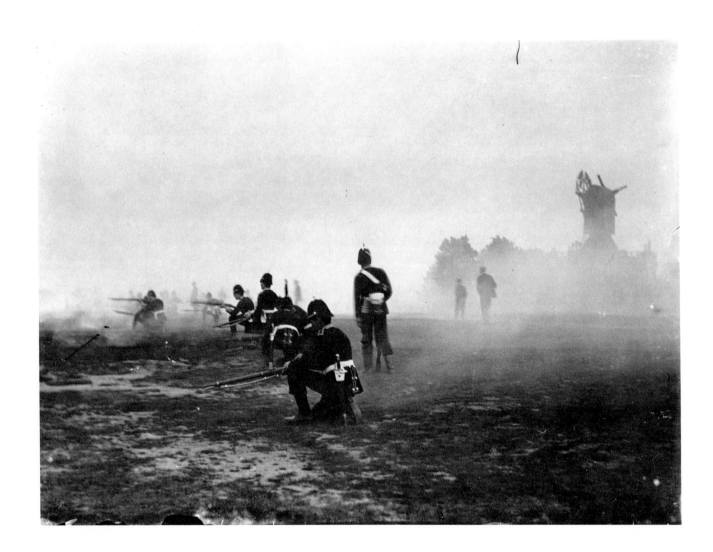

PLATE 3
London. 1892? An unidentified group.

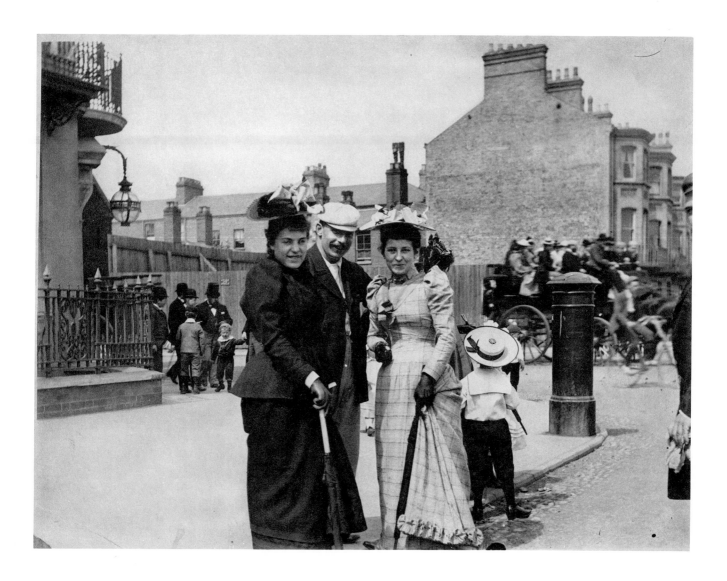

PLATE 4
London. 1893. Jack-in-the-Green.
"A Masquerade got up by sweeps to collect money for
charitable purposes on May Day. Now extinct."

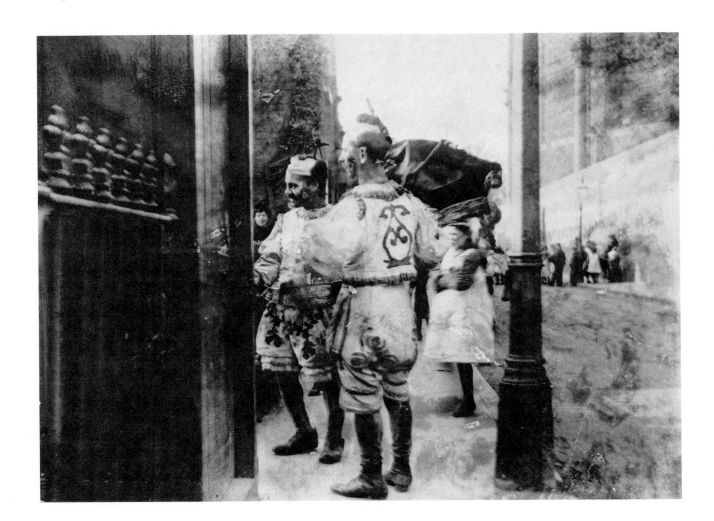

PLATE 5
*London. 1893. During periods of hot
weather the children were allowed to paddle in
the pool on the grounds of Lambeth Palace. Martin later
noted sadly that the area had been "turned into
tennis courts and a rock garden."*

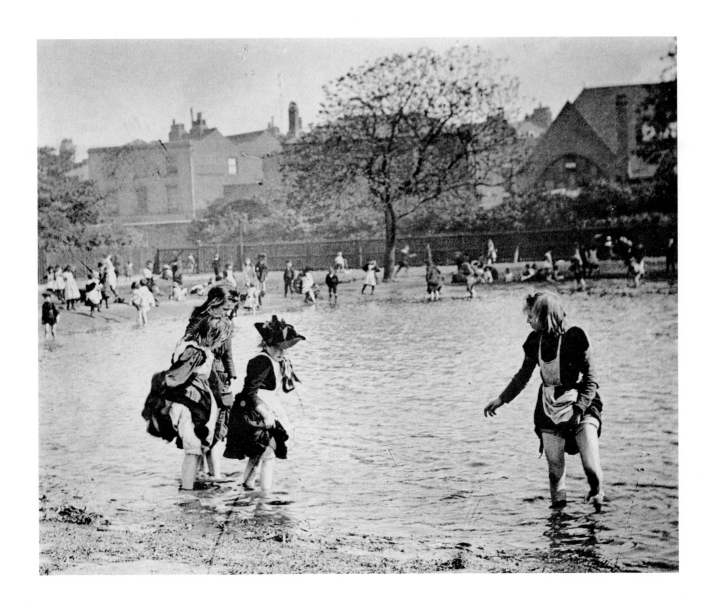

PLATE 6
*London. 1892? Children of the poor of
Lambeth following the ice cart in the New Cut (the lower
market) to get the pieces chipped off.*

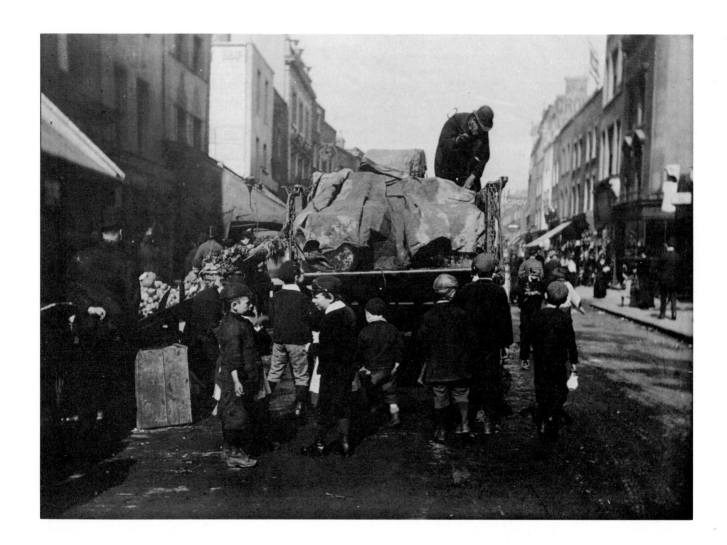

PLATE 7
*London. 1892. The children of the poor
involved in an altercation at the ice cream barrel in
the New Cut. "Note the old-fashioned beer can, usually carried
by errand boys with many others on a
broom stick."*

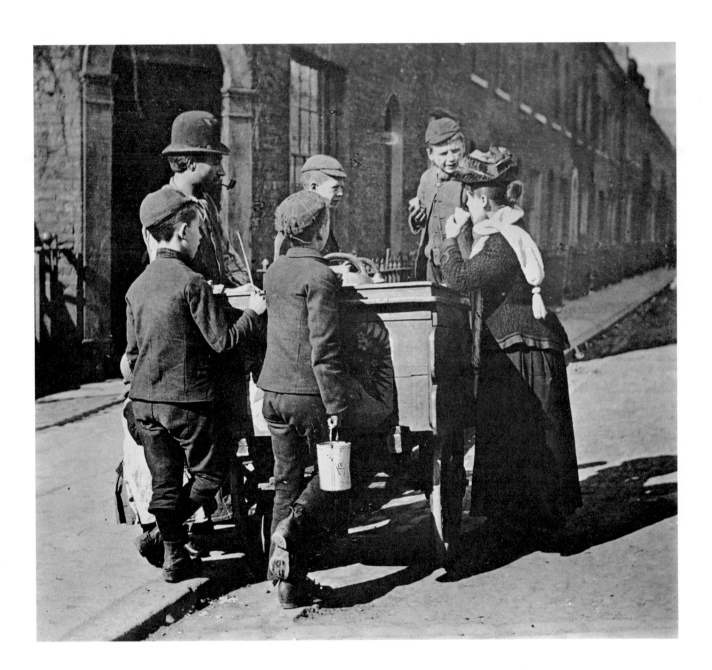

PLATE 8
London. 1893. "Dancing to the Organ."
"These kiddies are dancing to the Pas de Quatre, the
famous Gaiety piece. This entails plenty of leg twisting, which
is restricted by the children's clothes."

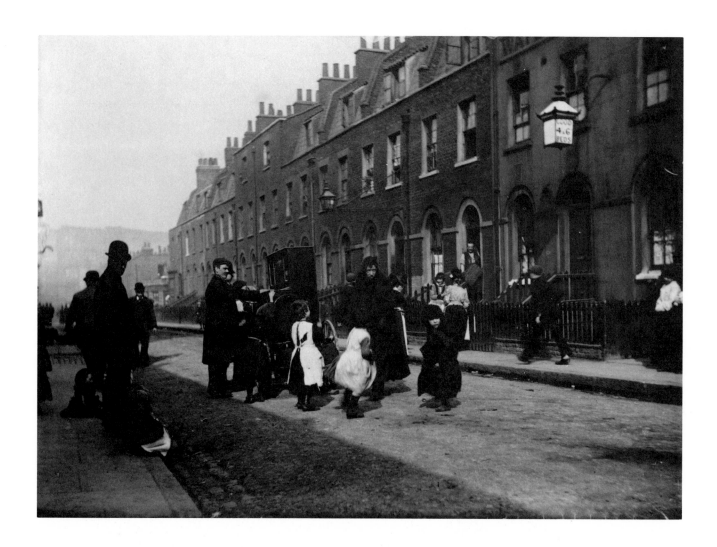

PLATE 9
London. 1894. A street market in Farrington Road.

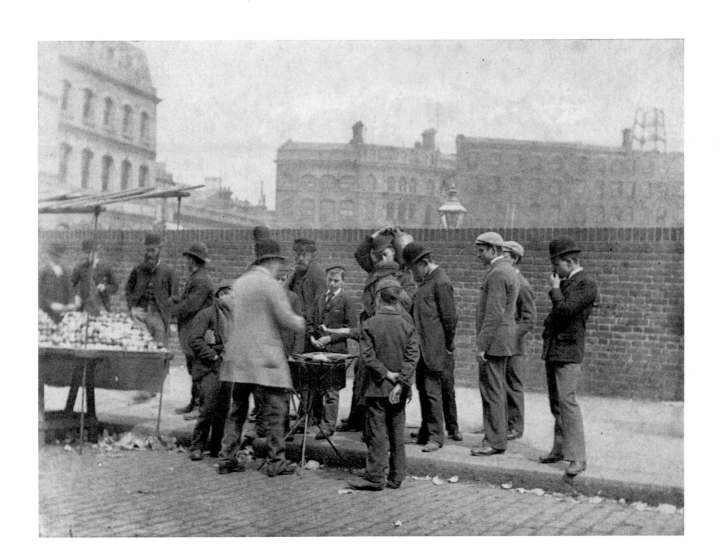

PLATE 10
London. 1892 or 1894. "Covent Garden Market, 7 A.M."

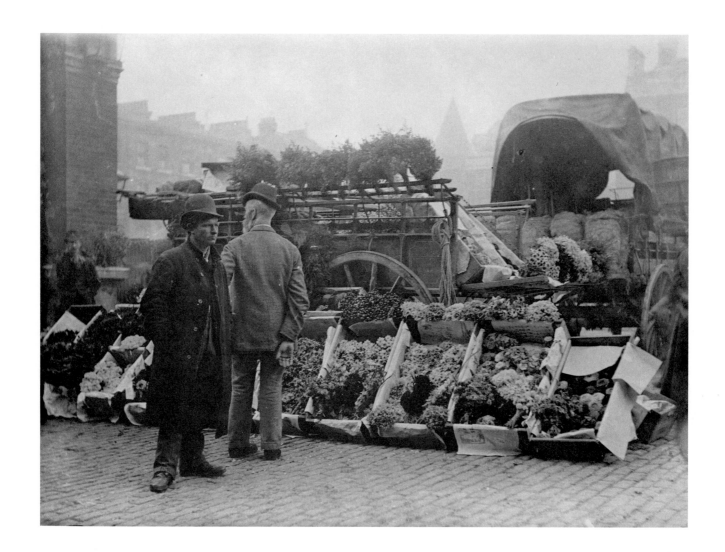

PLATE 11
London. 1894. The Billingsgate Fish Market.
"Loading Up the Railway Vans."

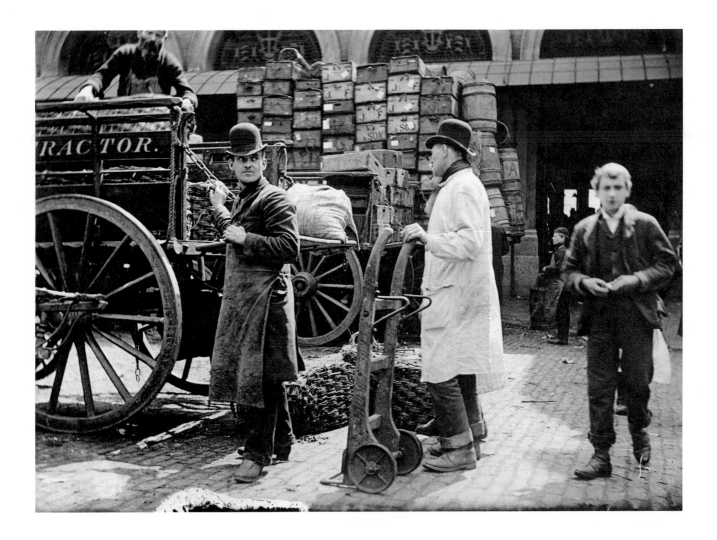

PLATE 12
*London. 1893 or 1894. Market
stalls in the New Cut. Martin noted that this particular stall
keeper had sold all her seafood goods.*

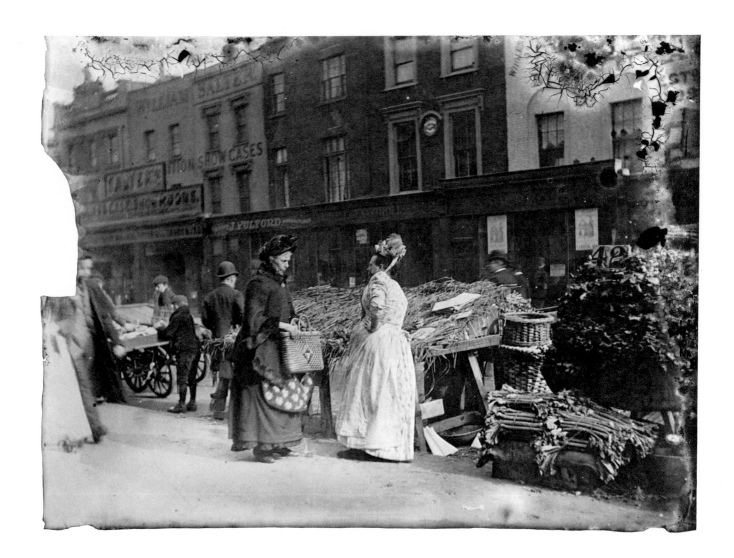

PLATE 13
*London. 1896. "The Midday Rest" of a
road repairing crew. "In the distance is seen Ludgate Hill
Station, now obscured by buildings, shops, etc."*

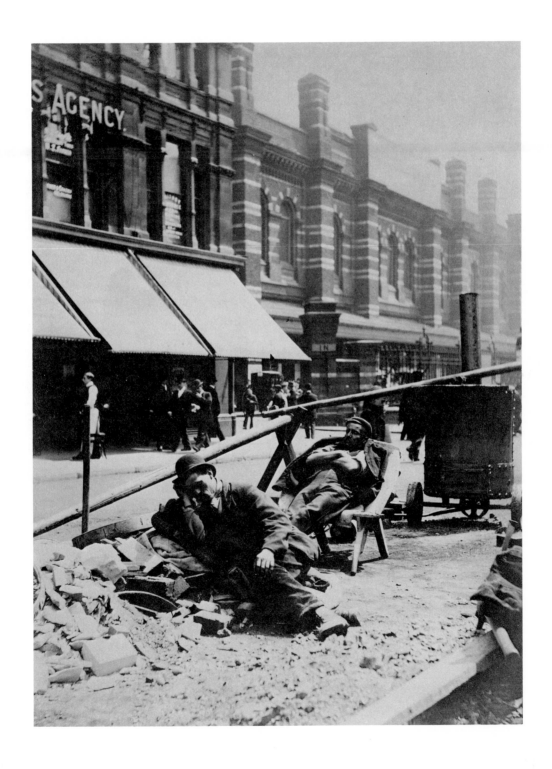

PLATE 14
*London. 1893? "The Cutler." Martin did
many studies in his series of one-man businesses in the city.
In this instance, although the subject is oblivious to
Martin's presence, note the interest of the
bystander.*

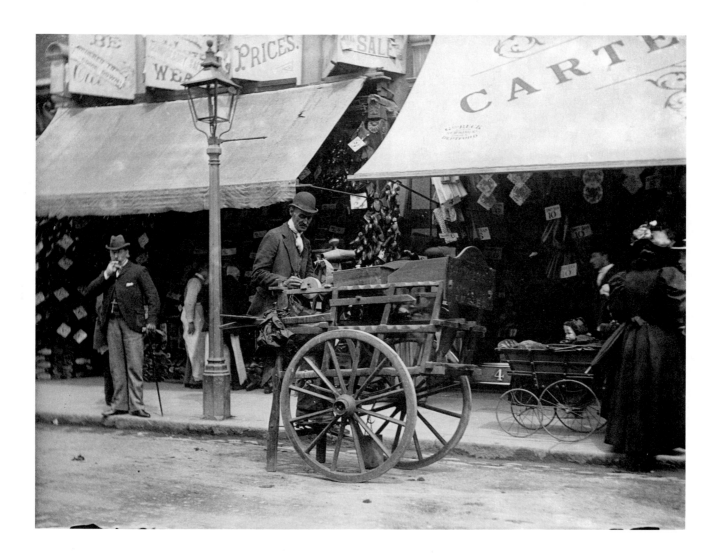

PLATE 15
London. 1893? "The Tinker." "Any Pots or Kettles to Mend."

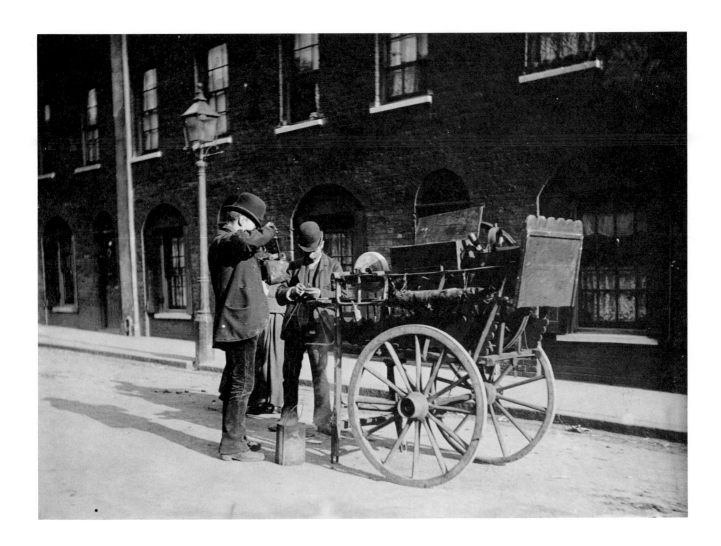

PLATE 16
*London. 1893. "A Drink in Cheapside." "Refreshments
(½d per glass, sherbet and water)."*

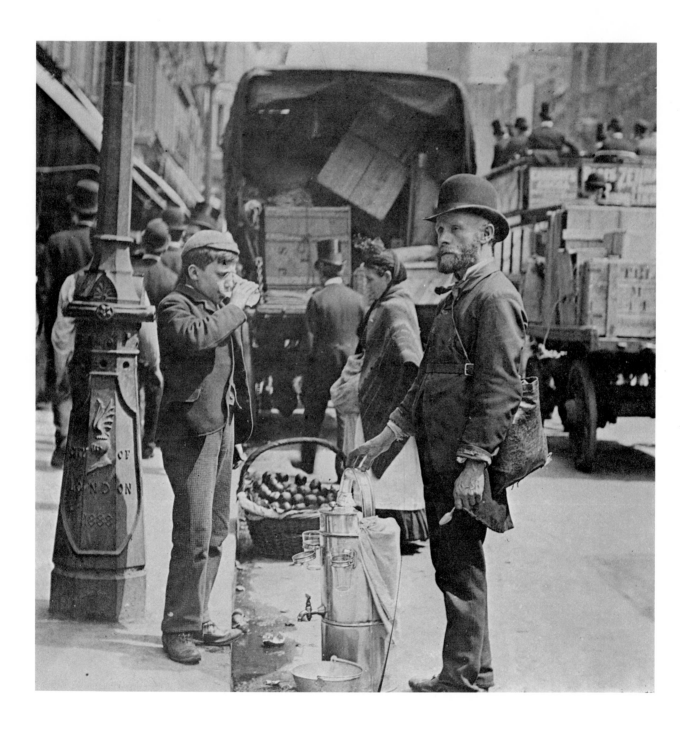

PLATE 17
London. 1893? "General Dealer."

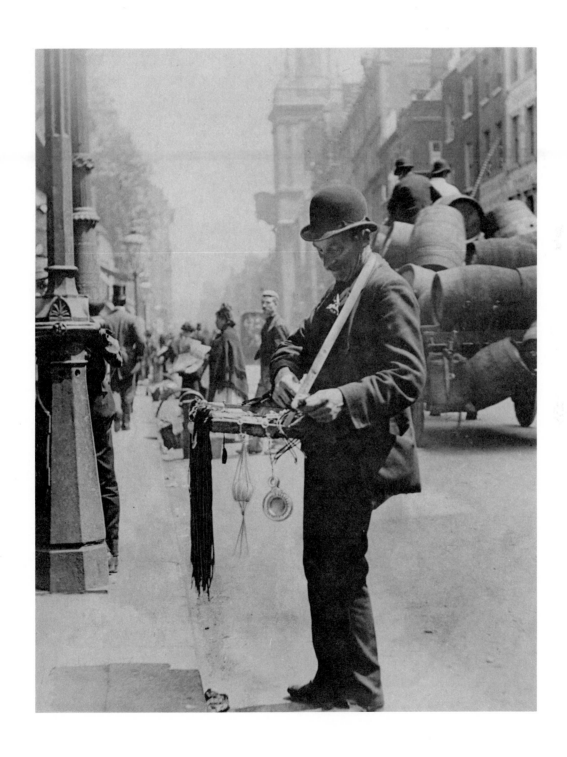

PLATE 18
London. 1893? "Butcher's Knives to Grind."

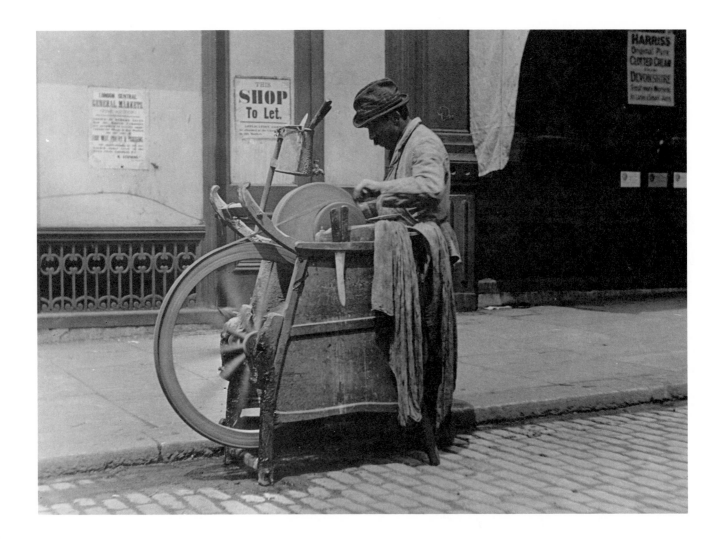

PLATE 19
London. 1894. "The Cheapside Flower Seller." "1d a Bunch."

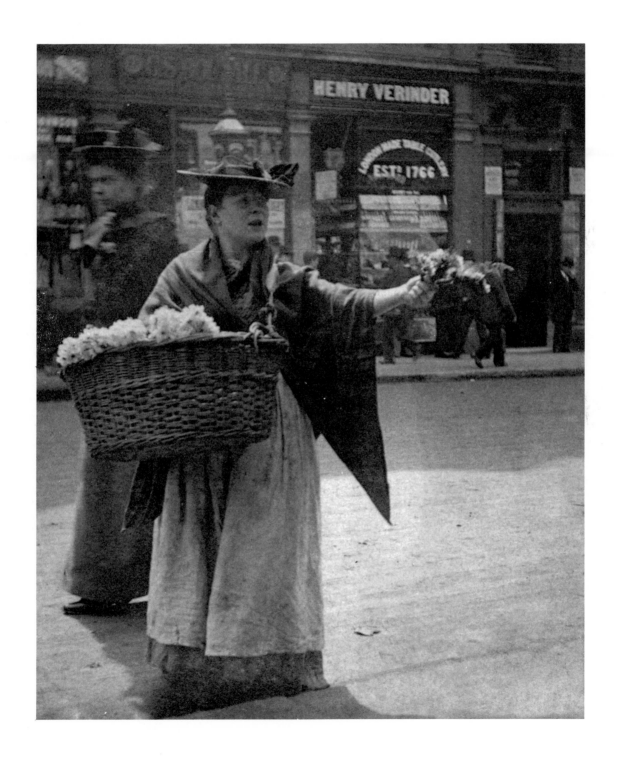

PLATE 20
London. 1893. The magazine seller at Ludgate Circus.
"Tit Bits was her greatest sale."

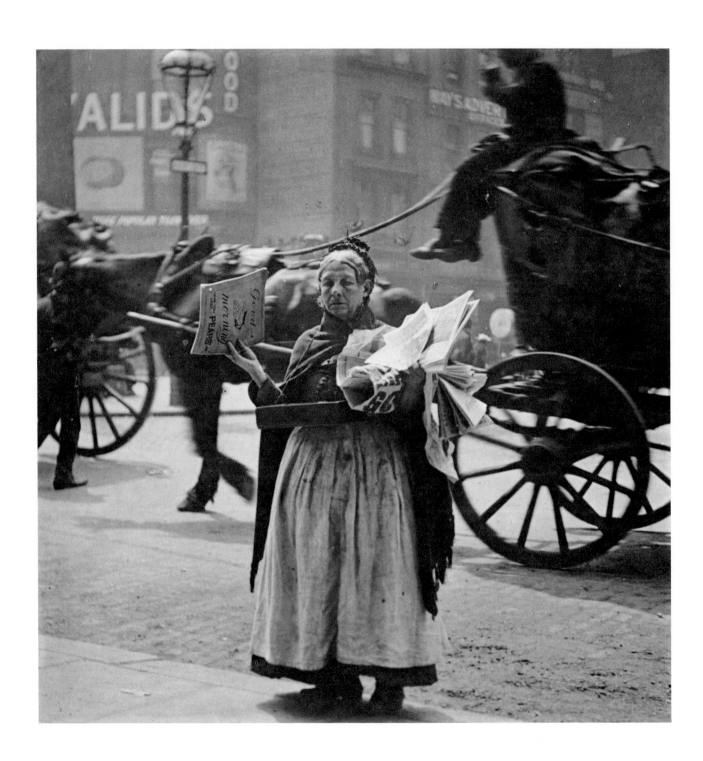

PLATE 21
London. 1893 or 1894. "Unloading Straw."
"Carrying Trusses of Straw from Barge." Martin
photographed a series of various
London porters.

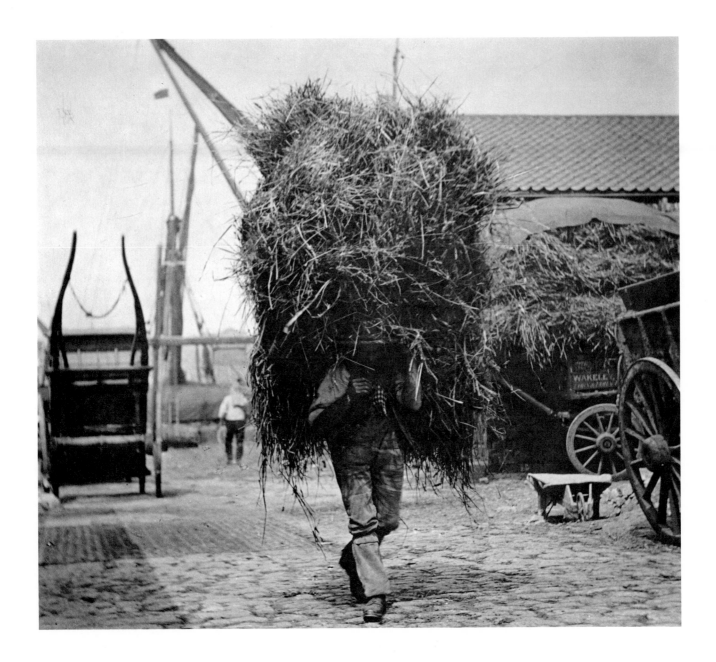

PLATE 22
London. 1893 or 1894. A fish porter at the
Billingsgate Fish Market.

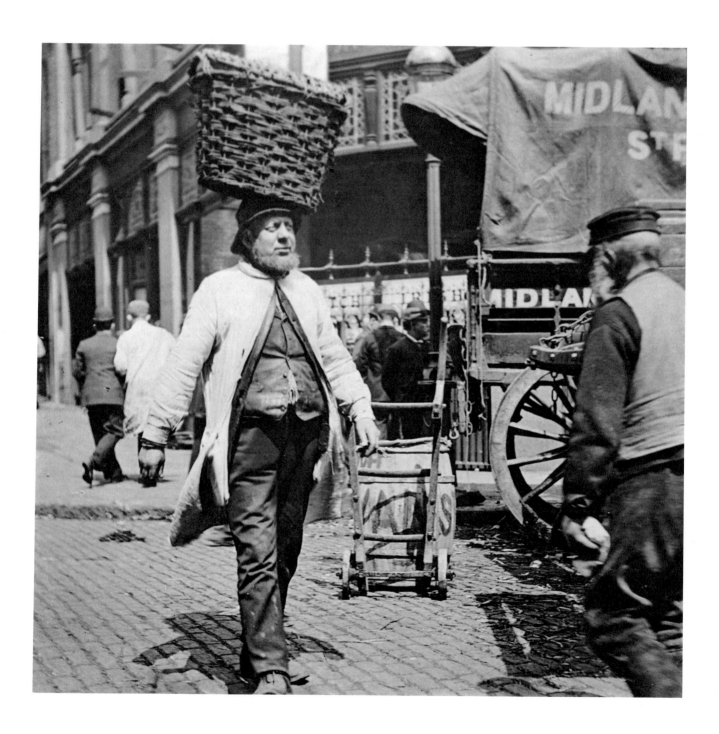

PLATE 23
London. 1893? Fish porters at the Billingsgate Fish Market.

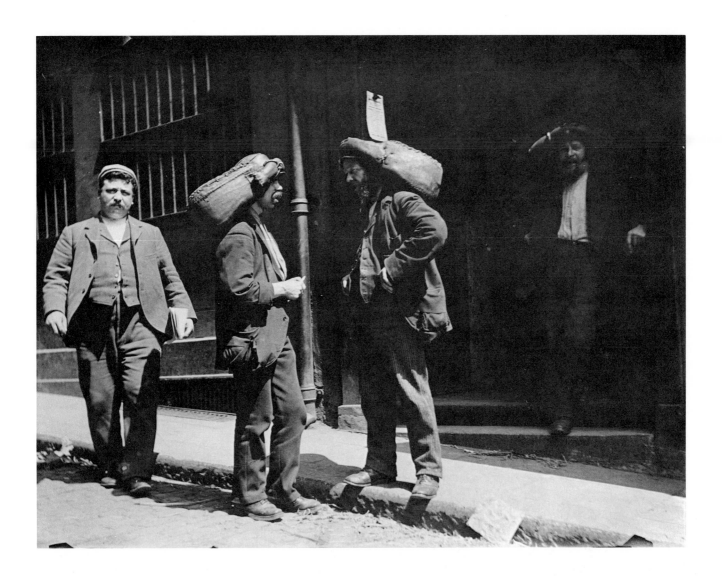

PLATE 24
*London. 1893? Fish porters at Billingsgate:
one of Martin's cut-out figure studies. He was to enjoy a great
deal of popularity with his slide presentations
of such "living statues."*

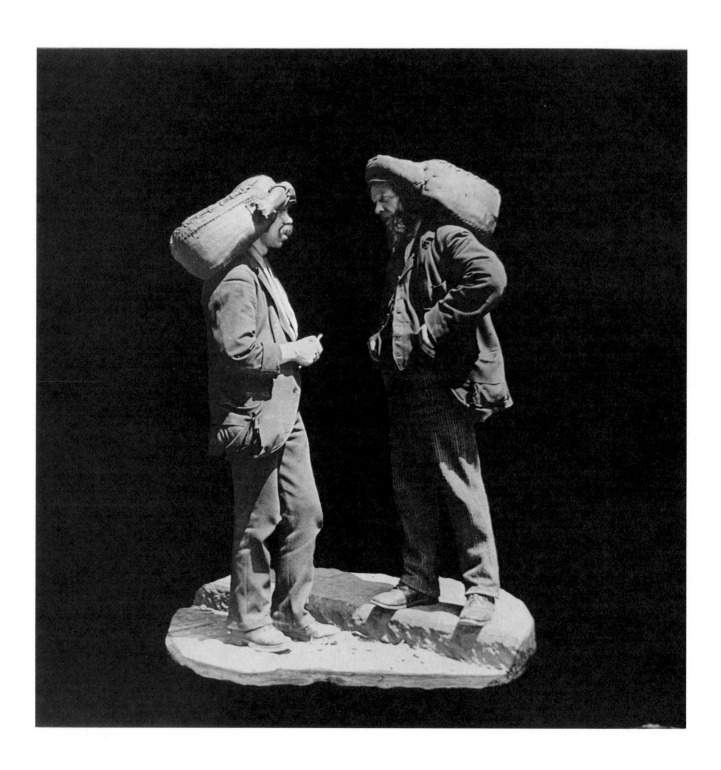

PLATE 25
London. 1894. The Cheapside flower seller: a cut-out figure.

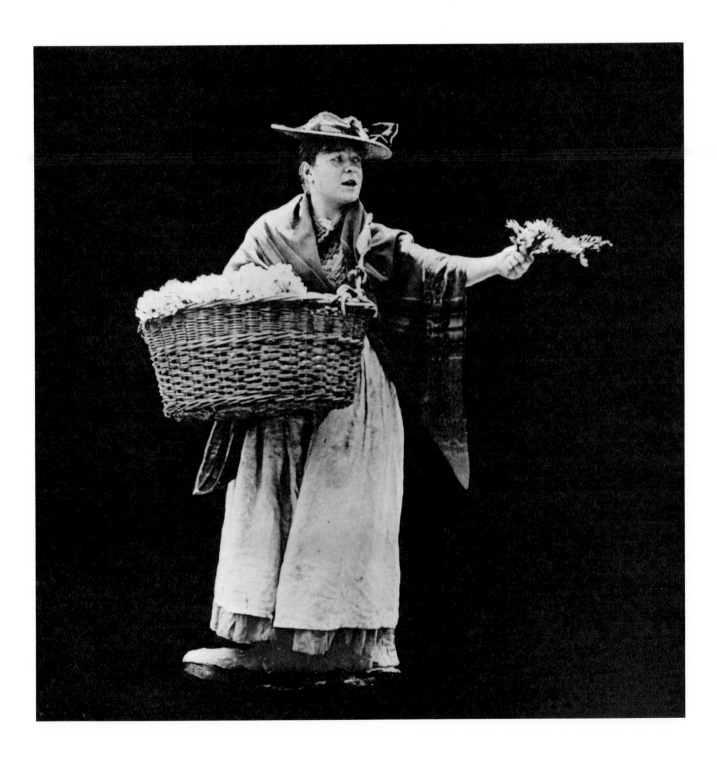

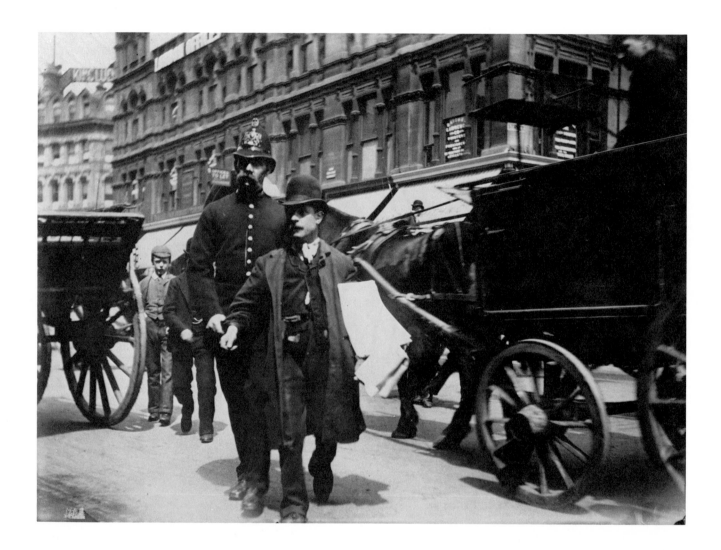

PLATE 27
*London. 1894. "Rescuing the Lady." An
overturned street cab in High Holborn. "Safe in the
hands of the Police. The bridegroom looks quite pleased
about it." Martin noted that "the first thing to do in
such a case is to sit on the horse's head."*

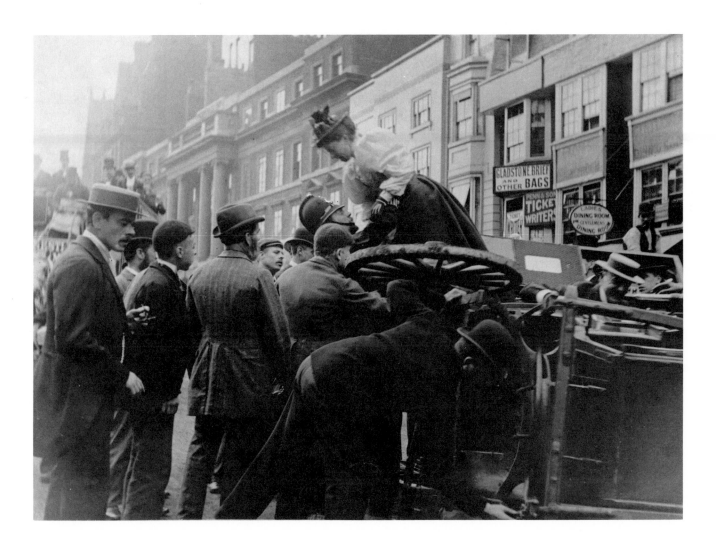

PLATE 28
*London. 1892? "Waiting to See the Policeman's
Funeral in Southwark."*

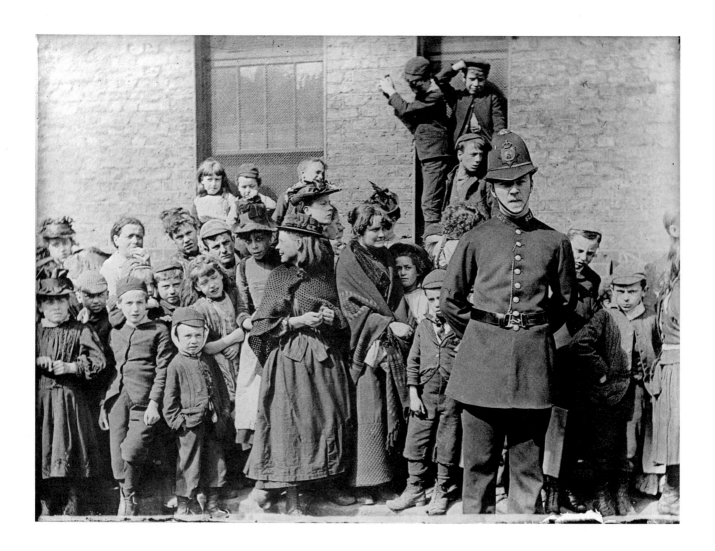

PLATE 29
London. 1892. "Chelsea Bridge Fair near
Battersea Park. Trying his skill with the air gun. 1d
a shot. If he gets a bull's eye he will have
some monkey nuts as a prize."

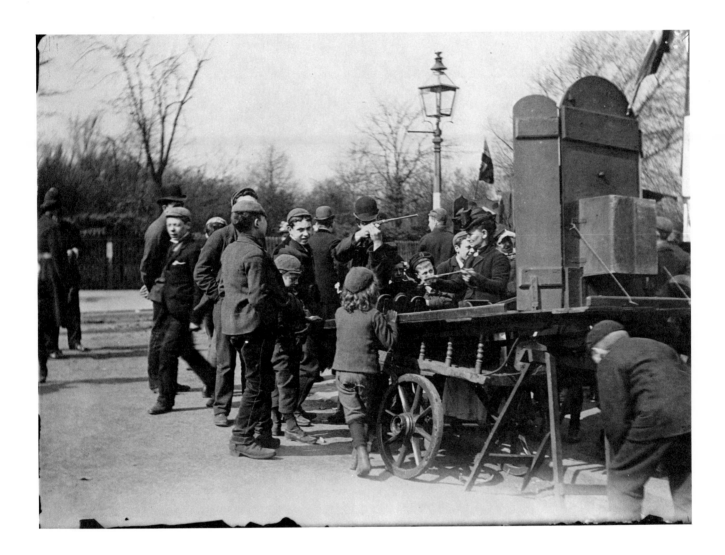

PLATE 30
*London. 1892. Battersea Park Fair. "Bread and Saveloy
(sausage) for 1d. All very fine and large."*

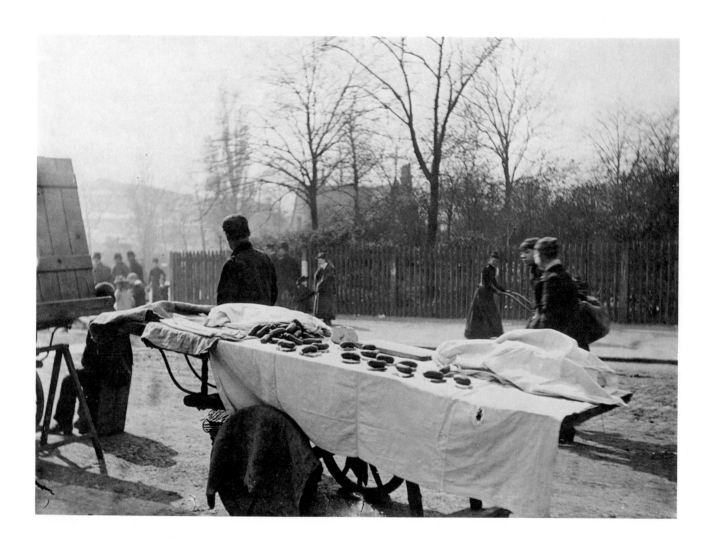

PLATE 31
*London. 1892. "Children of the Poor
of Battersea." "A Free Drink at the Fair." "Free
Refreshing Cup by the Roadside."*

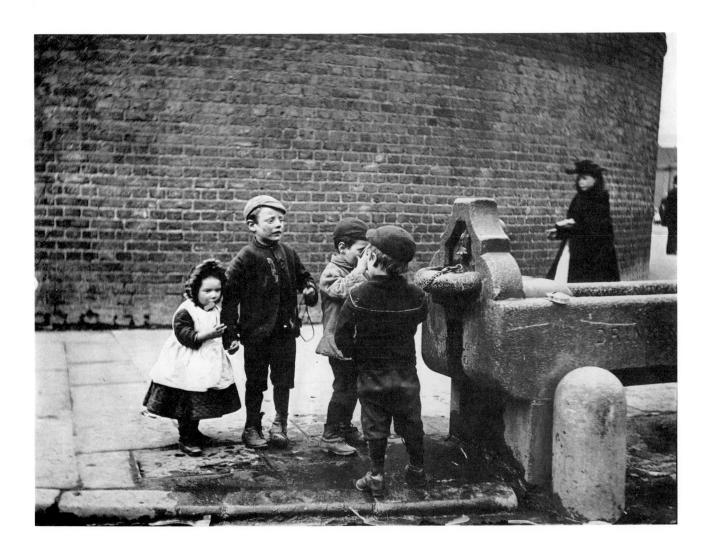

PLATE 32
*London. 1896. "Bank Holiday on Hampstead
Heath." Girls dancing to the music of the mouth organ. The
heath was a popular site for Londoners to celebrate the August
Bank Holiday with dancing and fairs.*

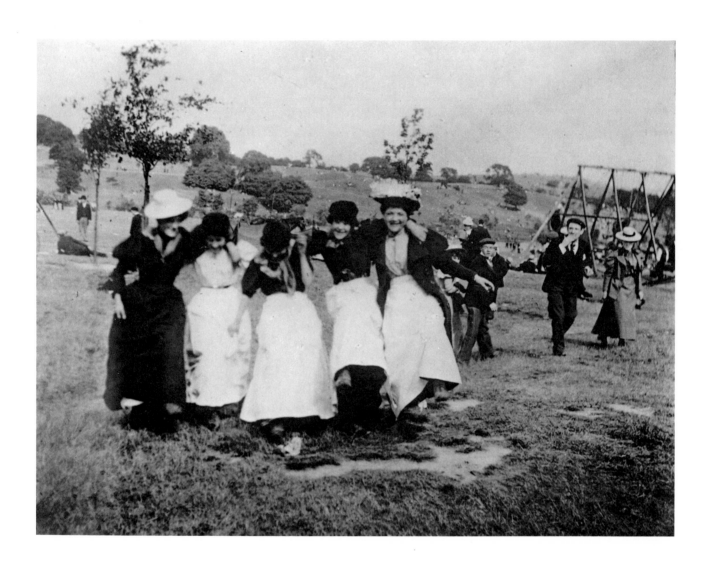

PLATE 33
London. 1897. "Entrance to Victoria Park."
The largest green park in East London, it became
a natural gathering place on Sundays and holidays for
members of the working and middle classes
who lived around it.

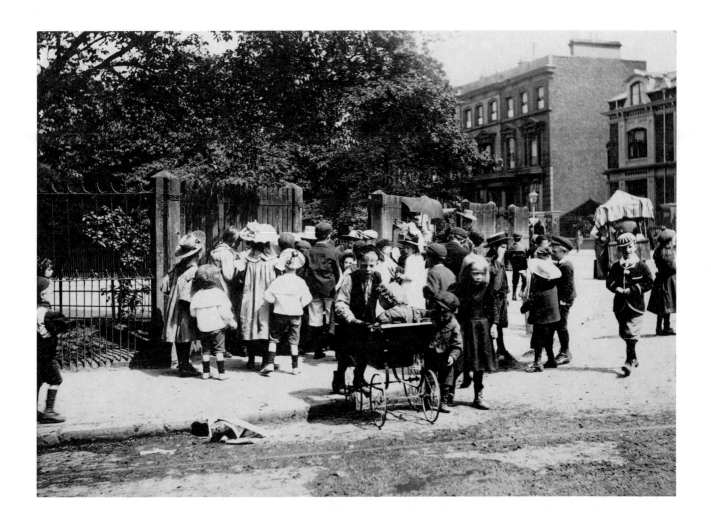

PLATE 34
*London. 1898. Victoria Park. "The Church
Parade." Members of the middle class stroll about the
park in their fashionable Sunday best.*

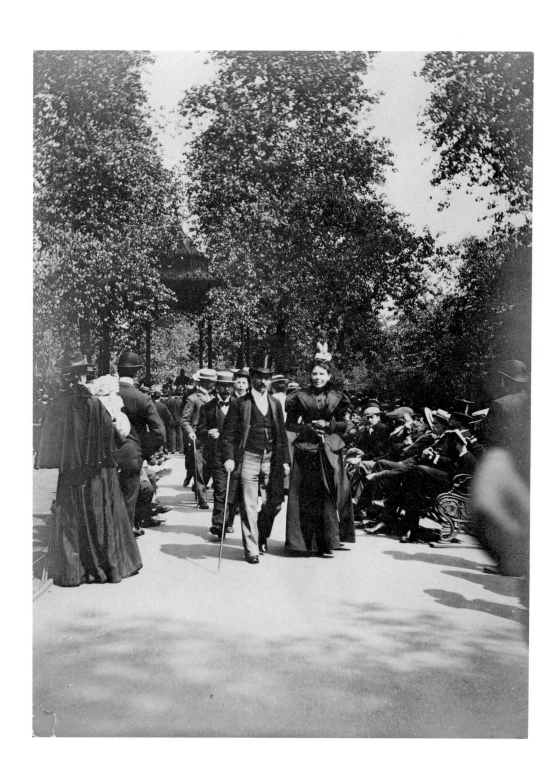

PLATE 35
London. 1898. Victoria Park. "Three Little Girls Resting."

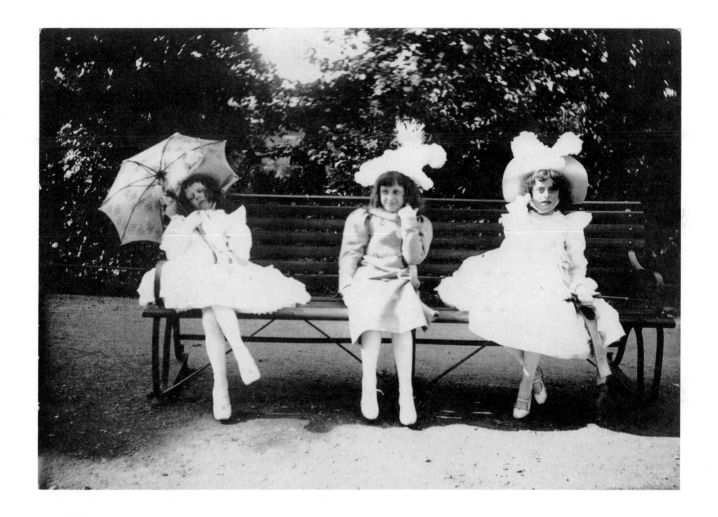

PLATE 36
London. 1894–1895. The Great Frost.
"An Ice Covered Barge near Blackfriar's Bridge."
The severe winter weather, some of the worst in the city's
history, lasted through well over two months.

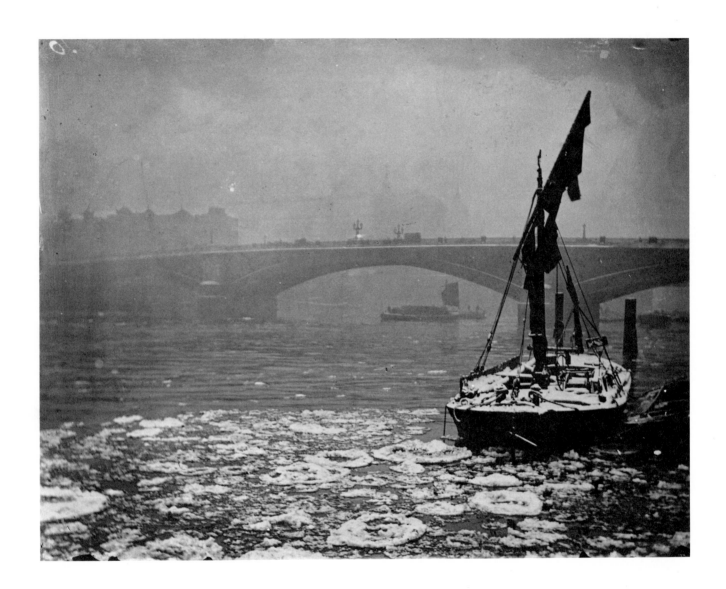

PLATE 37
*London. 1894–1895. The Great Frost. "Penn
Ponds in Richmond Park."*

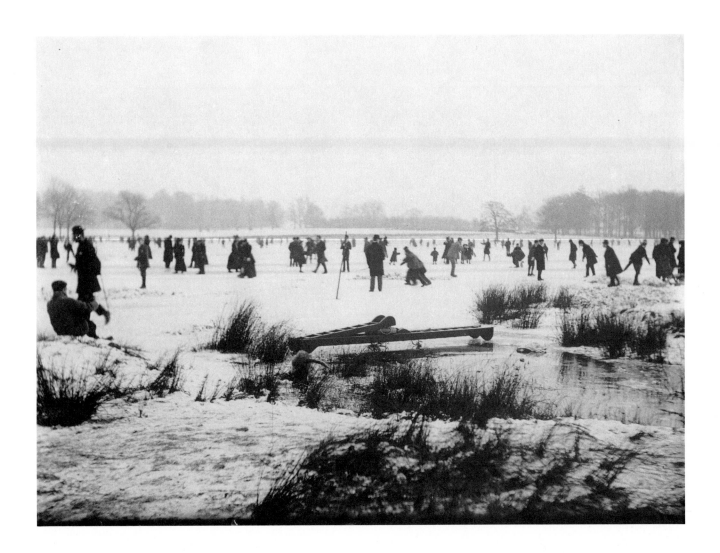

PLATE 38
*London. 1894–1895. The Great Frost. "Snow Scene along
the Embankment. No Trams Running There."*

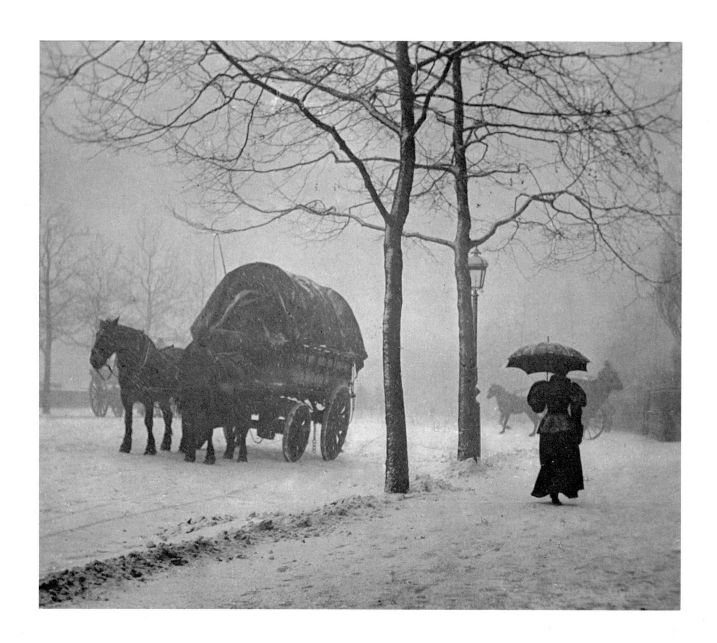

PLATE 39
*London by Gaslight. 1896. "Big Ben
(A Late Sitting) and Westminster Bridge." Martin's
series of night views, first presented publicly as lantern slides,
were to be his most famous and popular
images in his day.*

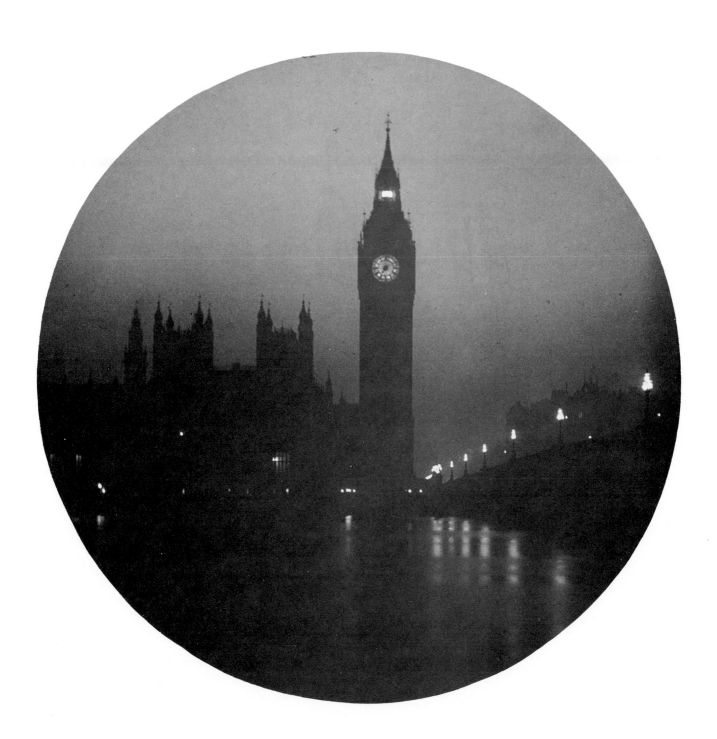

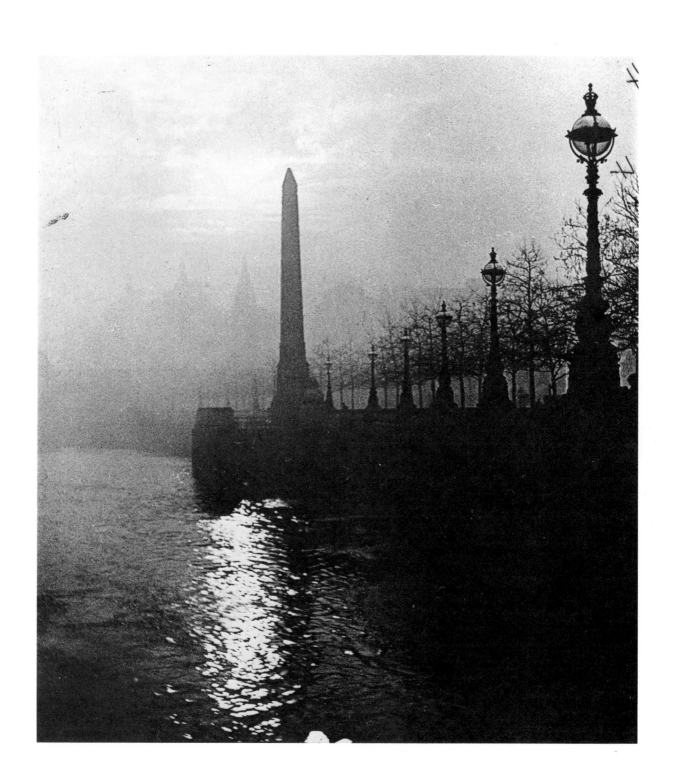

PLATE 40
*London by Gaslight. 1896. "Cleopatra's
Needle." The monolith was the subject of Martin's first
experiments in night photography.*

PLATE 41
*London by Gaslight. 1896. "The Alhambra
at Night." The theatre, located in Leicester Square, bears signs
announcing the Animatographe—an early kinematograph.*

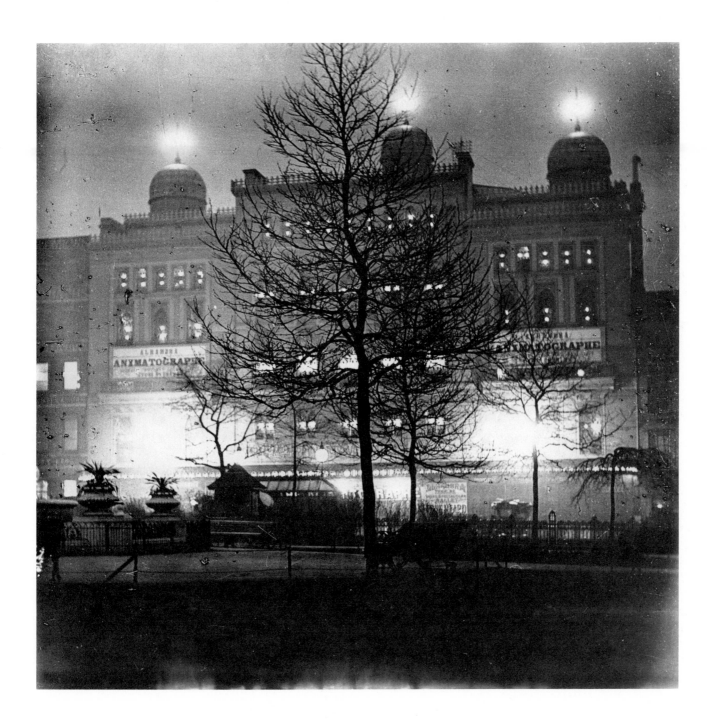

PLATE 42
London by Gaslight. 1896. "Eros in
Piccadilly Circus, taken just after being completed
(pre-war). A wet night effect." Martin gave the following data
on this image: "Fifteen minutes exposure—the lens
had to be shielded each time from the lights
of passing cabs."

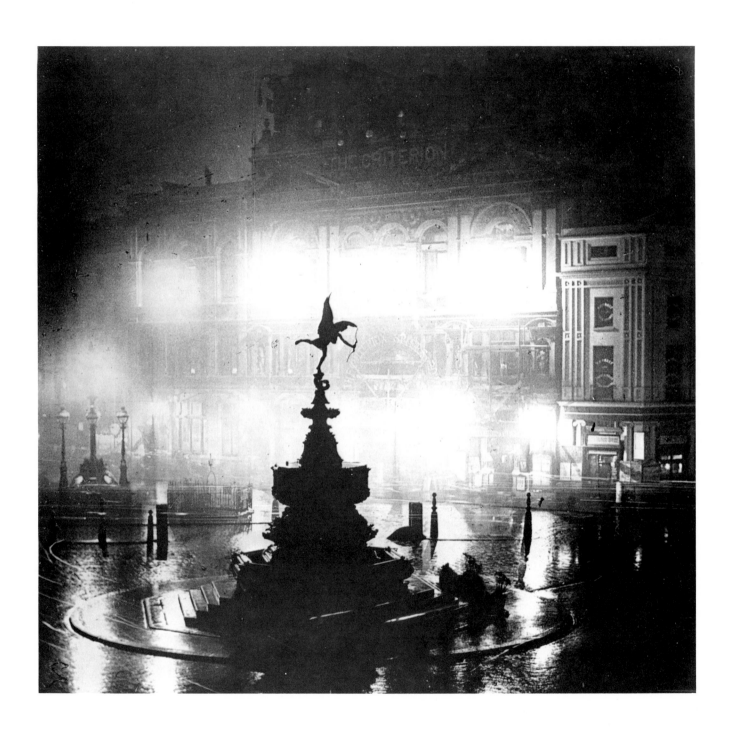

PLATE 43
*London by Gaslight. 1896. "The Old Empire
in 1896. Scene on a wet night. A great attraction was the
coming of the Cinematograph by Lumiere."*

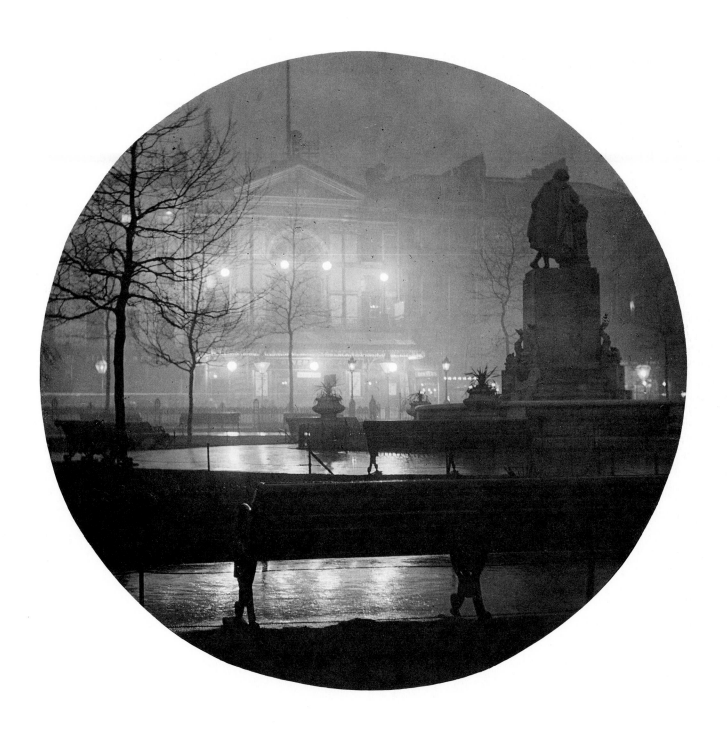

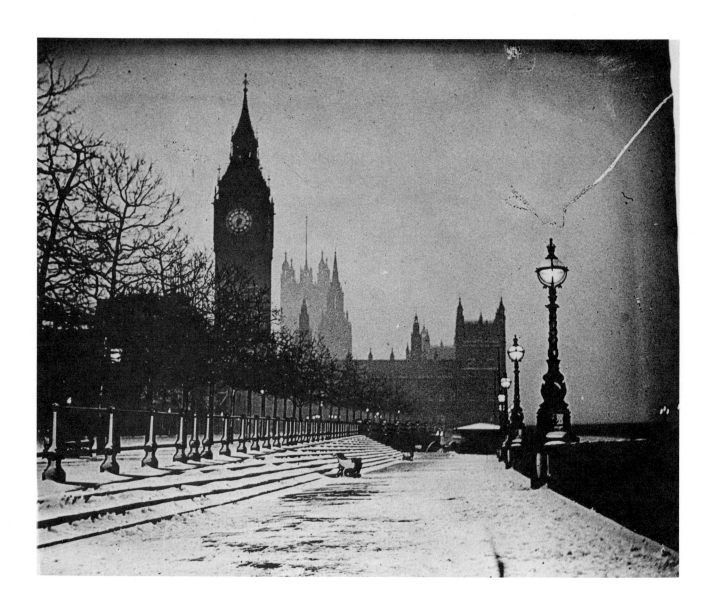

PLATE 45
A pictorial effect. No date. Martin was not unaffected by the pictorialists and landscape photographers of his day.

PLATE 46
Caterham. 1886. "A Game of Billiards."
Another rare interior photograph and one of Martin's early
images. The subjects were probably some of his
woodpecker friends on a holiday outing.

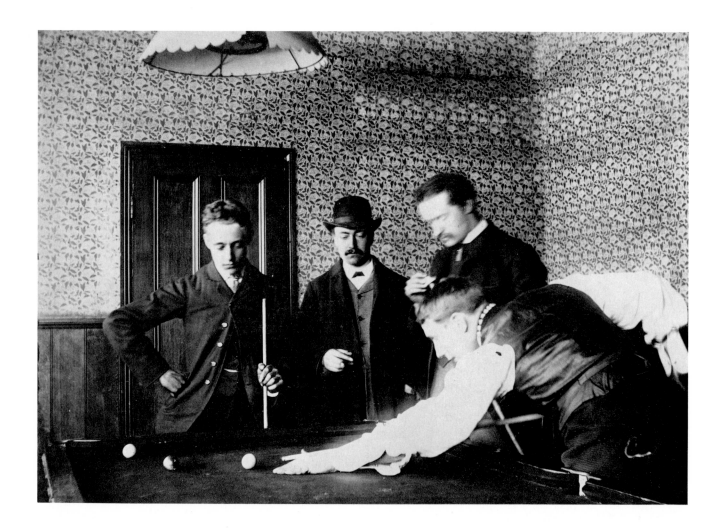

PLATE 47
*Camping out on the Thames River. 1888. The camp in Quarry
Woods. The campsite of Martin and his friends on holiday.*

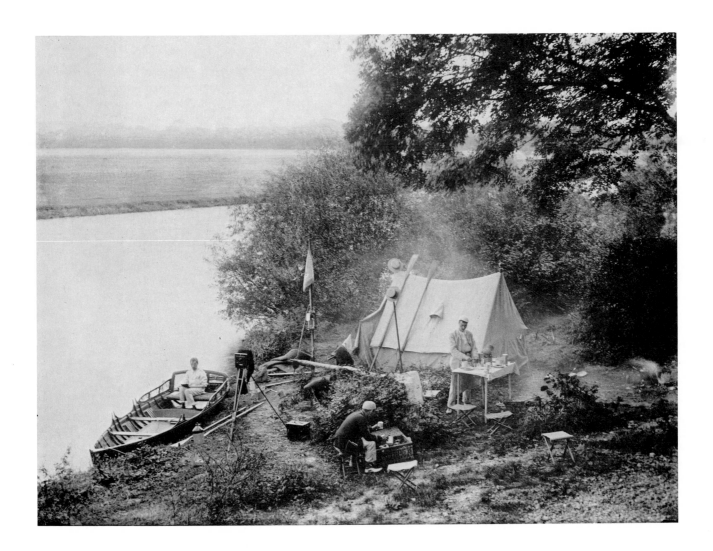

PLATE 48
*Camping out on the Thames River. 1887. A group of Martin's
fellow campers pose for a portrait at Iffley.*

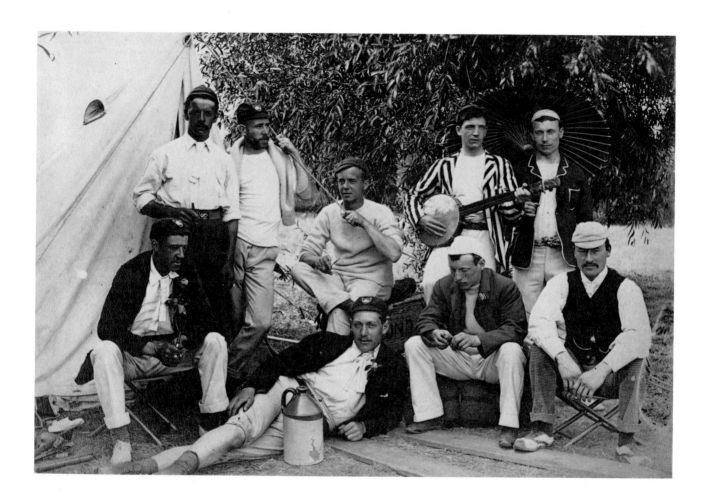

PLATE 49
Camping out on the Thames River. 1888.
An early morning scene at Pangbourne. It is this image
that won Martin a silver medal in a photography contest held
by The Amateur Photographer *magazine in 1889.*

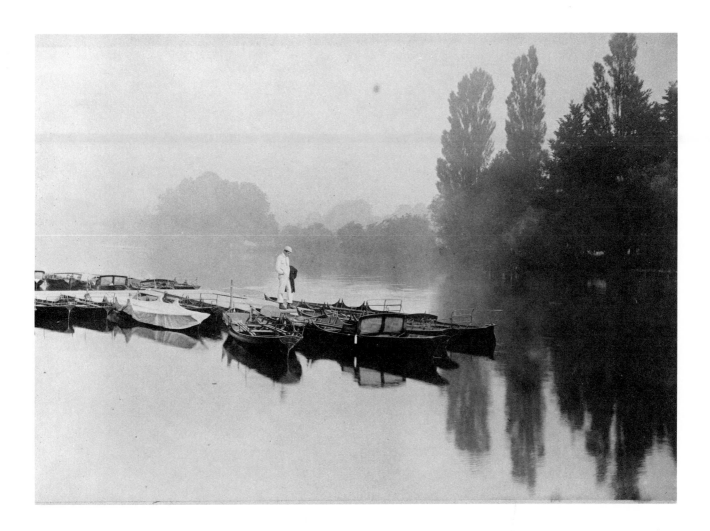

PLATE 50
On the River Mole. 1886 or 1889. "An Old Surrey Tramp."
Martin found his subject while exploring on holiday.

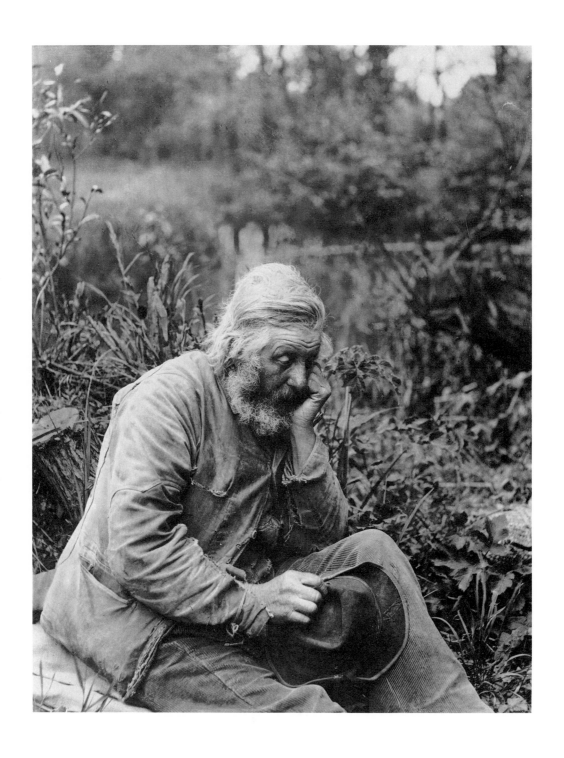

PLATE 51
*Yarmouth. 1892. "Trippers Caught by the
Sea." The holiday vacation marked Martin's first time out
with his newly acquired Facile camera; he returned
with many memorable photographs.*

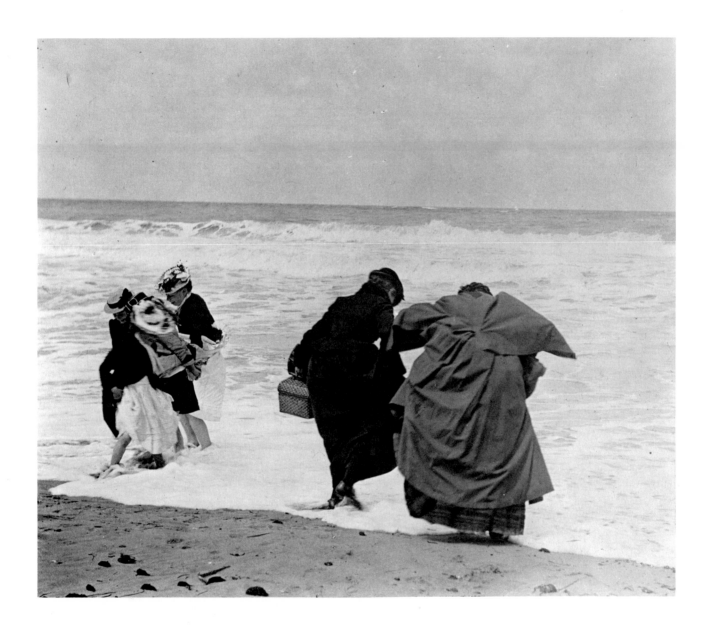

PLATE 52
Yarmouth. 1892. "Returning from a Dip in the Briny."

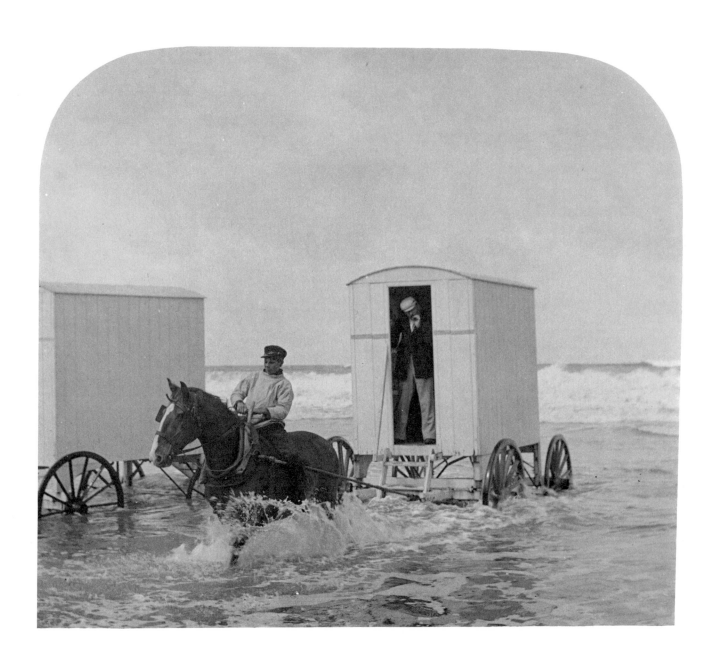

PLATE 53
Yarmouth. 1892. "Bathers at Yarmouth."
"How the ladies washed in those days." "The
section reserved for the ladies was at the opposite end of
the beach. The water was quite six inches deep, so
that the fear of drowning was negligible."

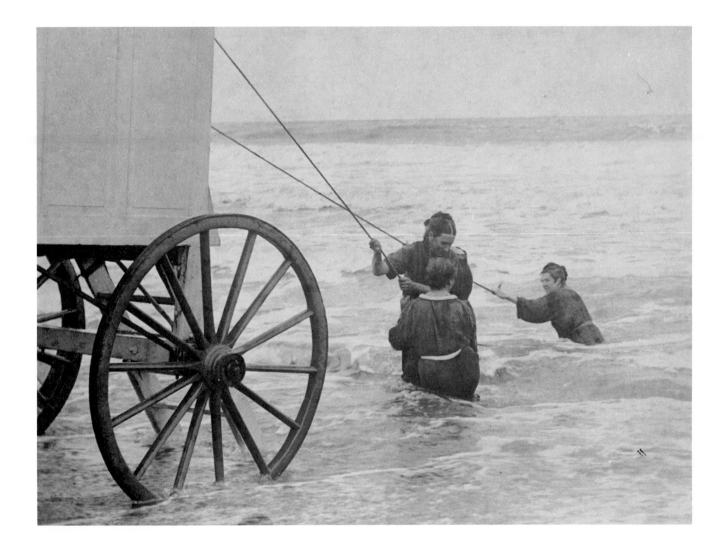

PLATE 54
Yarmouth. 1892. Capstone Hill, Ilfracombe.

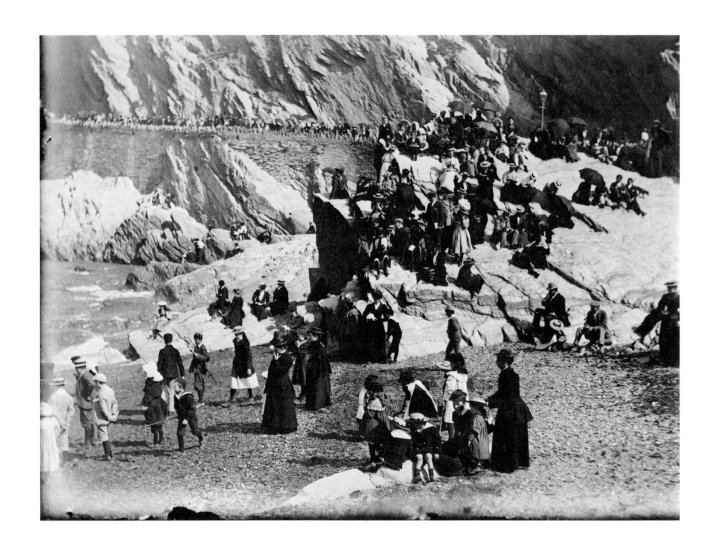

PLATE 55
Yarmouth. 1892. Children playing on the sands.

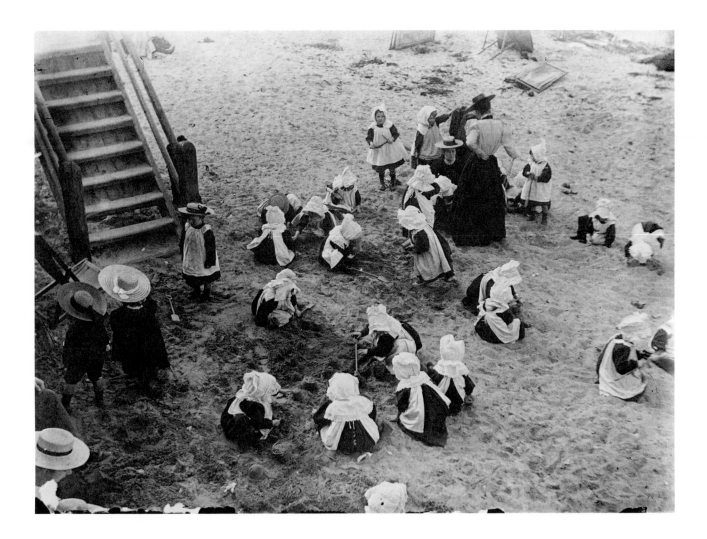

PLATE 56
Yarmouth. 1892. "A Loving Couple" on the sands.

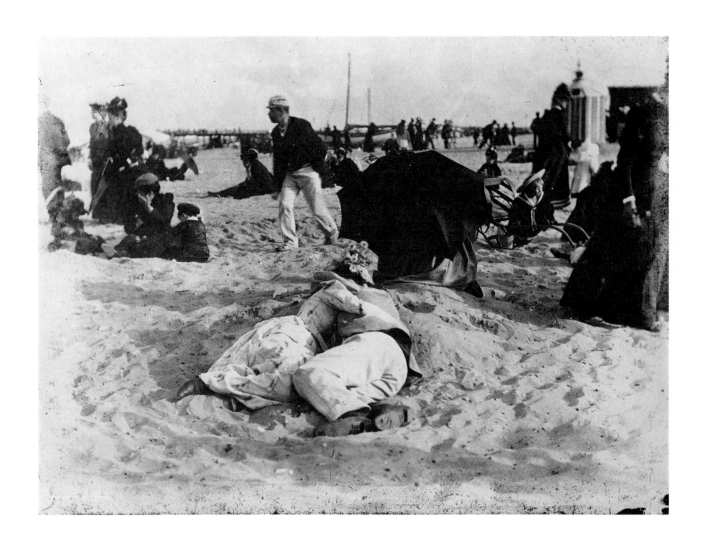

PLATE 57
Yarmouth. 1892. "Two Little Girls in
Blue." "The concert party does not begin until 3 PM, so
young couples have a rest on the sands."

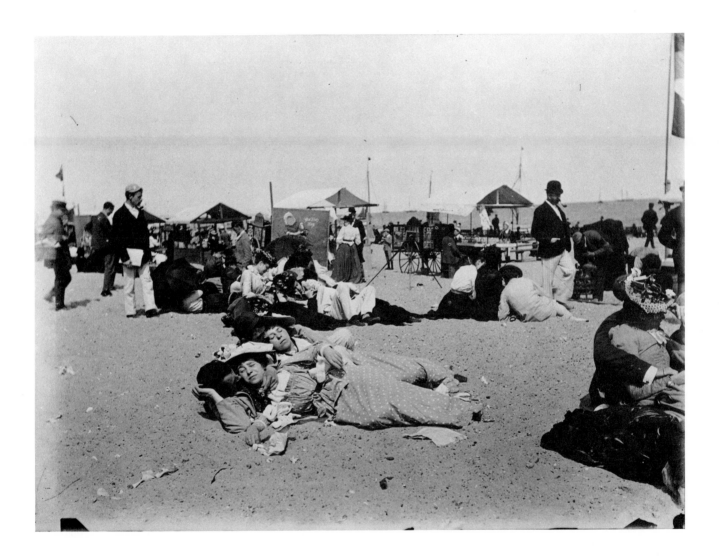

PLATE 58
Yarmouth. 1892. Another couple on the sands.

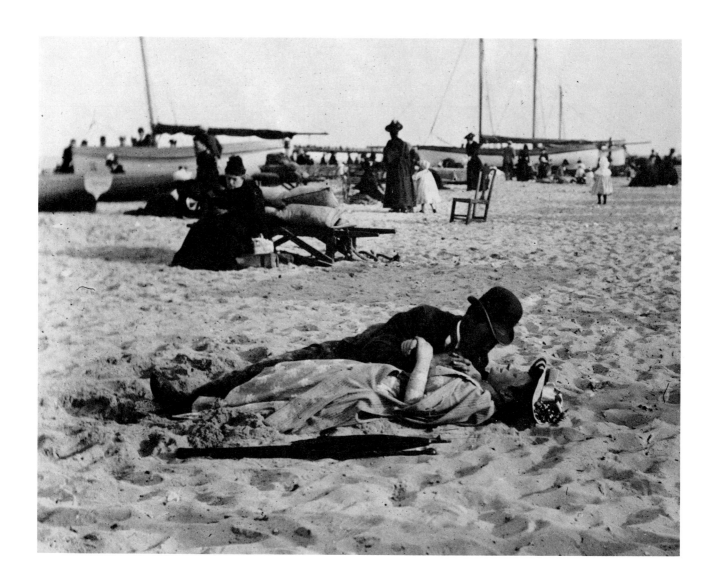

PLATE 59
*Yarmouth. 1892. Spectators watch the Punch
and Judy Show at Ilfracombe.*

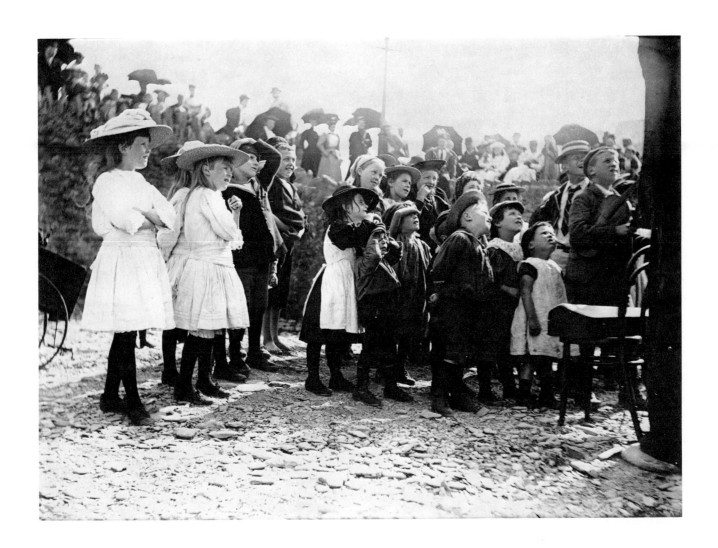

PLATE 60
*Yarmouth. 1892. A fortune teller. "Your fortune told
by a little love bird for 1d."*

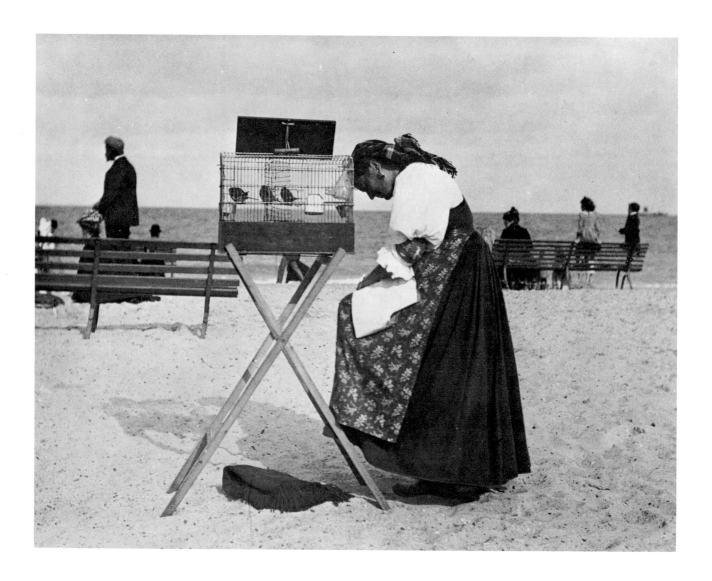

PLATE 61
*Yarmouth. 1892. During the absence of the
beach photographer, Martin took this snapshot of his friends
clowning around with the Pears Soap
advertisement board.*

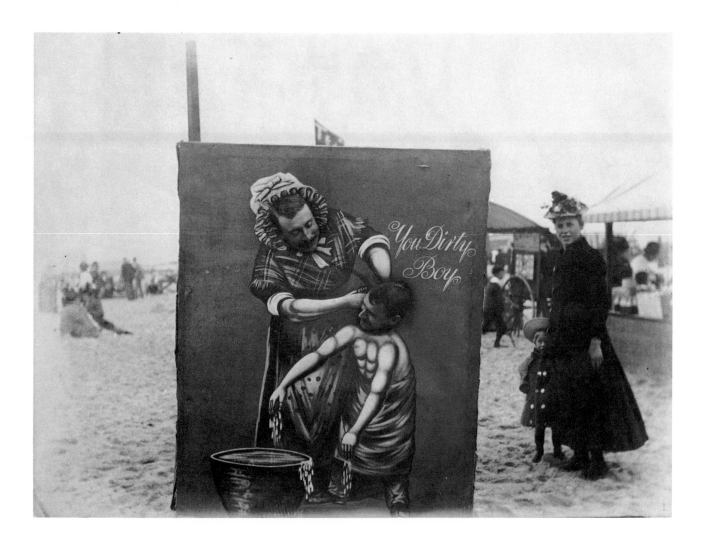

PLATE 62
Hammersmith. 1894. The University Boat Race.
Note the stands atop the buildings.

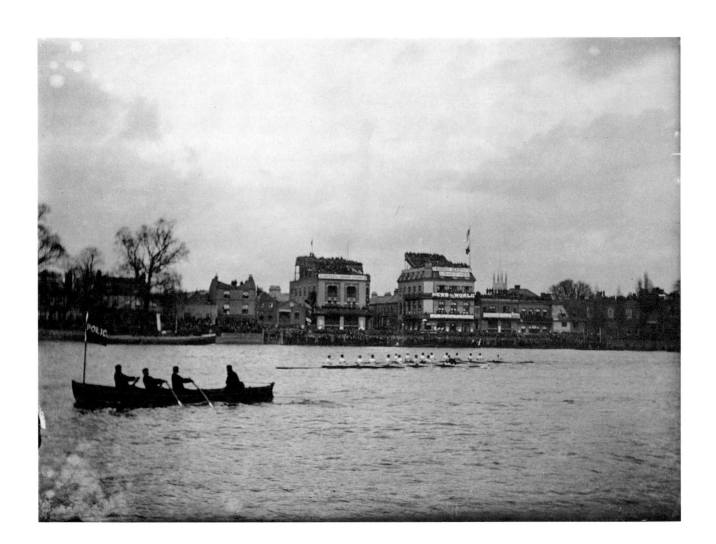

PLATE 63
*Hammersmith. 1894. The seats on one of the barges
for viewing the University Boat Race.*

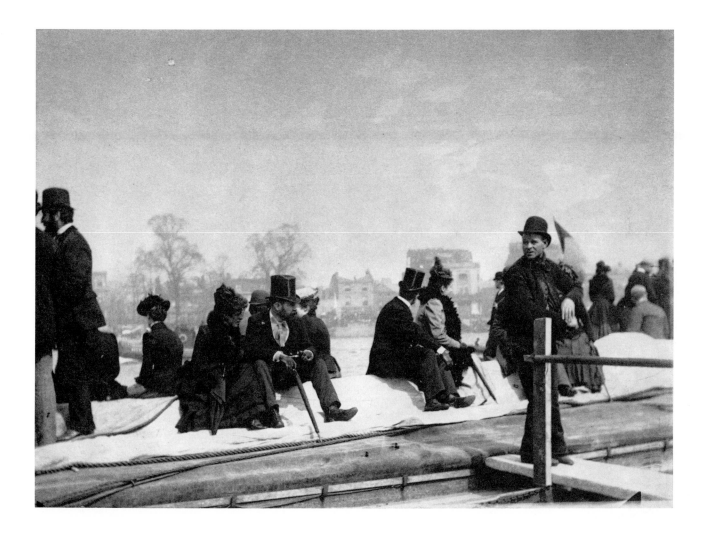

PLATE 64
*Hastings. 1896. Martin drenched himself
and his Facile camera to capture the stormy seas
and waves breaking at St. Leonard's.*

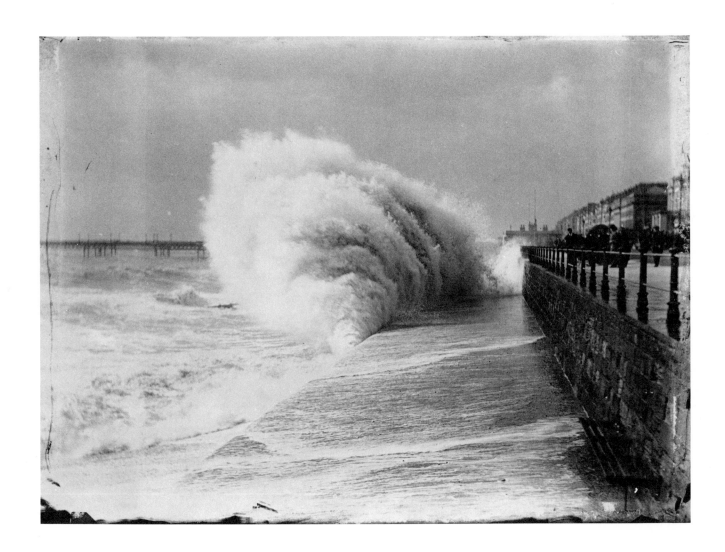

PLATE 65
*Hastings. 1896. During the gales which struck while Martin
was on holiday in this English coastal town.*

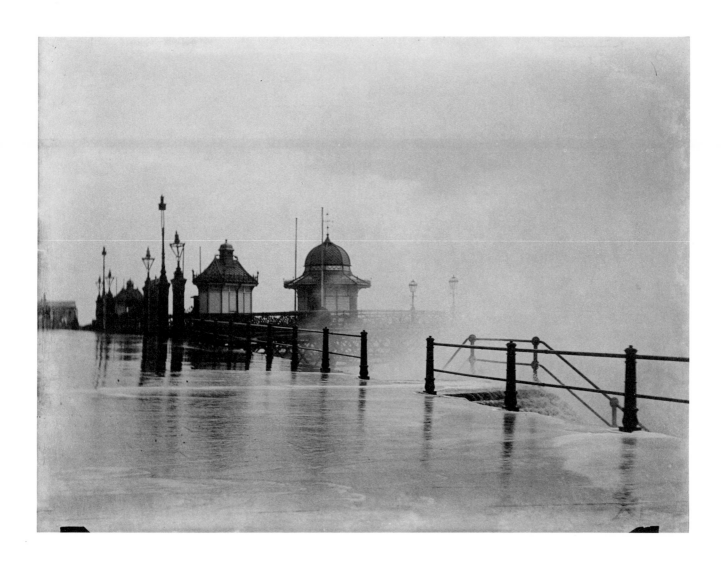

PLATE 66
*Deal. 1886. Deal boatmen. Even on his
holidays Martin sought out the common people
with his cameras. Since many of his vacations were to
coastal towns in England and on the Continent, he often
recorded the faces and environment of the
fishermen and their families.*

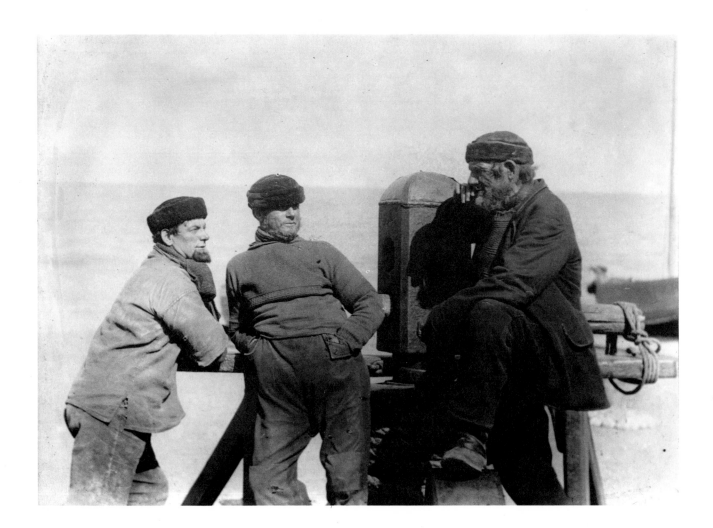

PLATE 67
Hastings. 1896. Fisherman dropping the anchor.

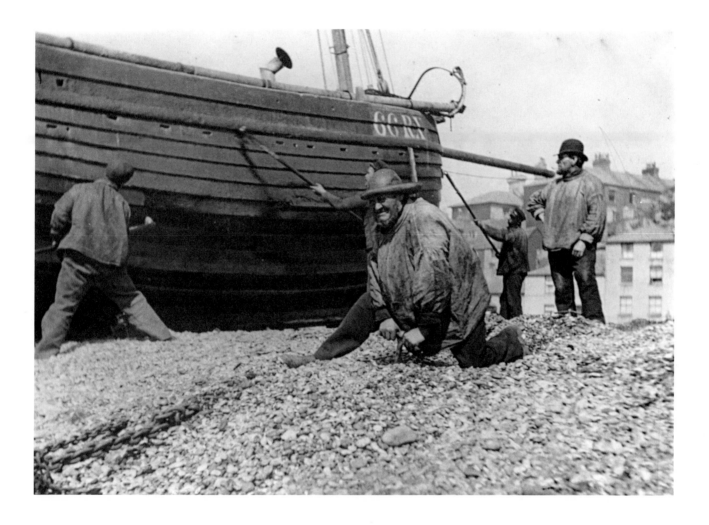

PLATE 68
Hastings. 1896. "A Swing from Father's Boat."
At the fishing end of the beach in Old Town, Martin found the
fishermen's children playing around their
fathers' beached boat.

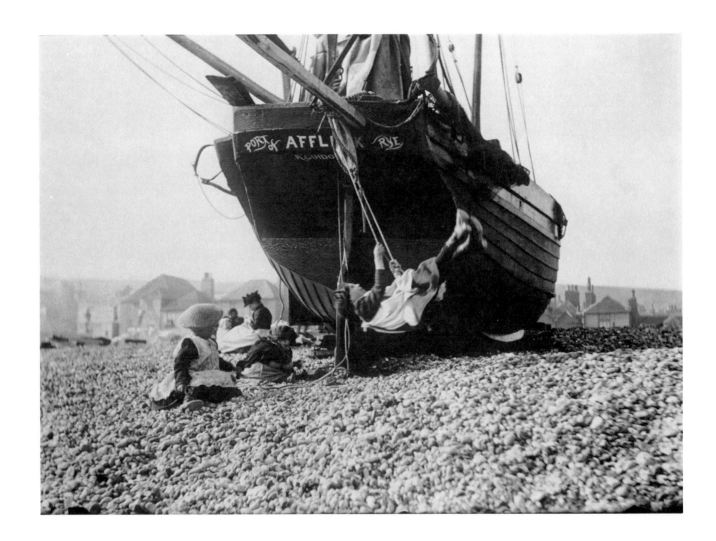

PLATE 69
*Hastings. 1896. A fisherman on the Old Town
beach gives his boat a name.*

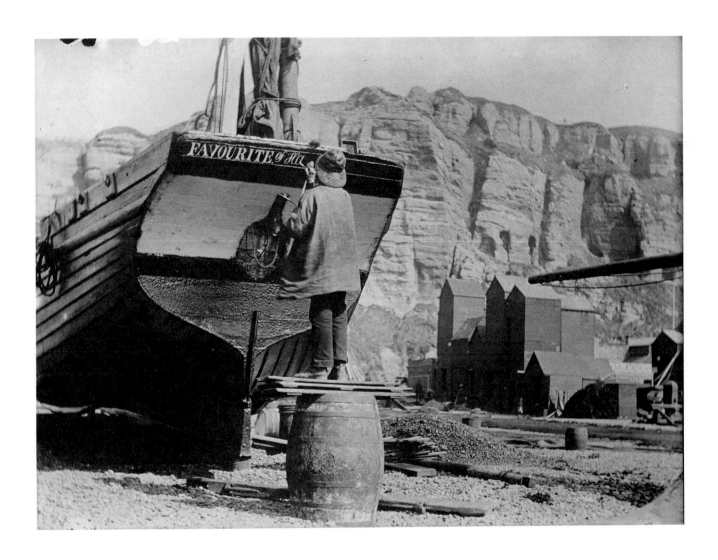

PLATE 70
Jersey. 1893. Gorey fishermen.

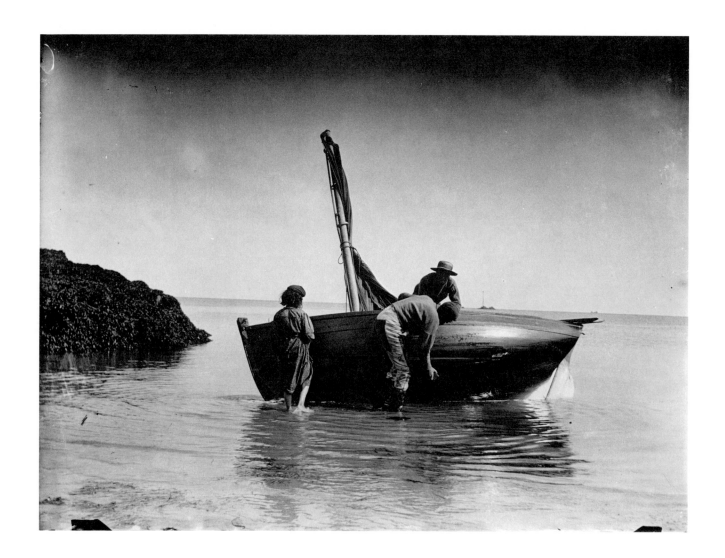

PLATE 71
Jersey. 1893. "The Fisherman."

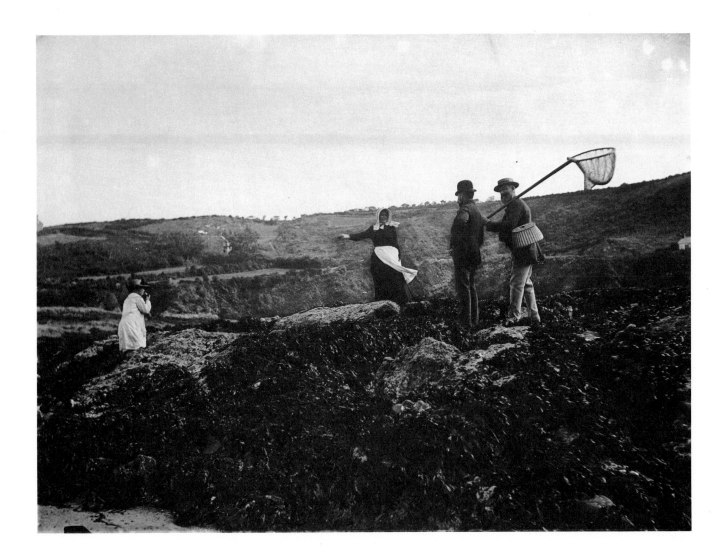

PLATE 71
Jersey. 1893. "The Fisherman."

PLATE 72
Boulogne. 1897. "Off to the Fishing Grounds."

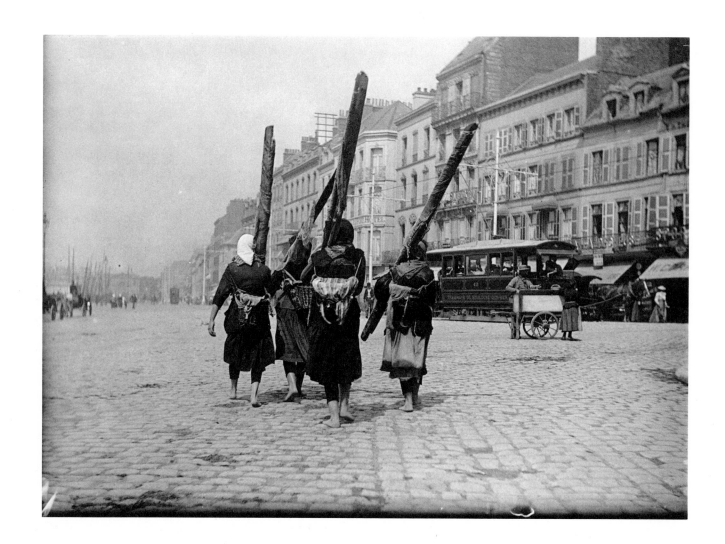

PLATE 73
*Deal. 1892. Entertainment on the Margate Sands. Martin
also trained his cameras on his fellow vacationers.*

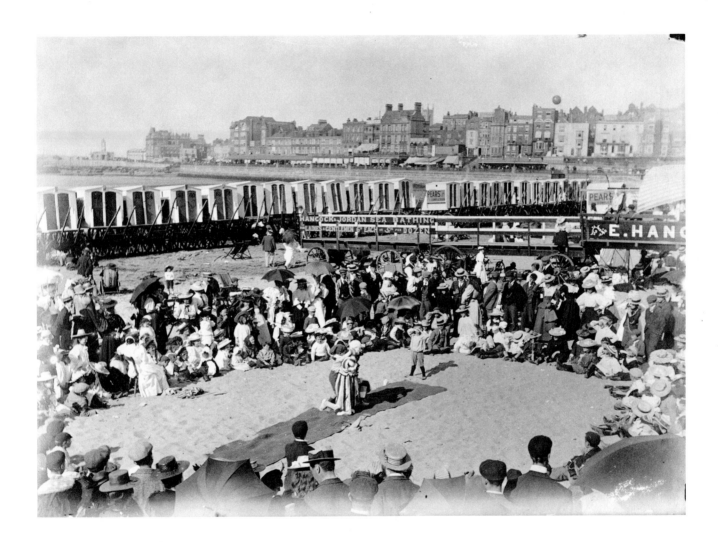

PLATE 74
Jersey? 1893?

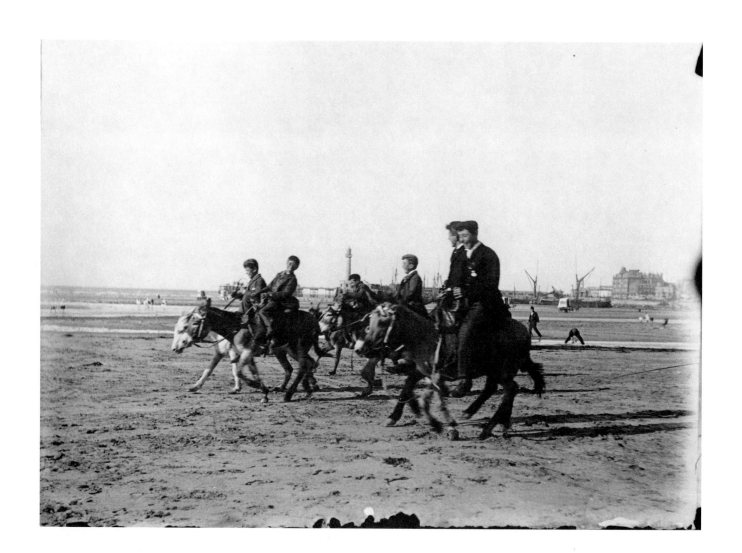

PLATE 75
Jersey. 1893.

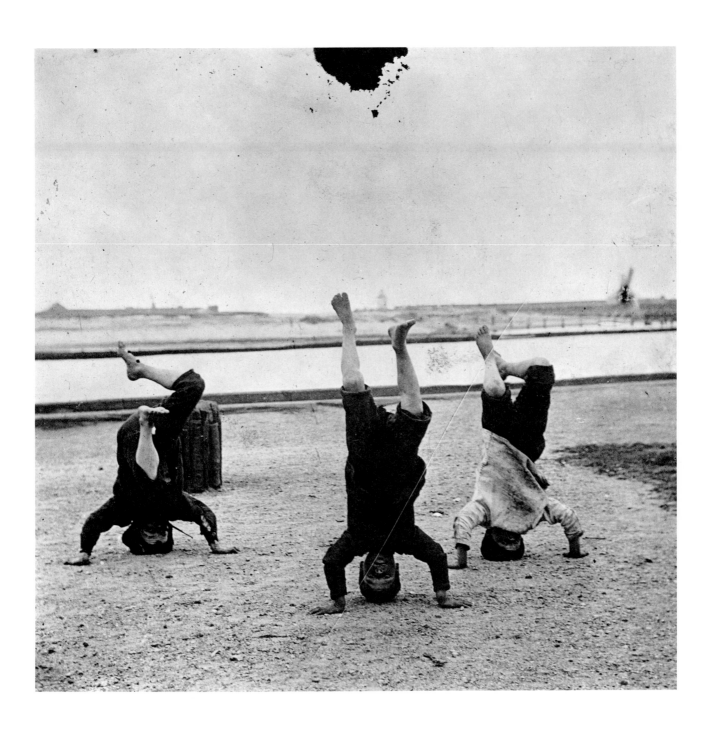

PLATE 76
*Jersey. 1893. Bathing at St. Helier, a
party of three from Birmingham.*

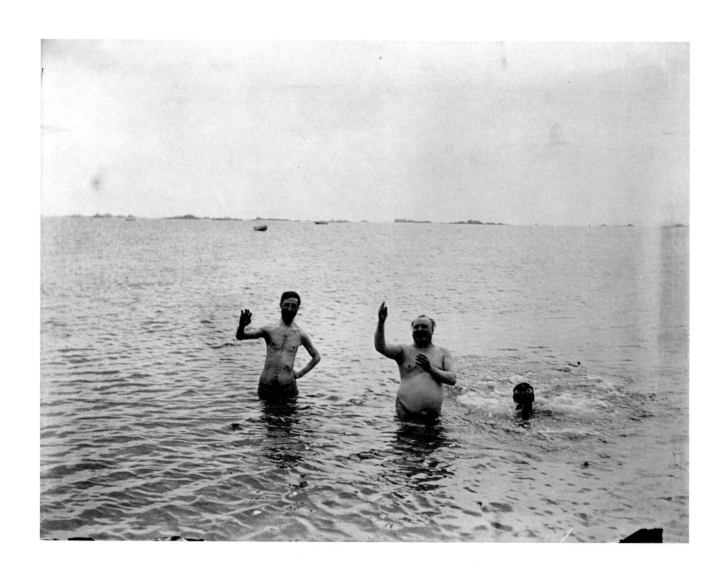

PLATE 77
Jersey. 1893. Burning seaweed.

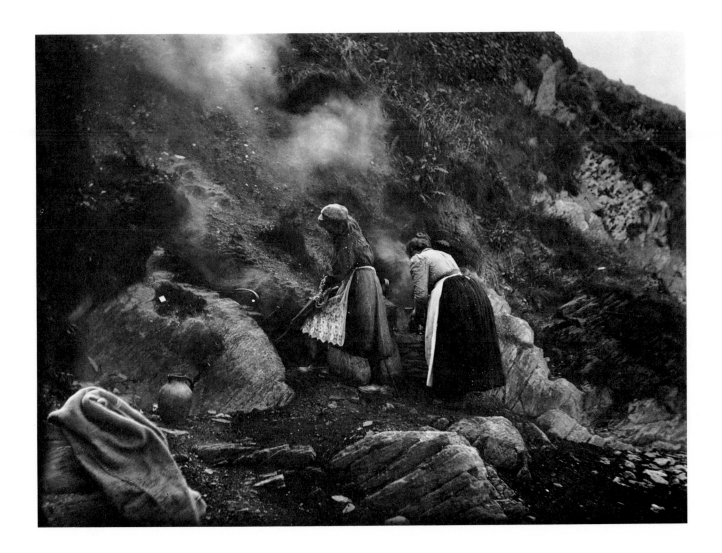

PLATE 78
Jersey. 1893. The mussel gatherer.

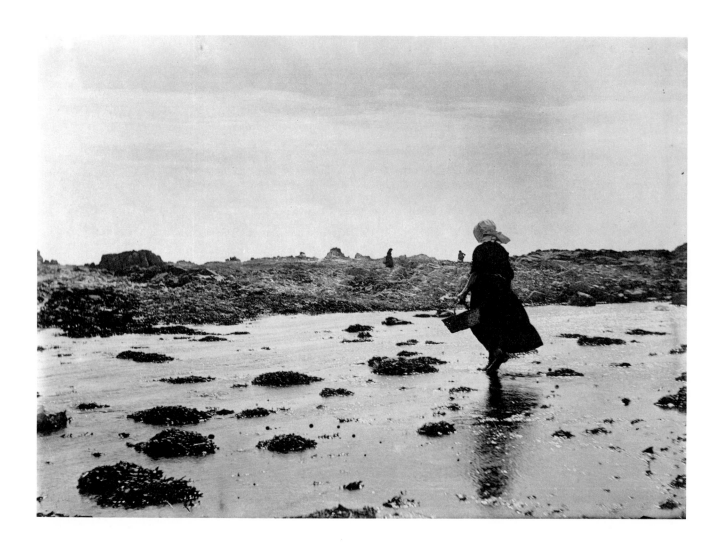

PLATE 79
Devonshire. 1894. A scene at Appledore, a noted place for
artists. Exhibition title: "The Critics."

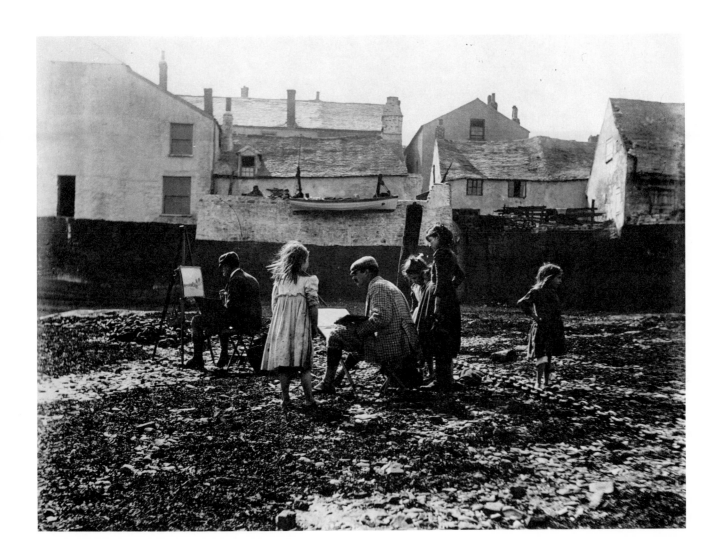

PLATE 80
Boulogne. 1897. On holiday in the French
coastal town, Martin again turned his camera on both the
native residents and his fellow vacationers.

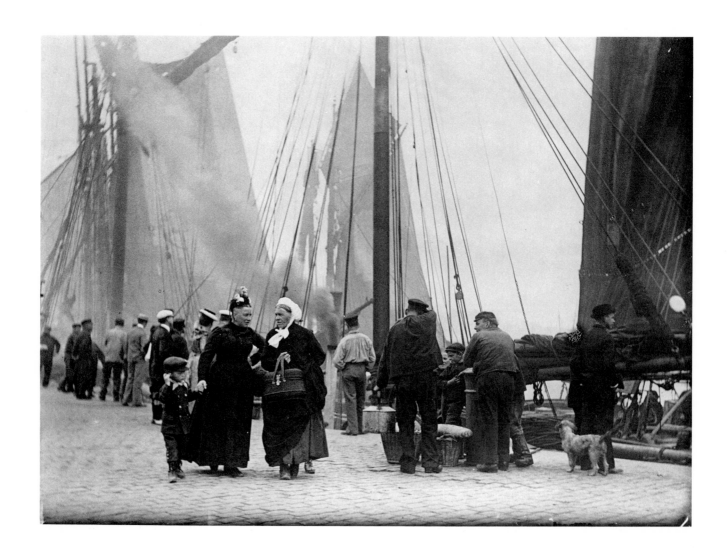

PLATE 81
*Boulogne. 1897. "Pioneers on the Quay." "First Appearance
of Women in Bloomers in Boulogne."*

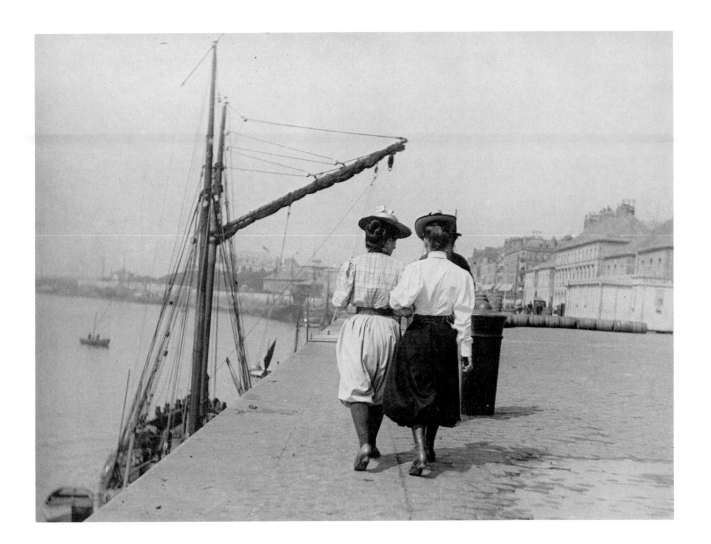

PLATE 82
Boulogne. 1897.

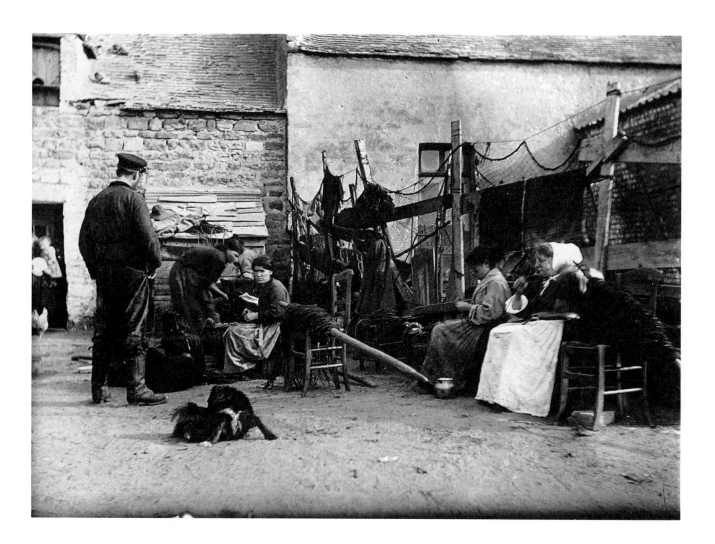

PLATE 83
Boulogne. 1897.

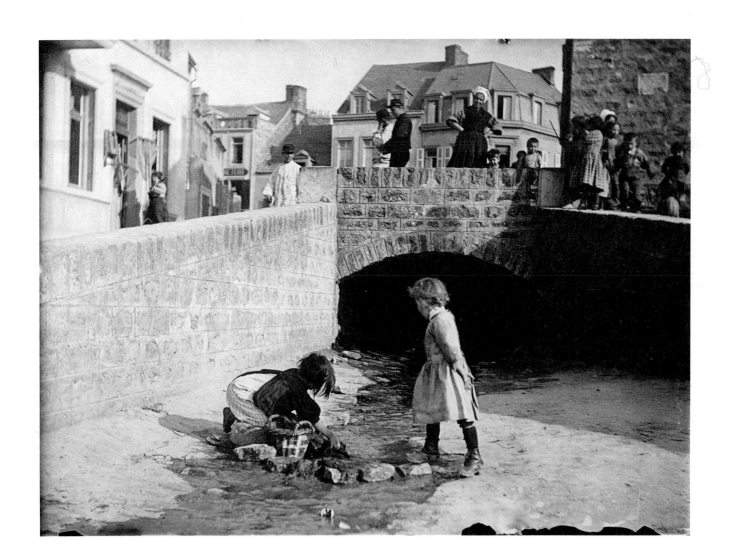

PLATE 84
Boulogne. 1897. "Hurry up, Lazy Bones."

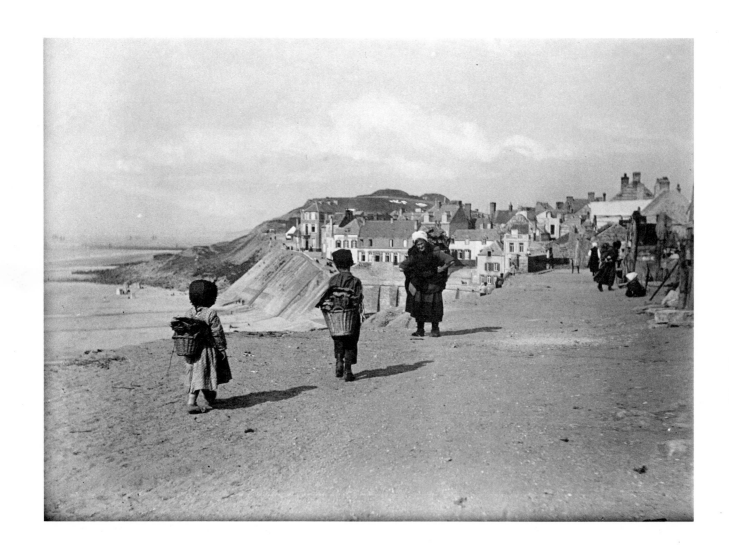

PLATE 85
Boulogne. 1897. "How a Kodak Works."

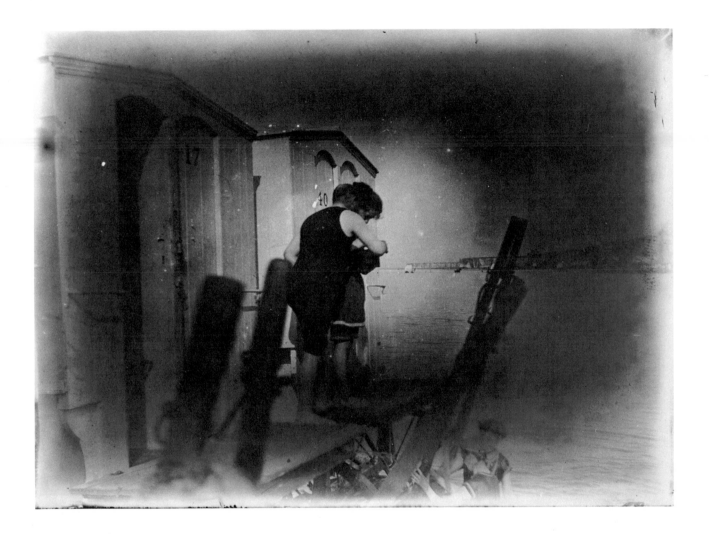

PLATE 86
Switzerland. 1895. At the railway station in Pilatus.

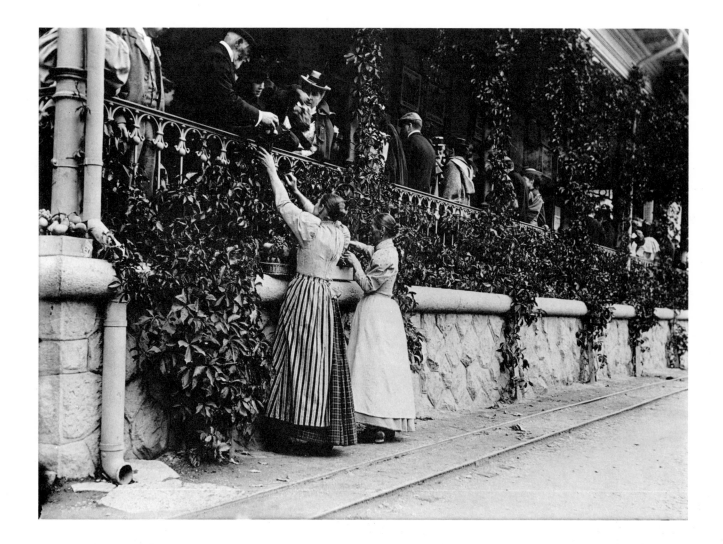

PLATE 87
*London. 1897. Preparations for Queen Victoria's Diamond
Jubilee. "Decorating at Ludgate Circus."*

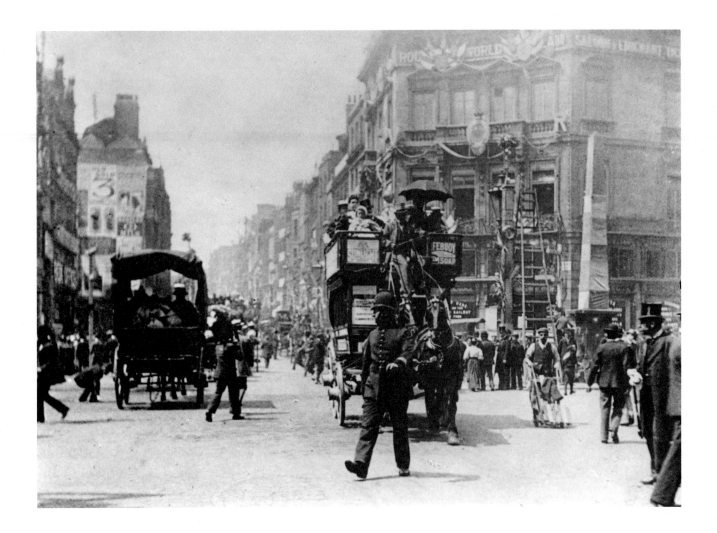

PLATE 88
*London. 1902. "Lord Kitchener (in Mufti)
talking to General Trotter at the unveiling of
General Gordon's Statue by the Duke of Cambridge. It was
eventually erected in Khartoum." Martin noted the
ceremony was "A Feast for the Ladies."*

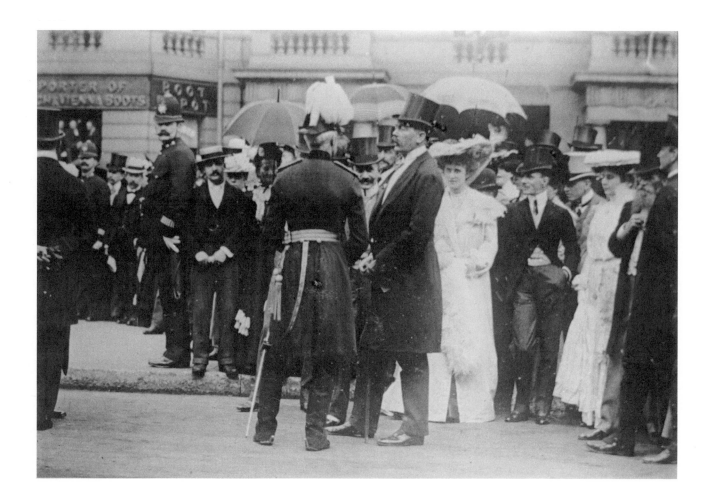

PLATE 89
London. 1902. Coronation of King Edward
VII. "Opening of Parliament by King Edward VII."
The occasion of the new monarch's ascendancy to the throne
was one of the earliest news events covered by
Martin in his professional career.

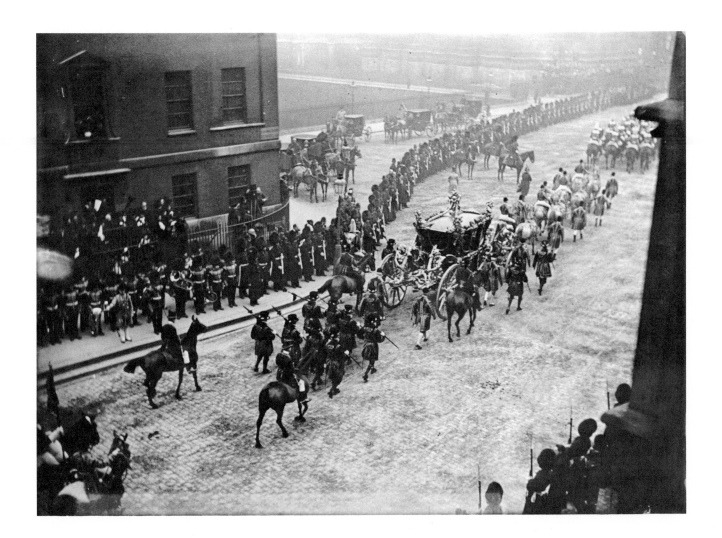

PLATE 90
*London. 1902. Coronation of King Edward
VII. "Review of Indian and Colonial Troops." "Prince
Eddy (or 'Eddie') (Prince of Wales) or ('Duke of Windsor') made
to pose properly to the photographer, by Prince
George of Greece (on the right)."*

PLATE 91
*London. 1902. Coronation of King Edward
VII. "The King and Queen Alexandra Leaving the Horse
Guards Parade after the Military Review
of the Colonial Troops."*

PLATE 92
*London. 1902. Coronation of King Edward
VII. "The Canadian Arch in Whitehall." Martin applied
his skill in night photography once more, noting that it was
"The first big electric display seen in London."*

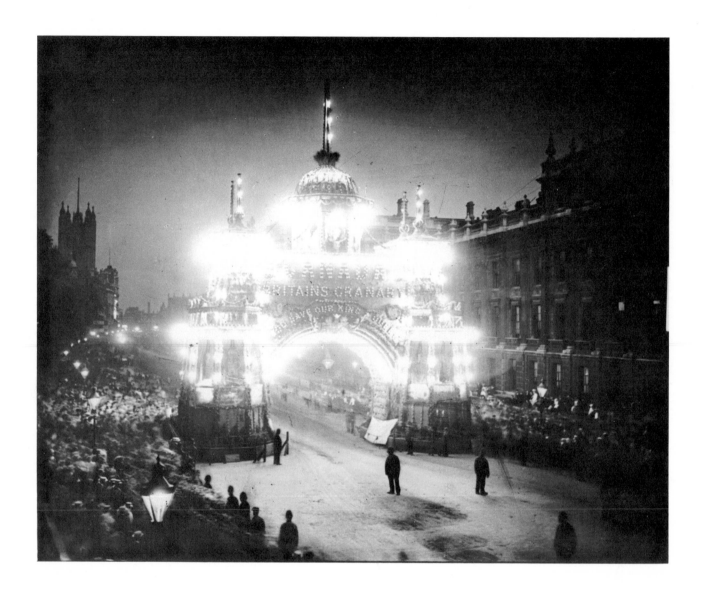

PLATE 93
*London. 1902. "Society at Tea during
the Interval." The occasion was a charity bazaar, the Great
Country Sale at the Earl's Court Exhibition.*

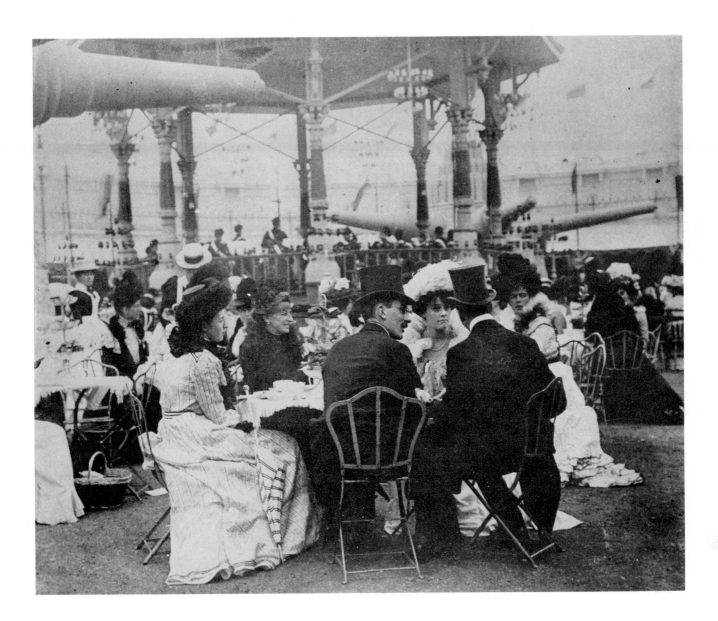

Index

A B C of Photography, 28, 108 n.30
Abney, William de Wiveleslie, 56, 112 n.103
Ackery, Clara Emily, 65
Adams, Ansel, 33
Amateur Photographer, The, 30, 75
amateur photography, xi, 9, 15, 18, 20, 52, 59, 64, 74
Annan, James Craig, 52, 59
apprenticeship, 99
Archer, Frederick Scott, 15
Artisans' Dwelling Act (1875), 85
Atget, Eugene, 3, 75
Athol Studios. *See* Dorrett & Martin
Autotype Company, 56, 58

Battersea (London), 86
Battersea Museum, 70
Battersea Park (London), 33
Beard, Richard, 47, 111 n.79
Beaton, Cecil Walter Hardy, 33
Bethnal Green (London), 99
Bitter Cry of Outcast London, 79
blocked-out lantern slides, 43, 44–46, 111 n.77
Bolt Court School of Engraving, 61
Booth, Charles, 79, 80, 86, 88, 94
Bow (London), 99
Brassaï (Gyula Halàsz), 74
breweries, 94
British Journal of Photography, 24, 28, 35, 68
British Journal Photographic Almanac, The, 28, 64, 65, 66, 67
Burgess, John, 17, 19, 107 n.15
Burton, William Kinnimond, 28, 108 n.30

cabinetmaking, 99, 101
calotype, 107 n.12
Camera Club of New York, 58
Camera Work, 75
Cameron, Henry Herschel Hay, 52
Cameron, Julia Margaret, 106
Cartier-Bresson, Henri, 74
"casualization" of labor, 85, 91
Centenary of Photography Exhibition, 70
"Characters from London Streets," 43
Cheapside (London), 61
Clapham (London), 86
contact printing, 17, 28, 42–43
costermongers, 96–99
Covent Garden (London), 98
cut-out figures. *See* blocked-out lantern slides
cycling and photography, 75, 110 n.57

Daguerre, Louis Jacques Mandé, 107 n.12, 109 n.31
daguerreotype, 47, 107 n.12, 109 n.31, 111 n.79
Daily Graphic (New York), 11, 13
"Dark Corners in Darkest London," 43
Davison, George, 30, 33, 34, 50, 52, 59, 61, 74, 109 n.40, 113 n.105
detective camera. *See* hand camera

domestic service, 104
Dorrett, Harry Gordon, 63, 64, 114 n.125, 115 n.142
Dorrett & Martin, 63–70, 114 n.126, 115 n.142
Douet, Paul, 8, 9
Dresser, A. R., 35, 37, 52, 110 n.59
drink, 92–93, 104
dry plates, xi, 15, 17, 18, 19, 20, 27, 28, 75, 107 n.15, 112 n.94
Dudley Galleries. *See* Photographic Salon

East Ham (London), 85
Eastman, George, 18, 20, 59, 109 n.40
Eastman Dry Plate & Film Company, 18, 30, 59, 61, 64, 109 n.40
Eastman Exhibition, 59
Edmunds, Walter, 55, 113 n.105
Emerson, Peter Henry, 33, 52, 108 n.26, 109 n.40
enlarging, photographic, 18, 43, 56, 58, 59, 64, 68, 70, 115 n.139
Epping Forest (London), 104
Evans, Frederick Henry, 52, 59

f/64 School, 33
Facile hand camera, 24, 26, 37–42, 47, 54, 56, 59, 61, 64, 66, 70, 74, 111 n.72
Fallowfield, Jonathan, and Company, 20, 37, 42, 66, 111 n.72
Fleet Street (London), 8, 47, 59
Fraser, William A., 58
Friedlander, Lee, 43
Fry, Roger, 106

Gale, Joseph, 30, 33, 50, 52, 74, 109 n.41
gas lighting, 54, 56, 74
Gernsheim Collection, xi, xiii, 28, 70
Gissing, George, 89
Great Exhibition of 1851, 18

half-tone process, 8, 11–12, 13, 15, 54, 61, 107 n.5, 109 n.40
Hampstead Heath (London), 26, 61, 102, 104–105
hand camera, 17–27, 33, 35, 42, 52, 59, 75, 108 n.26
Hastings, 59
Heart of the Empire, The, 79
Herschel, John Frederick William, 3
Hine, Lewis, xi, 43
Hinton, Alfred Horsley, 52
Hoggart, Richard, 91
holidays, 104–105
Hollyer, Frederick M., 52
Horgan, Stephen Henry, 13
housing, 85–86, 89, 92
Hyde Park (London), 26, 64

Illustrated London News, The, 10, 11
instantaneous exposures, 28, 38, 40–41, 108 n.30, 115 n.133
Instantograph camera, 28

Islington (London), 96

jam-making, 102

Kodak camera, 18, 20, 35, 39, 59, 61
Kodak Company. *See* Eastman Dry Plate & Film Company

Labour Party, 91
Lambeth (London), 80, 86, 92, 104
Lancaster, J., & Sons, 28, 43
lantern slides, xi, 24, 30, 42–43, 53, 56, 58, 59, 63, 70, 74, 75, 110 n.48
Lartigue, Jacques Henri, 74
Leica camera, 115 n.143
Leytonstone Camera Club, 43
Life and Labour of the People in London, 79
Linked Ring, 52, 109 n.40
Lloyd, Marie, 105
London, passim; employment and industry in, 83, 85; housing in, 85–86, 89, 92; markets in, 90, 104; neighborhoods of, 86–91, 92; social and economic conditions in, 79
London and Provincial Photographic Association, 54, 58, 59
"London by Gaslight," 56, 59
London Directory, 15
London Labour and the London Poor, 43, 47, 80, 111 n.79

Maddox, Richard Leach, 17
Manchester, 79, 90
Marey, Etienne Jules, 110 n.66
markets, 90, 104
Maskell, Alfred, 52
Masterman, C. F. G., 79, 80
Mayhew, Henry, 43, 47, 80, 96, 111 n.79
Mearns, Andrew, 79
Méritoire, Le, camera, 28
Miall, F., 37, 39
Mile End (London), 99
Mills, F. W., 115 n.133
Morrison, Arthur, 88–89
Museum of Modern Art, 70
Muybridge, Eadweard, 38, 40, 110 n.66

National Photographic Record Association, 33, 35
Naturalistic Photography, 33
neighborhood, 86–91, 92
Newhall, Beaumont, 70
New York City, 80
Niépce, Joseph Nicéphore, 11, 107 n.7
night photography, 54–58, 59, 66, 75, 113 n.105

Old Ford (London), 99
Orwell, George, 86

Pall Mall. *See* Royal Photographic Society of Great Britain
Palmos camera, 70, 73, 115 n.143

Paris Photographic Salon, 58
Peckham (London), 92
Pember Reeves, M. S., 88
permits, photographic, 24
Philadelphia Salon, 58
photo buttons, 66, 68, 69, 70, 74
photogenic drawing, 107 n.12
Photogram, The, 54, 58, 63
Photograms of the Year, 58
Photographic Salon, 34, 36, 52, 54, 56, 70, 113 n.105
Photography, 17, 52
"Photography, 1839–1937" (exhibition), 70
photojournalism. *See* press photography
pictorialism, 5, 35, 50, 52, 59, 61, 74
police, 96, 98
poverty, 86, 89
press photography, xi, 3, 63–66, 74
process engraving. *See* half-tone process
Pugh, Edwin, 90

Rejlander, O. G., 60
rents, 88, 92
respectability, 90–91, 96
Richmond Park (London), 26
Riis, Jacob, xi, 3, 43, 75, 80
Roberts, Robert, 90
Robinson, Henry Peach, 33, 52, 59, 60, 108 n.26
Robinson, William Heath, 38, 110 n.63
Rodinal, 56, 112 n.98
roll film, 59, 61, 70
Royal Photographic Society of Great Britain, 52, 54, 56

Salon. *See* Photographic Salon
schools, 104
shutter, photographic, 17, 28, 38, 39, 61, 74, 75
slums, 86, 88
Smith, Adolphe, 43, 80, 98, 111 n.79
Smith, W. Eugene, 74
snapshot, 3, 24, 27, 35, 42, 43, 47, 59, 61, 64, 66, 70
Social Democratic Federation, 101
Society of Night Photographers, 57, 58
Stedman Jones, Gareth, 83
Stieglitz, Alfred, 3, 5, 33, 57, 58, 59, 75
Stone, Benjamin, 33, 110 n.50
Street Life in London, 43, 47, 48, 80, 111 n.79
Sunday Schools, 102
Sutcliffe, Frank Meadow, 52, 59, 75, 76

Talbot, William Henry Fox, 107 n.12
Taylor, R. & E., 9
technological change, 91
tenements, 89
Thames Embankment (London), 26, 54, 113 n.105
Thomson, John, xi, 43, 47, 48, 80, 111 n.79
291 Gallery, 75

Victoria and Albert Museum, 70

Victorian Snapshots, 70
Victoria Park (London), 26, 89
Victoria's World (exhibition), xi

wages, 93, 94, 99, 102
Wandsworth Common (London), 26
Wanstead Flats (London), 104
Welford, Walter D., 35, 108 n.20, 110 n.57, 110 n.62
Wellington, J. B. B., 52
West Surrey Amateur Photographic Society, 4, 7, 30, 35, 37, 43, 52, 58, 59, 63
wet collodion process, 15, 16, 17, 109 n.41, 111 n.79, 115 n.133

Wimbledon Camera Club, 70
Woodburytype, 11, 111 n.79
woodcuts (wood engravings, wood blocks), xi, 8, 9, 10, 11, 13, 14, 15, 28, 33, 38, 70, 73, 75, 107 n.5, 107 n.6, 111 n.79
wood engraving (wood cutting, woodpeckers), xi, 3, 8, 9, 11, 12, 15, 28, 43, 47, 54, 59, 61, 64, 70, 73, 107 n.5, 109 n.40
Woodford Photographic Society, 115 n.139

Yarmouth, 37, 104–105